CHIHULY
GARDEN AND GLASS

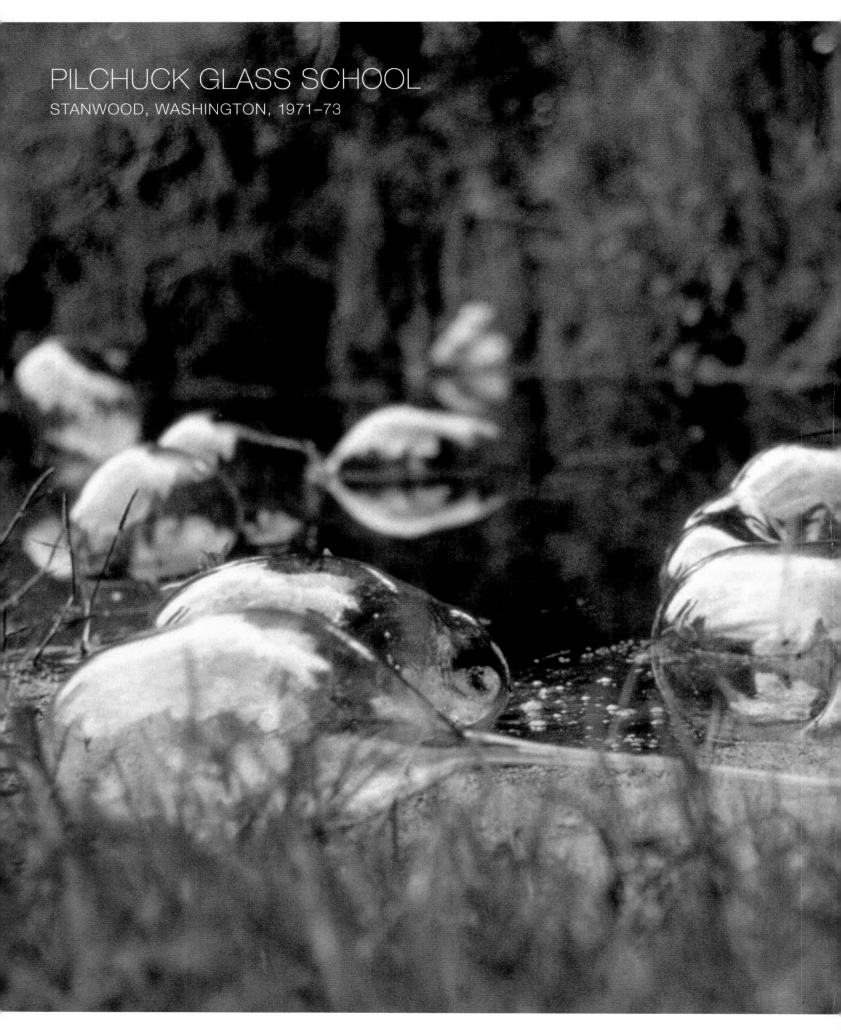

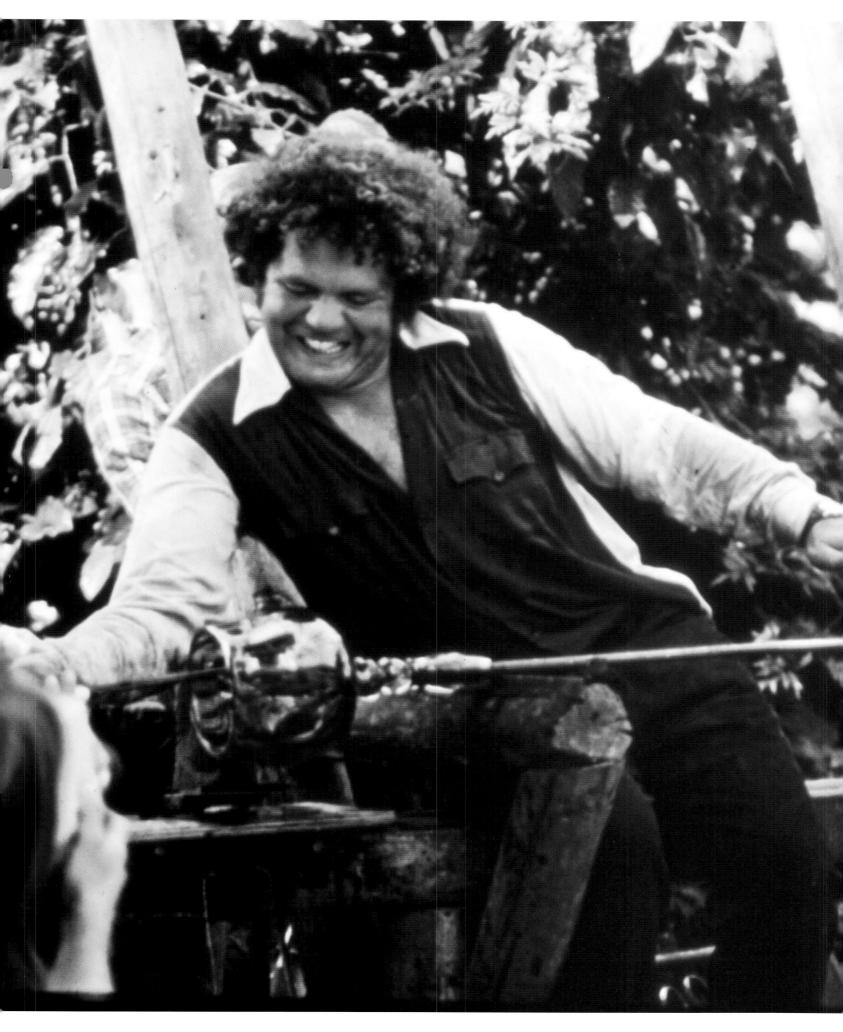

3

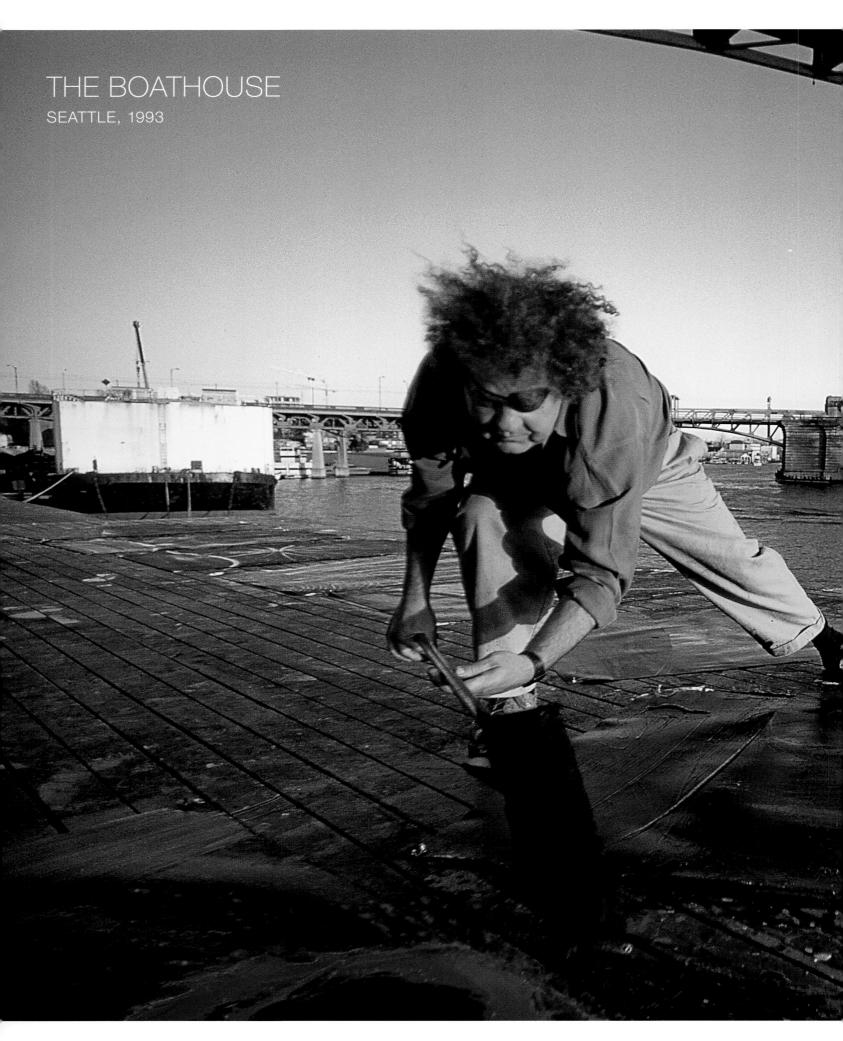

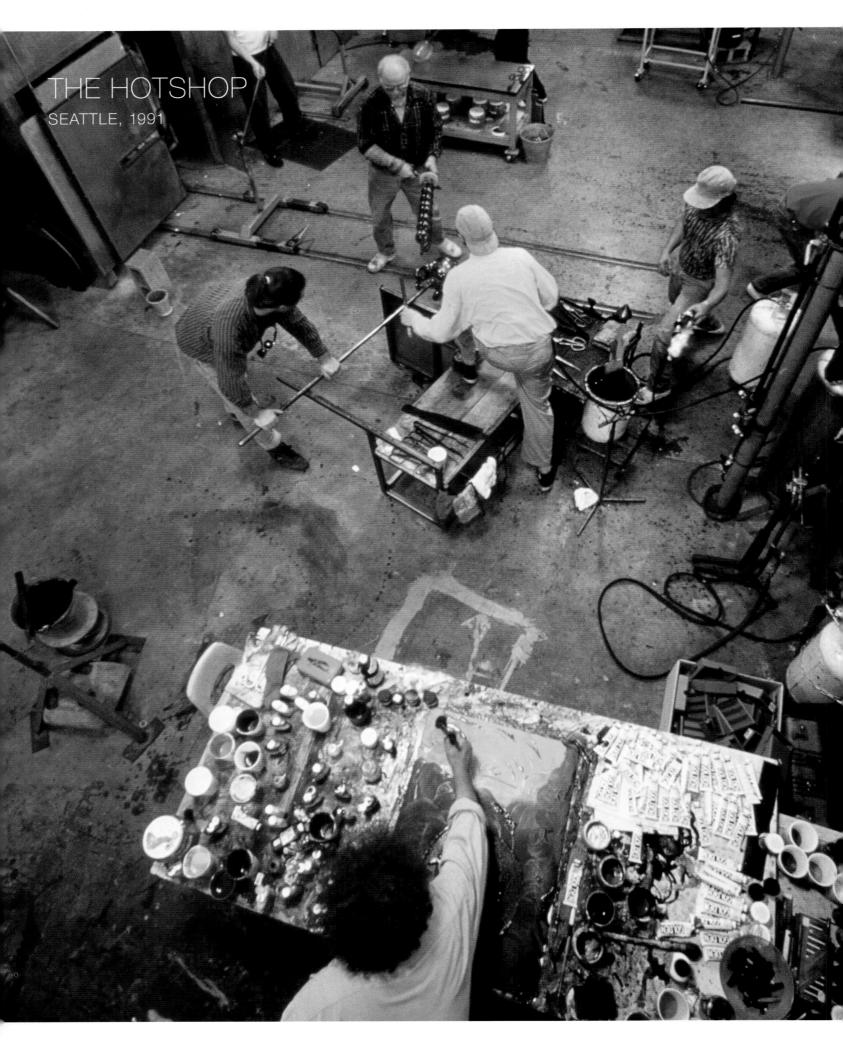

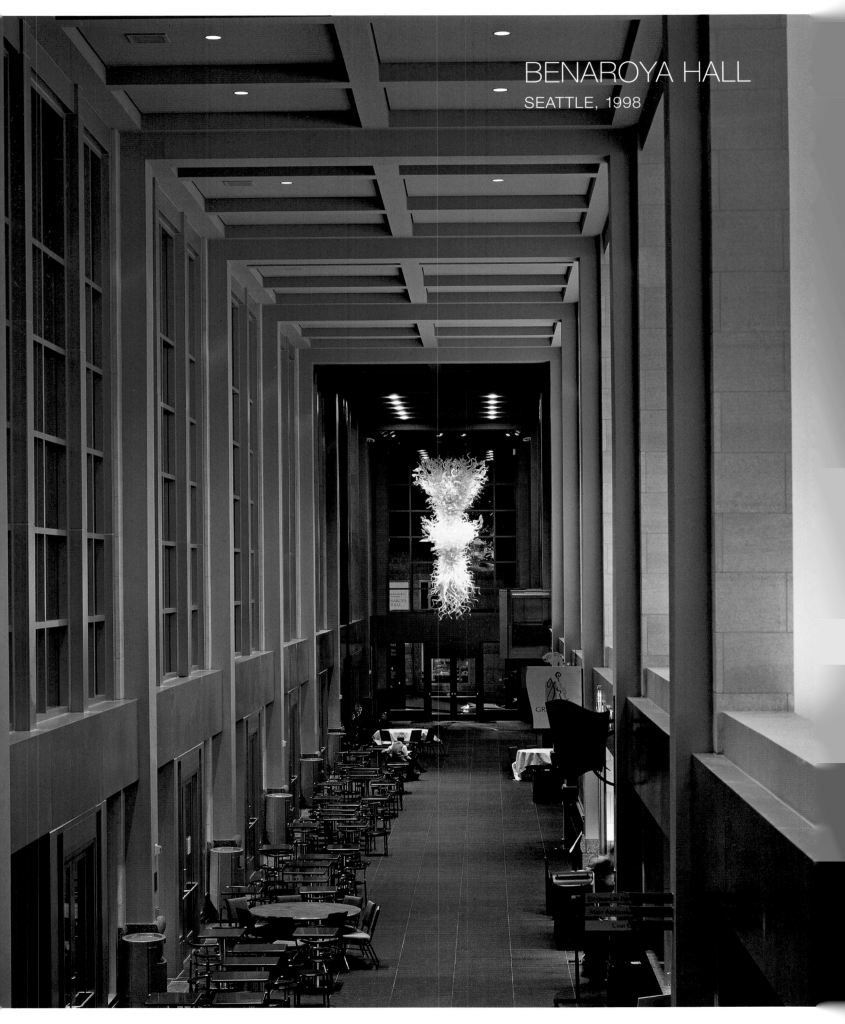

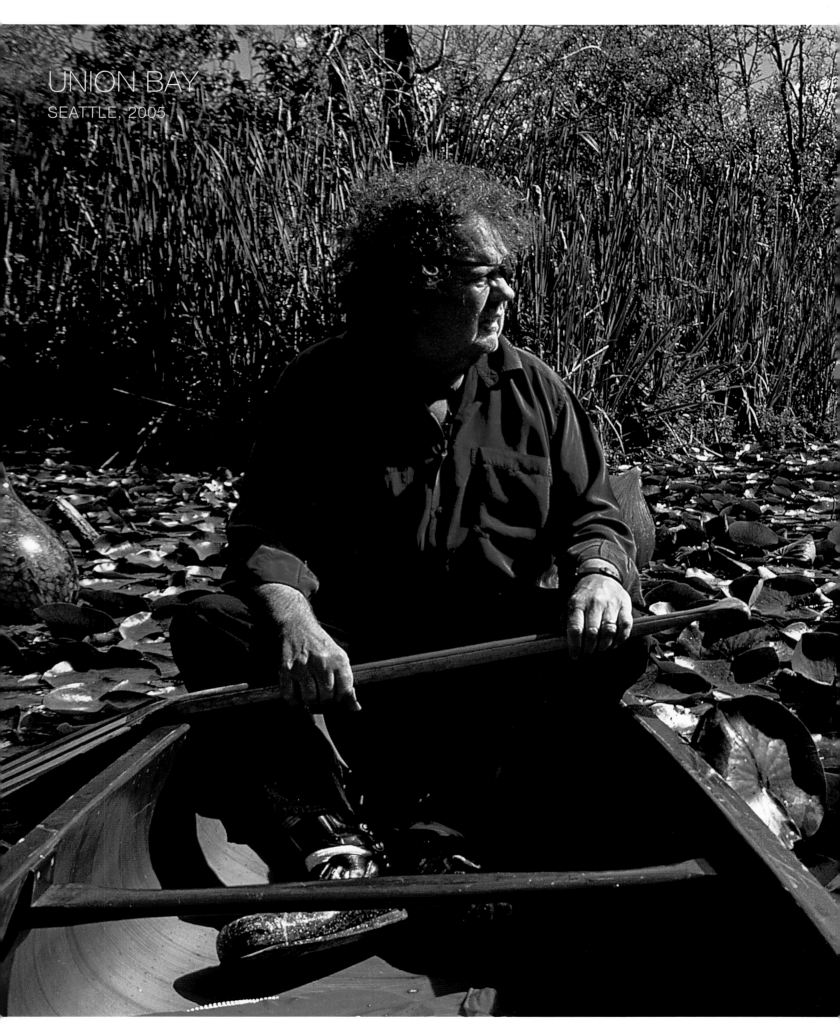

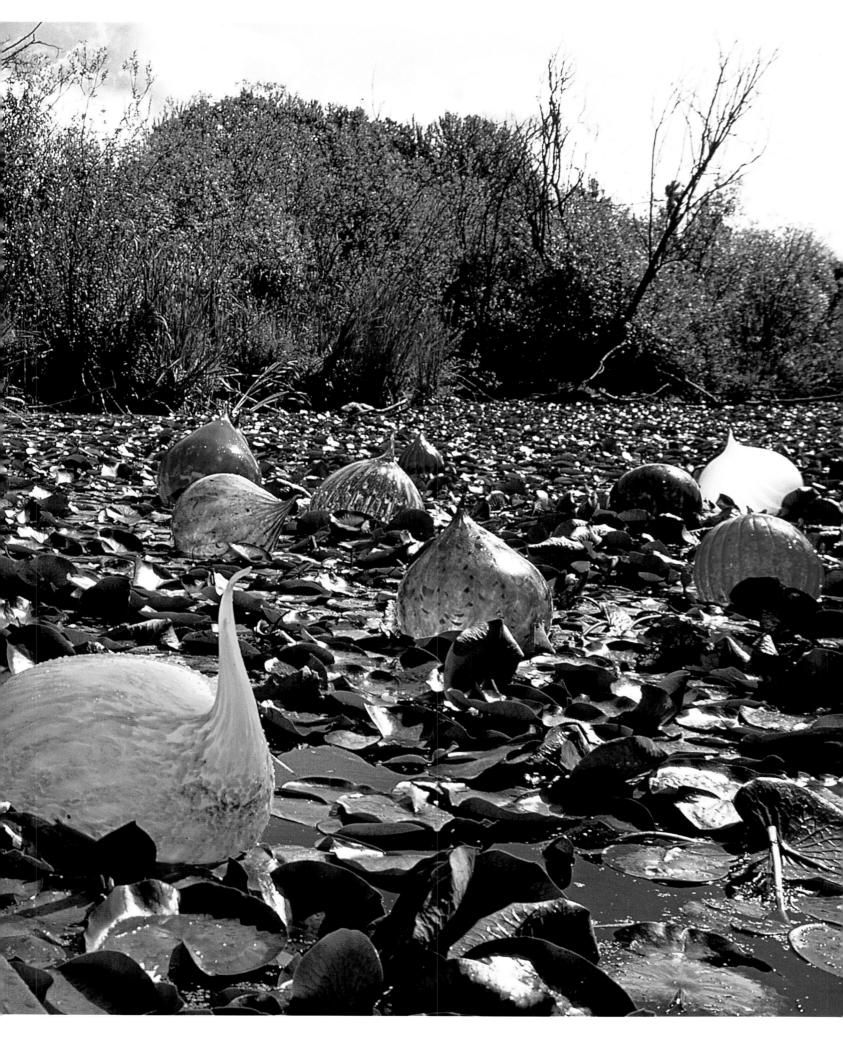

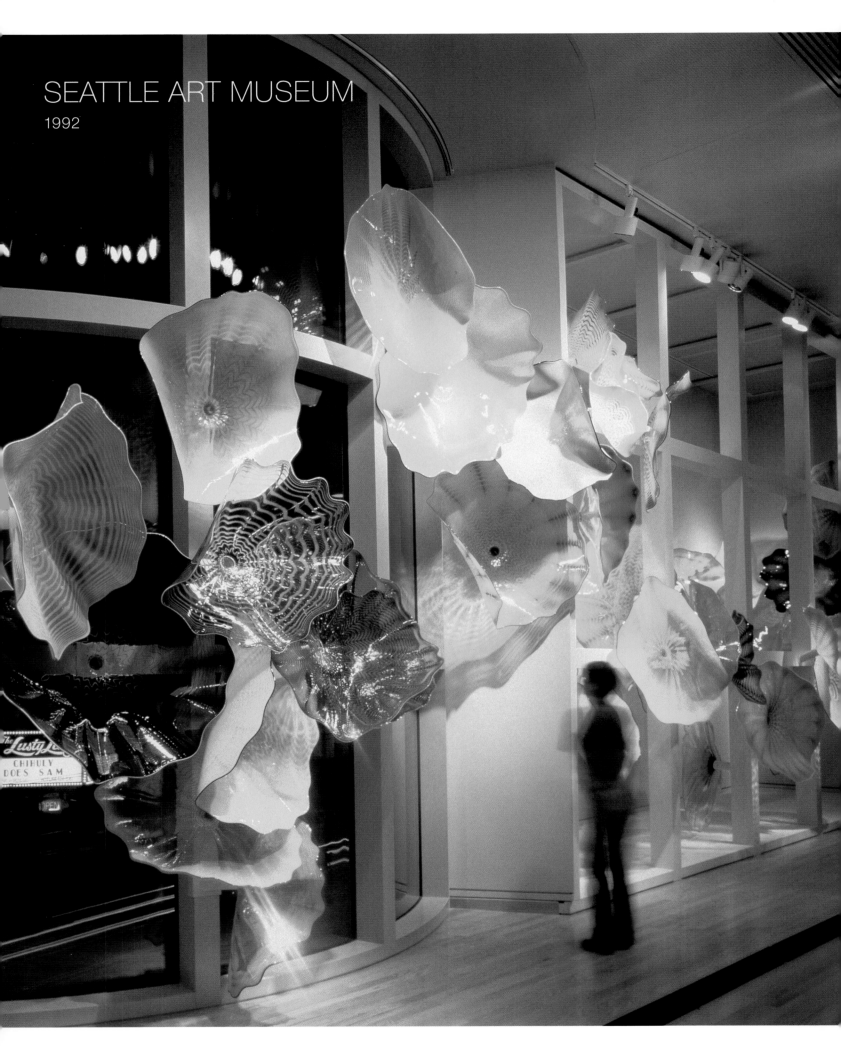

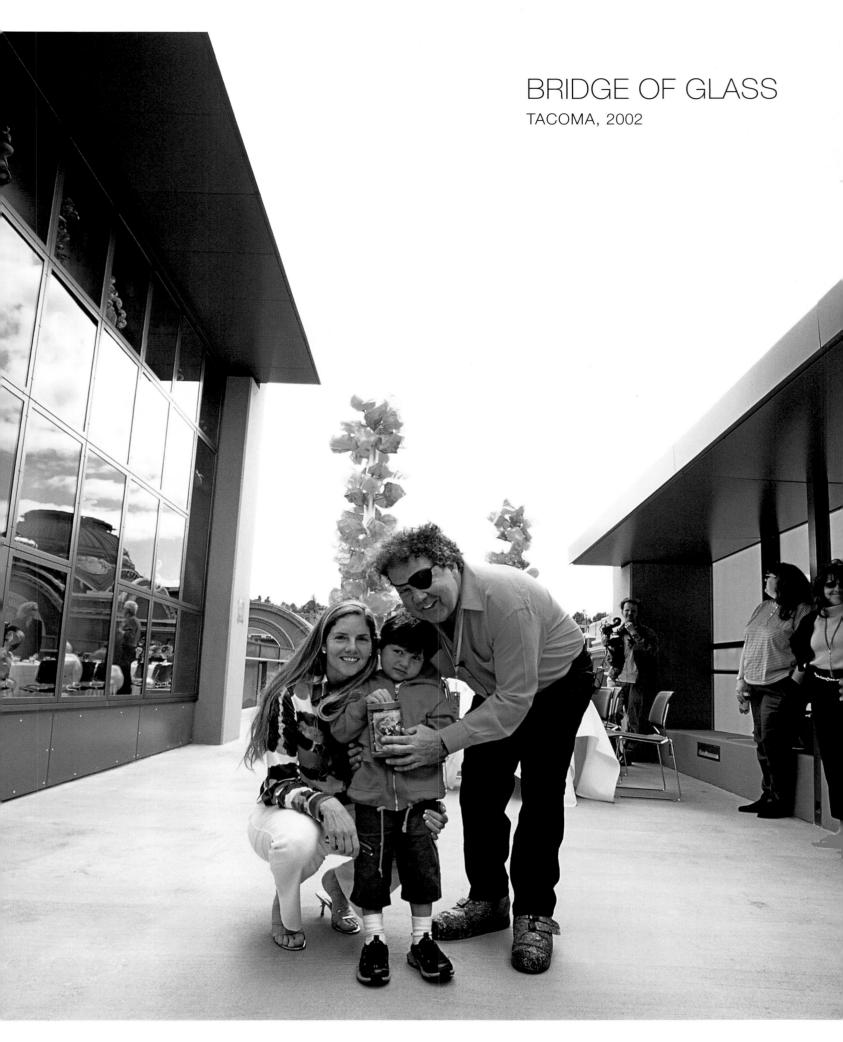

BRIDGE OF GLASS
TACOMA, 2002

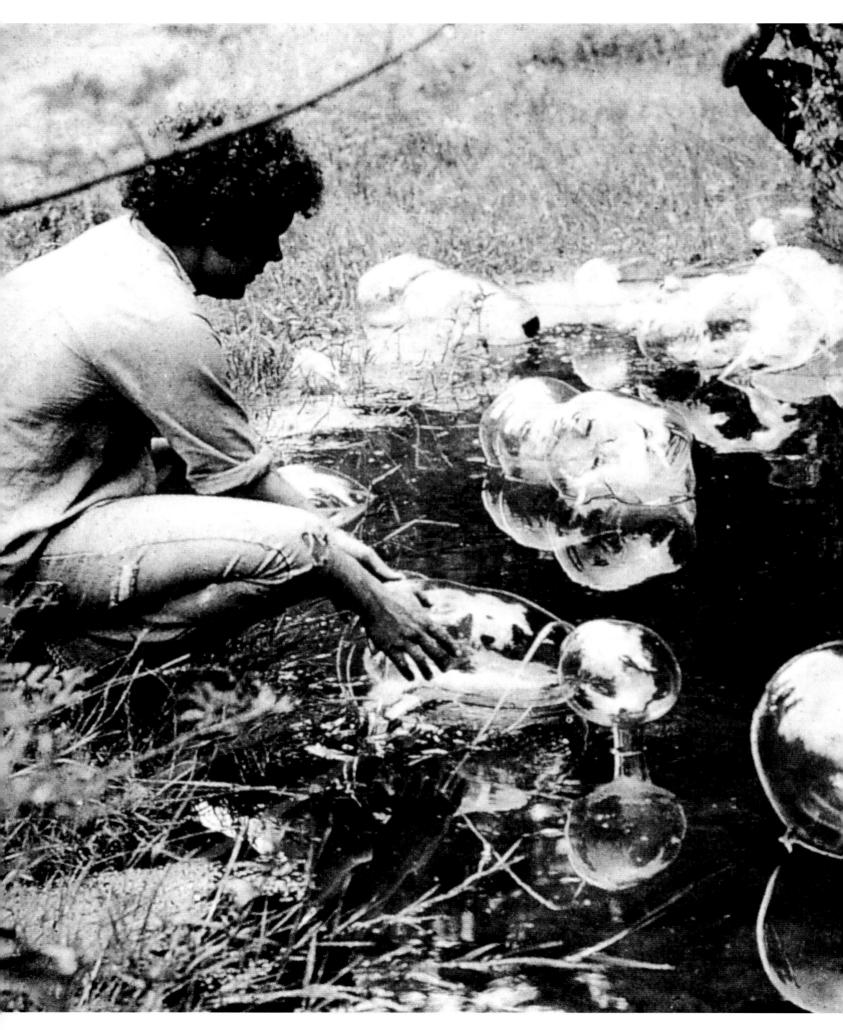

TO ALL THE GLASSBLOWERS
AND FRIENDS I'VE WORKED
WITH OVER THE PAST 50 YEARS.

CHIHULY
GARDEN AND GLASS

Portland Press

TABLE OF CONTENTS

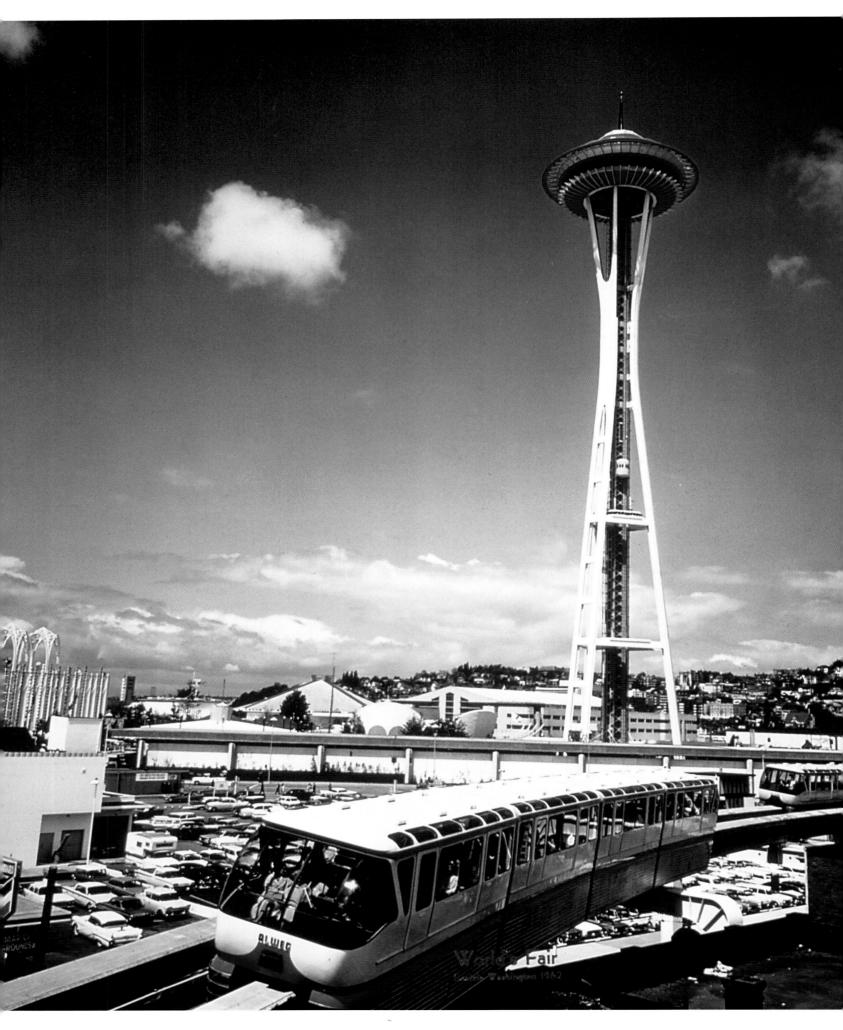

In 1962, Seattle was a modern city that had recently emerged from an old frontier and was heading into a new one. The citizens of Seattle believed we would be leaders in the twenty-first century as an innovative, technologically advanced community, looking toward a more global future with optimism and confidence.

That year, Seattle hosted a world's fair devoted to this vision, in which science, innovation, and creativity were the basis of national and regional success. A group of architects, engineers, craftsmen, and private investors worked together to create a physical symbol to embody those ideals. I am proud my family played an important role in the effort. As the Space Needle rose, it became an international symbol of the spirit of the times, inspired by the Space Age and the belief that expanding our horizons was critical to human progress.

After half a century, my family's commitment to the Needle is unwavering. It has become an icon, like the Eiffel Tower, and after all these years it still feels as vibrant and inspiring as it felt then. It combines the elements sought to be present when Seattle turned the fairgrounds into Seattle Center: a place where art and science could form the basis of civic common ground.

It is this kind of innovative thinking that brought us to ask Dale Chihuly about an opportunity to create a unique exhibition. We were delighted to learn it was his dream to have a venue to showcase the breadth and scope of his vision, and he was thrilled it would be in the city that has been his home. He immediately focused on how the exhibition could inspire visitors and connect with local art activities, and it was important to all of us to partner with arts organizations and include free educational opportunities for students in Seattle. Like the Needle, we see it as a catalyst for inspiring innovative approaches to life, work, and culture.

Chihuly is a true Northwesterner—independent, creative, talented, and innovative. He has pioneered new techniques in art, influencing new generations of artists. For decades, his art has amazed and delighted millions of people around the world. There are strong ties between Chihuly, my family, and the Space Needle. I have admired his work and have been a collector of it for many years. We have displayed many of his works of art at the Space Needle for the enjoyment of our visitors.

Chihuly Garden and Glass is a source of pride for all of us, and is the most comprehensive collection of his artwork on public display. We believe it is an invigorating addition to Seattle Center, and hope it will inspire new generations to embrace creativity, innovation, and risk-taking, the ideas that Chihuly's work represents and have made Seattle what it is today, and will take us all to a better future.

Thank you.

Jeffrey Wright
Chairman
Space Needle, LLC

SPACE NEEDLE AND MONORAIL
SEATTLE WORLD'S FAIR, 1962

Over the past fifty years, Dale Chihuly has made a remarkable commitment to creating art. In that time, he has tirelessly expanded his vocabulary through experimentation and exploration, producing a body of work consistently pushing the boundaries of glass as a medium and an expressive material. It is a unique and humbling opportunity to bring together great examples from more than half a lifetime of work into a single exhibition space—a space where the ideas Dale has worked with throughout his career are revealed, relate to one another, and tell the story of his journey as an artist.

More than anything else, we feel this exhibition will become a great place to celebrate the power of creativity and serve as an activating venue for the larger arts community. It is our hope the space will become a gathering place for all the arts—dance, theater, music, lectures, symposia—a setting to explore the arts and learn about the artists who are making their marks, especially for the arts community in the Pacific Northwest.

We hope *Chihuly Garden and Glass* will be as great a gift to those who have shared it with us as it has been to imagine and design it. We are honored to be given this opportunity by the Wright family to create this exhibition for the Seattle Center campus and present Dale's work to the world.

With gratitude,

Leslie Jackson Chihuly
President
Chihuly Studios

DALE CHIHULY'S ART AND
THE NORTHWEST LANDSCAPE
ROCK HUSHKA

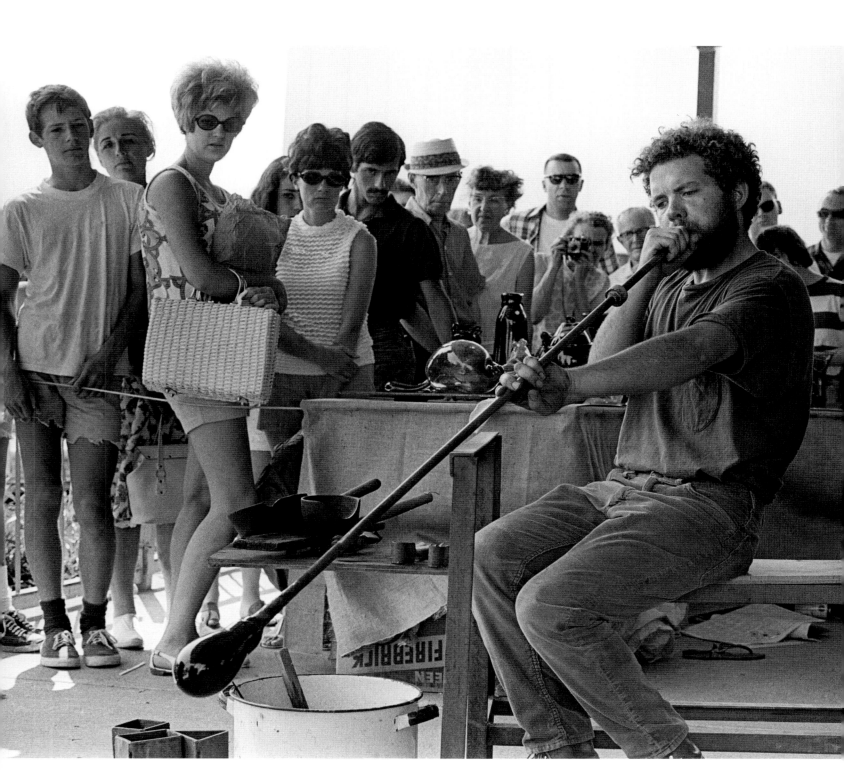

Dale Chihuly stands as one of the leading figures in American art. Since the late 1960s, his central role as a pioneer and innovator in the studio glass movement has been widely understood and celebrated. Yet his story is far more complex and richly textured. Defying simple categorization, Chihuly has melded glass, sculpture, installation, and conceptual art into a vibrant practice that is uniquely his own. Even with worldwide recognition, his art remains deeply influenced by the culture and environment of the Pacific Northwest.

In numerous ways, Chihuly's career has been shaped and nurtured by his love for and connections to the Northwest. As a young child, he collected colorful bits of glass on Puget Sound beaches in Tacoma and glass floats from Japanese fishing boats that washed ashore from the Pacific Ocean. Later, as a college student, Chihuly began working with glass, weaving rectangular inlays of fused, colored glass for a class assignment. Fascinated by the properties and intense colors, he continued to experiment with glass in his basement apartment, using a small kiln and unexpectedly blowing his first glass bubble through a short length of plumbing pipe.

DALE CHIHULY AT BELLEVUE ARTS FESTIVAL
BELLEVUE, WASHINGTON, 1968

DALE AND VIOLA CHIHULY
TACOMA, CIRCA 1943

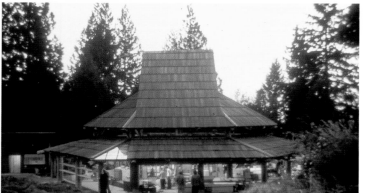

PILCHUCK HOTSHOP
STANWOOD, WASHINGTON

AT PILCHUCK THEY TRIED TO START
AFRESH. BRAND NEW. IT WAS VERY
PRIMITIVE. . . . ROUGH. VERY AMERICAN,
VERY NORTHWESTERN. I THOUGHT IT
WAS VERY, VERY ORIGINAL.

—ITALO SCAGNA, 1996

Chihuly continued his study of glass at the University of Wisconsin–Madison, in the nation's first glass program, and later at the Rhode Island School of Design (RISD). While at RISD in 1968, Chihuly was awarded a Fulbright Fellowship that allowed him a year of study in Italy, of which he spent nine months at the world-famous Venini Fabrica glass workshop on the island of Murano, near Venice. On his return to RISD, he started a glass program for the school.

By this time, Chihuly had emerged as one of the nation's leading innovators in glass. But even with his increasing acclaim and opportunities on the East Coast, he remained closely connected to the Northwest for personal and professional reasons. After his brother, George, a Navy pilot, was killed in a training accident in 1957 and his father passed away the following year, Chihuly and his mother, Viola, developed very strong bonds. He maintained almost daily contact with his mother in Tacoma until her death in 2006.

Professionally, the first museum exhibition that included Chihuly's work occurred at Tacoma Art Museum in 1968. Three years later, supported by the generosity of patrons John Hauberg and his first wife, Anne Gould Hauberg, Chihuly and his colleague Ruth Tamura established the Pilchuck Glass School in Stanwood, Washington. With the help of a group of energetic students, they built a hotshop on a campsite in the middle of a tree farm with spectacular views of Puget Sound and the Cascade Mountains. They envisioned Pilchuck as a place for radical experimentation with glass, a reputation the school retains today at the forefront as a leading educator of studio glass artists.

For Chihuly, constructing Pilchuck in the Northwest was critical for its success. In a 1992 interview with curator Lloyd Herman, he explained, "The temperate Northwest climate was perfect, and we liked the idea of art students hitting the road and heading West to work in a rugged new landscape." In 1996, with curator Tina Oldknow, Chihuly's close friend and collaborator Italo Scanga further elaborated: "But at Pilchuck they tried to start afresh. Brand new. It was very primitive. . . . Rough. Very American, very Northwestern. I thought it was very, very original."

The Northwest strengthened and nurtured Chihuly's creativity and daring experimentation. He embraced the cherished values of progress and independence that are at the core of the Northwest identity. These values allowed him to explore the boundaries of his art. Driven by this ethos, Chihuly has spent his career expanding the perceived limits of glass as an artistic medium in terms of scale, color, form, and technical mastery.

The Northwest landscape and history also have provided an endless source of inspiration for his works. In 1977, along with James Carpenter and Italo Scanga, Chihuly visited the Northwest Coast Native American basket collections at the Washington State Historical Society in Tacoma. In addition to the extraordinary designs, he saw a wide range of forms and relationships between groups of baskets that inspired his *Basket* series. Incorporating his understanding of Native American weaving forms as seen in his earlier *Navajo Blanket Cylinder* series, the *Baskets* were a startling revelation. With their undulating forms, delicate and elaborate patterning, and shockingly thin walls, the *Baskets* brought Chihuly further critical acclaim for his daring explorations of the expressive potential of glass.

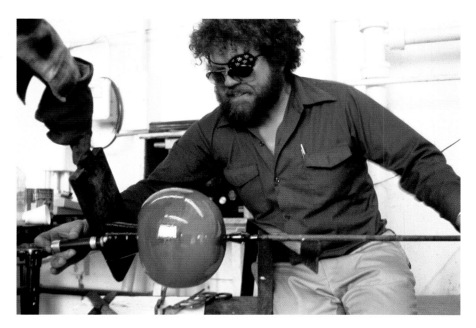

DALE CHIHULY
RHODE ISLAND SCHOOL OF DESIGN
PROVIDENCE, RHODE ISLAND, CIRCA 1983

BASKET, 1979
6 x 10 x 10"

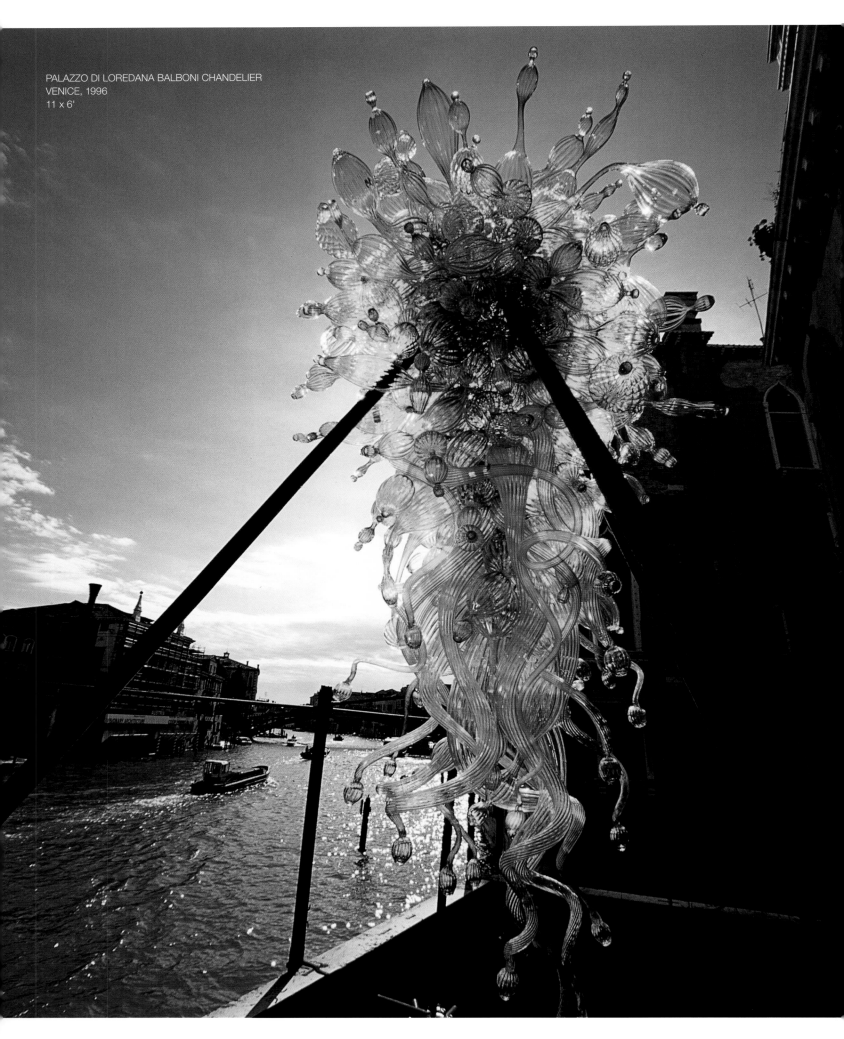

PALAZZO DI LOREDANA BALBONI CHANDELIER
VENICE, 1996
11 x 6'

Over the course of several years, Chihuly's work with the *Basket* form evolved into the *Seaforms*. Even more delicate and more highly patterned, *Seaforms* played on the fluidity of glass and evoked the vast array of sea creatures in Puget Sound. As with the *Baskets*, Chihuly nested vessels together to create installations that unintentionally resembled seashells, sea anemones, and other creatures.

With his increasing success and growing reputation, Chihuly made the strategic decision to relocate to Seattle in 1983. Allowing him to be geographically closer both to his mother and to the Pilchuck Glass School, this moment in his career was pivotal. Freed from the constraints and responsibilities of full-time teaching, Chihuly refocused his energies on his studio practice. In 1987, he established a hotshop in Seattle and began to assemble a group of collaborators. Together, they would repeatedly push the limits of glass to an unprecedented degree of technical virtuosity and invent breathtaking new forms on a scale previously unimagined due to the perceived fragility of glass.

Out of these experiments, the *Persian* and *Chandelier* series slowly evolved. Chihuly evoked early glass traditions of Middle Eastern glass and Venetian chandeliers and infused the works—virtually unprecedented in scale—with his celebrated sense of color, texture, and patterning. Often utilizing entire walls or cascading down from single points, these installations engaged architectural spaces in dynamic new ways and engulfed the viewer in brilliant splashes of color and riotous displays of Baroque forms. With these new series, Chihuly confirmed his reputation as a major figure in American art, deliberately blurring the distinctions between glass art and sculpture.

MONARCH WINDOW (DETAIL)
UNION STATION, TACOMA, 1994
22 x 40 x 3'

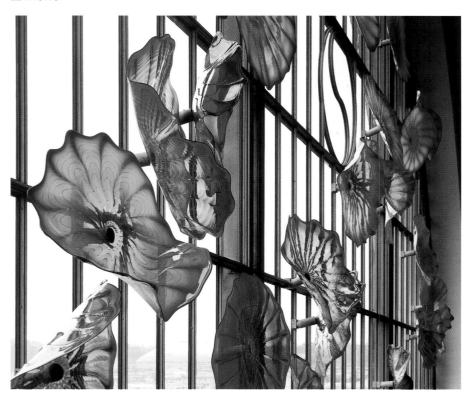

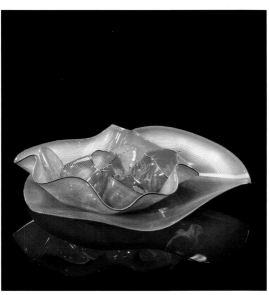

DESERT ROSE SEAFORM SET WITH
SMOKE LIP WRAPS, 1982
8 x 27 x 19"

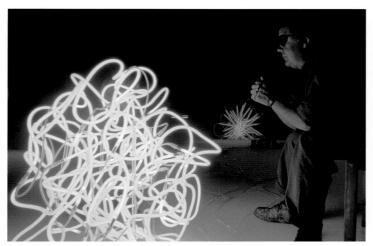

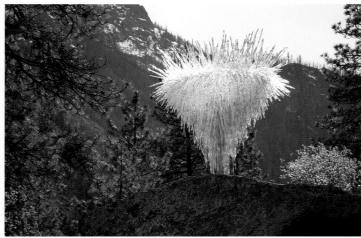

DALE CHIHULY AND TUMBLEWEED
TACOMA DOME, 1993

ICICLE CREEK CHANDELIER
SLEEPING LADY RESORT, LEAVENWORTH, WASHINGTON, 1996
12 x 9 x 6'

Using the Northwest as a laboratory, Chihuly began to experiment relentlessly at an ever-increasing scale and degree of complexity. In 1987, Tacoma Art Museum opened a permanent room to showcase its retrospective collection of Chihuly artwork. In 1992, he opened the new downtown Seattle Art Museum building with *Dale Chihuly: Installations 1964–1992*, a series of immersive gallery experiences for visitors. The following year, he presented *100,000 Pounds of Ice and Neon* at the Tacoma Dome and designed the sets for the Seattle Opera's production of *Pelléas and Mélisande*, which would inspire the dramatic and magical series *Pilchuck Stumps* and reengage Chihuly with his radical experimentation at the Pilchuck Glass School. In 1996, Chihuly created the *Icicle Creek Chandelier*, his first permanent outdoor installation, fitted on a rock at the famed Sleeping Lady Conference Retreat in Leavenworth, Washington, and in 1998 he created two *Chandeliers* for Benaroya Hall, the new home of the Seattle Symphony. In 2002, he dedicated the Chihuly Bridge of Glass in Tacoma, a unique work of public art and a gateway to Tacoma.

The following year, Chihuly introduced *Mille Fiori* at Tacoma Art Museum. This spectacular garden fantasy developed from his temporary installations in gardens and conservatories, beginning two years earlier at Garfield Park Conservatory in Chicago. Adapting an interest in flowers and gardens that was instilled by his mother, Chihuly garnered instant critical acclaim with his *Fiori* series and garden installations. With his virtually unlimited vocabulary of form and color, Chihuly proved, once again, not only that the medium of glass is extraordinary beautiful but also that glass may evoke powerful emotions about, and connections to, the natural world. Since that time, versions of his *Mille Fiori* have become integral in a number of his exhibitions and installations, from his solo shows at the de Young Museum in San Francisco and the Museum of Fine Arts, Boston, to his *Mille Fiori Venezia* installation for the 53rd Venice Biennale.

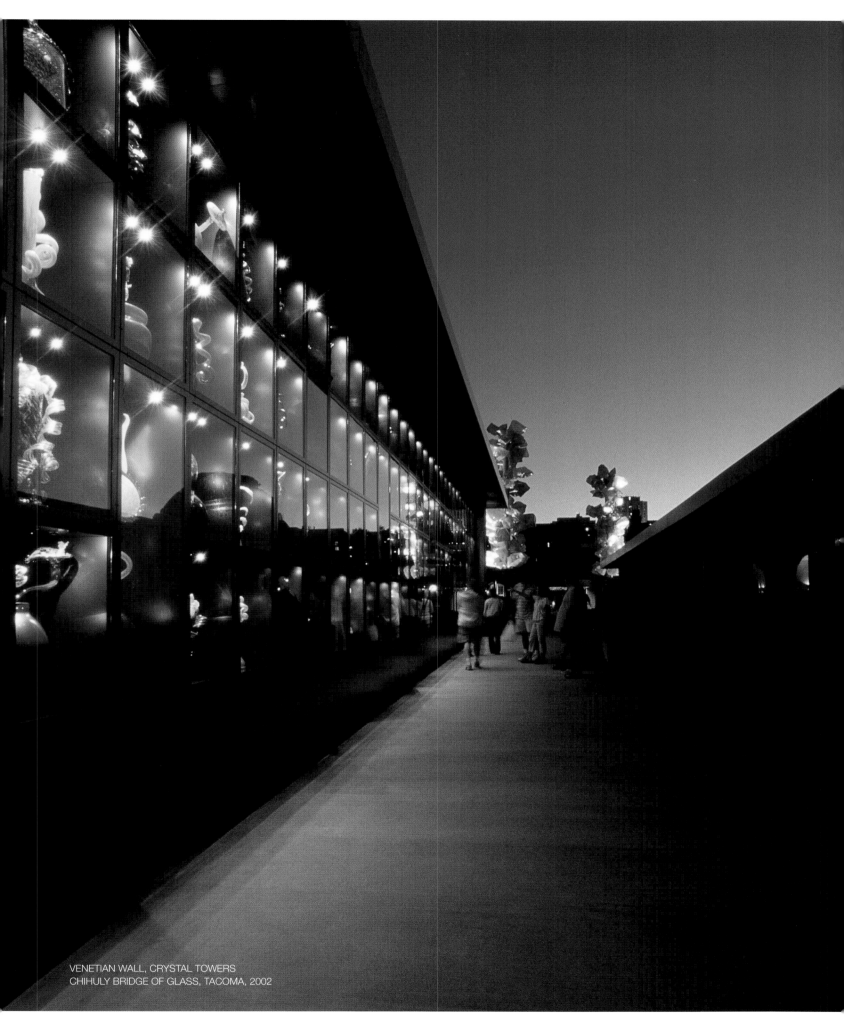

VENETIAN WALL, CRYSTAL TOWERS
CHIHULY BRIDGE OF GLASS, TACOMA, 2002

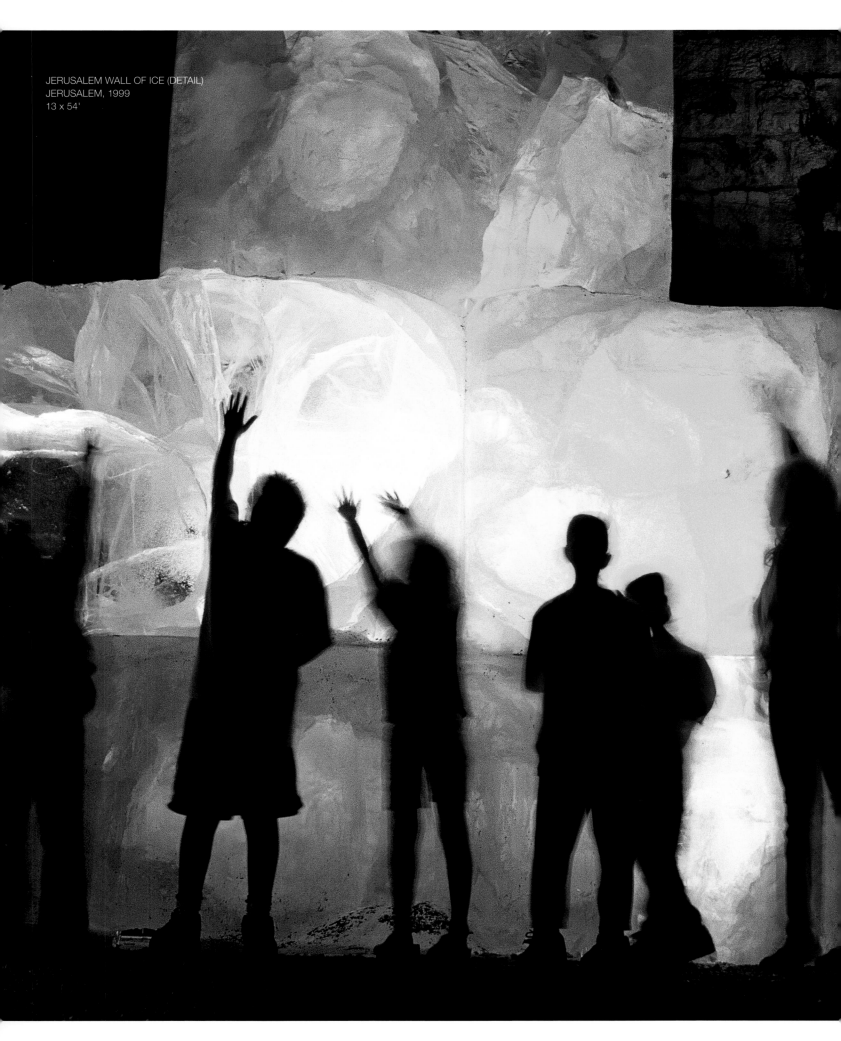

JERUSALEM WALL OF ICE (DETAIL)
JERUSALEM, 1999
13 x 54'

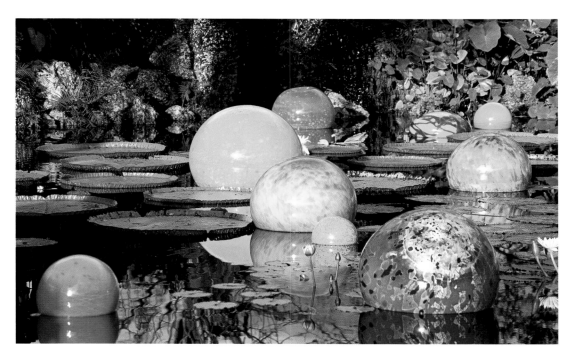

NIIJIMA FLOATS
FAIRCHILD TROPICAL BOTANIC GARDEN
CORAL GABLES, FLORIDA, 2005

With their first iterations almost always in the Northwest, these major projects set the conceptual foundations and helped test the logistical preparations for his world-renowned installations throughout his career. Two of his most celebrated exhibition projects, *Chihuly Over Venice* in 1996 and *Chihuly in the Light of Jerusalem 2000*, had their nascent beginnings in the work he had developed for the 1992 exhibition at the Seattle Art Museum and *100,000 Pounds of Ice and Neon* in Tacoma in 1993. His decade-long engagement with garden-based installations since 2001 can be seen, in many ways, as the logical extension of both the Venice and Jerusalem projects. International in scope and ambitious in its design, what is being called *The Garden Cycle* has presented major installations in a wide range of gardens: the New York Botanical Garden, Missouri Botanical Garden, and Royal Botanic Gardens, Kew, in the United Kingdom, among many others.

Chihuly Garden and Glass is a magical summation of this innovative and daring artist's iconic works over his forty-year career. The installations reveal Chihuly's pride in the Northwest and embody the special qualities of the region's natural environment, from the Cascade forests to the omnipresent rain to the marine wonderland hidden beneath the surface of Puget Sound. Nestled under the Space Needle, the exhibitions enable visitors to experience the breadth of Chihuly's art and to understand how the region profoundly influenced Chihuly throughout his career. These works have been celebrated around the world, yet they wholly belong to the Northwest.

Rock Hushka
Curator of Contemporary and Northwest Art and
Director of Curatorial Administration
Tacoma Art Museum

EXHIBITION

I don't think much about the past.
I think more about the future.

CHIHULY

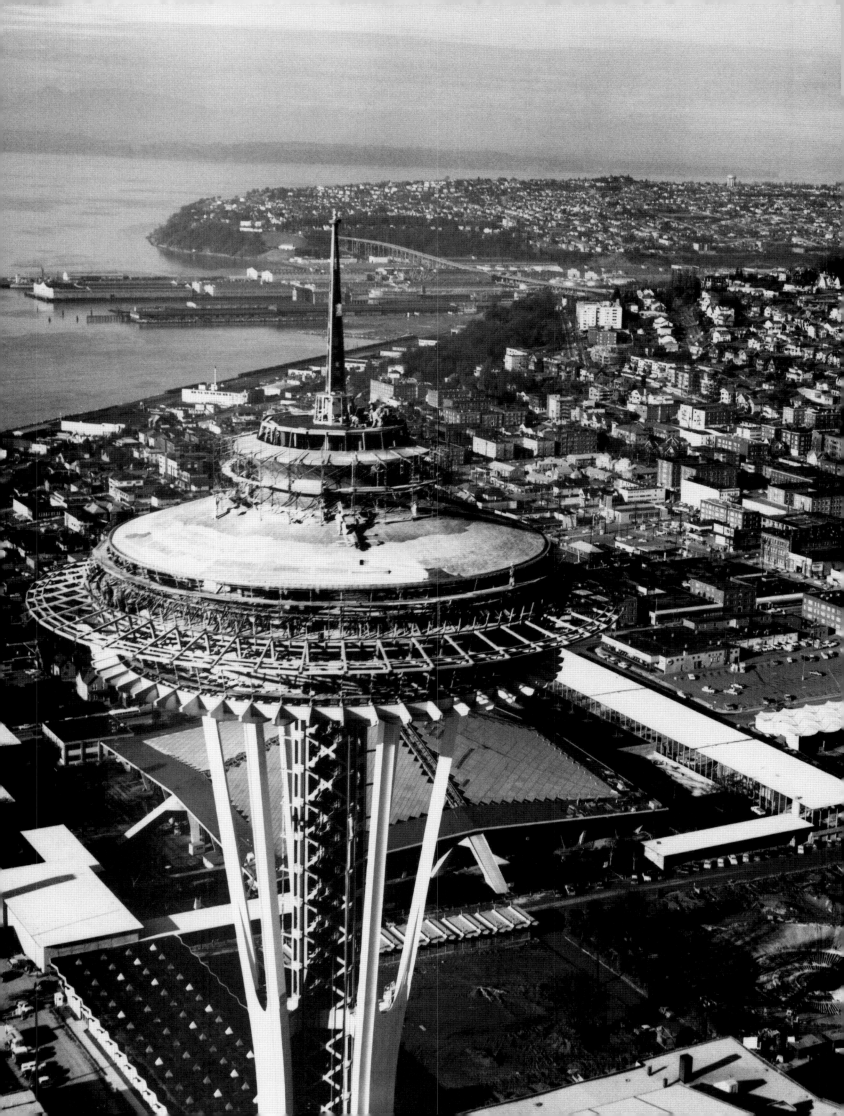

EXHIBITION /

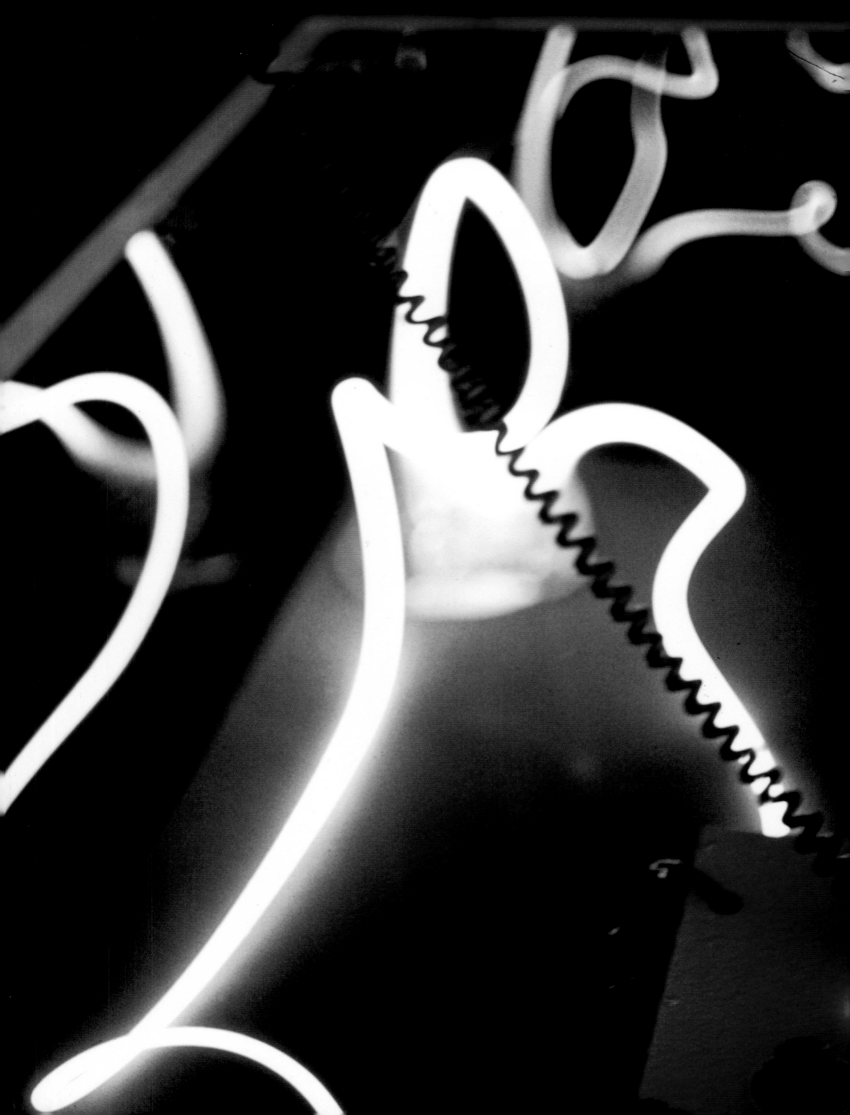

NEON FOREST

I want people to be overwhelmed
with light and color in some way
that they've never experienced.

CHIHULY

ALL THE WAY OUT TO EAST CUPCAKE (DETAIL)
IN COLLABORATION WITH JAMES CARPENTER
TACOMA ART MUSEUM, 1971

GLASS FOREST PIECES IN A TRUCK
CIRCA 1971

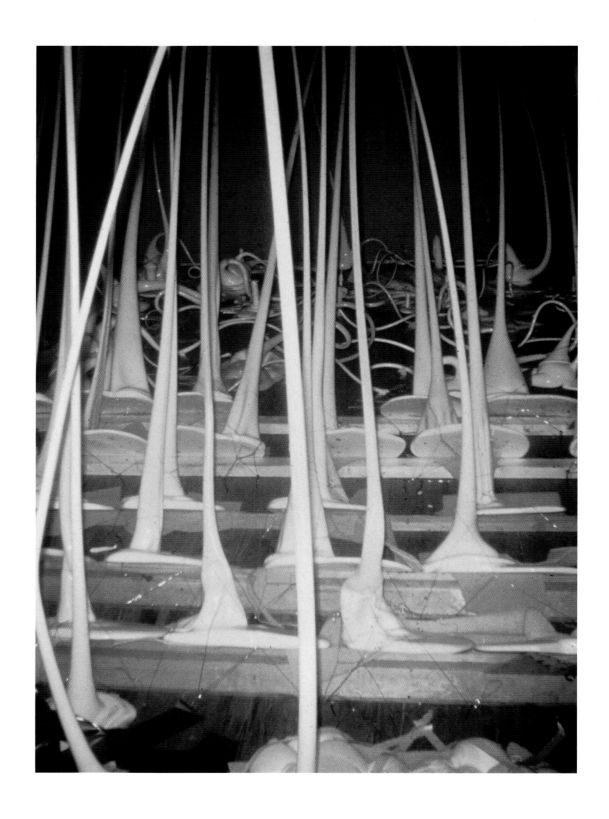

CHIHULY AND JAMES CARPENTER
CIRCA 1971

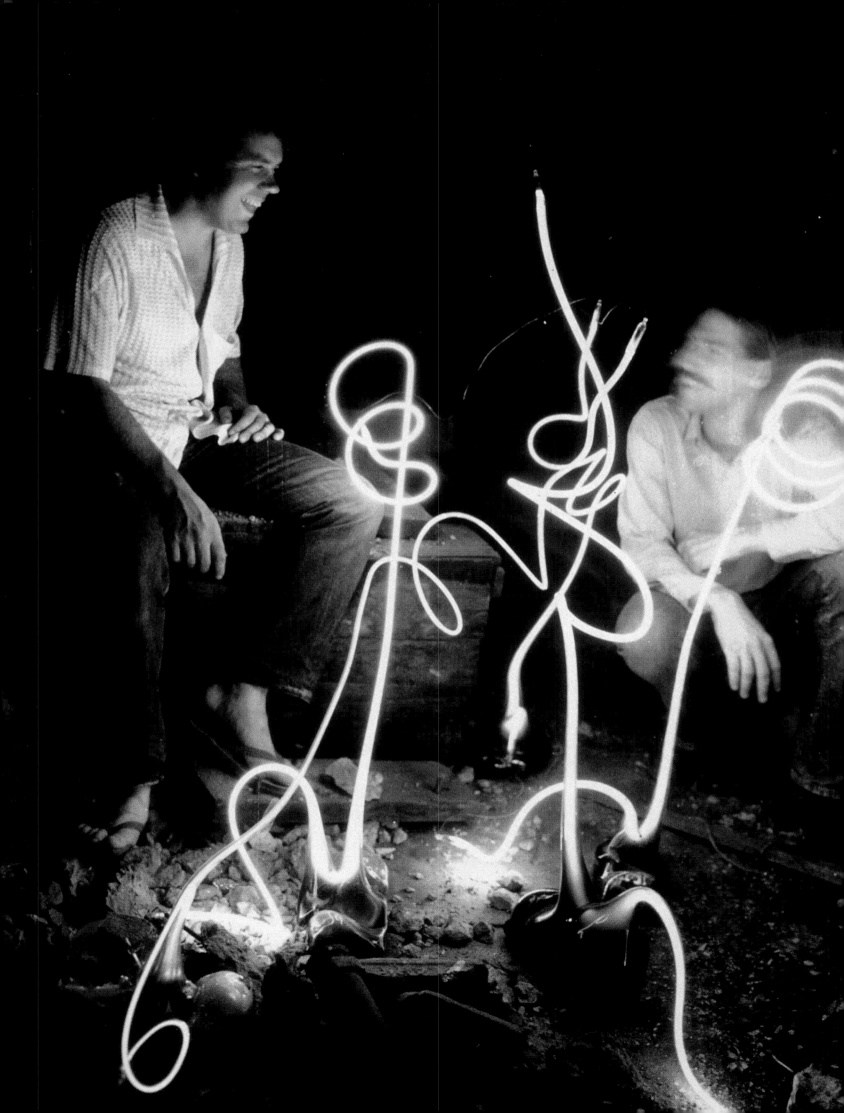

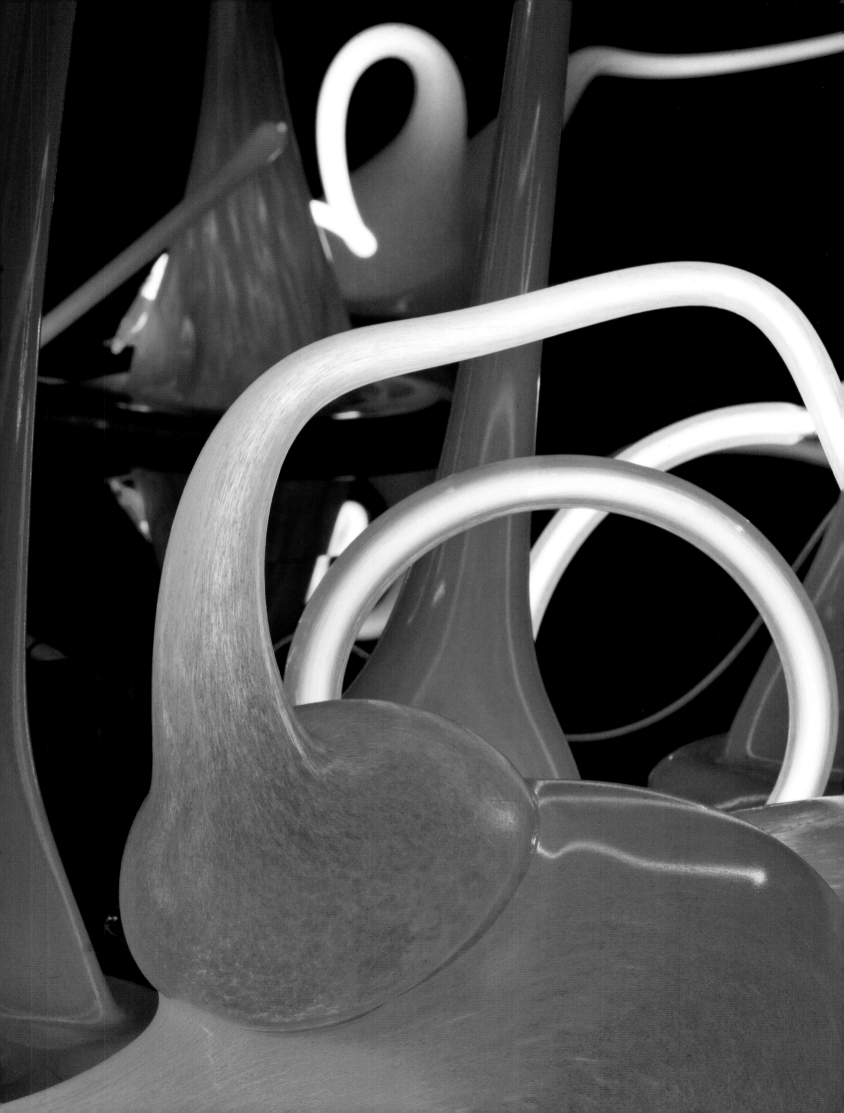

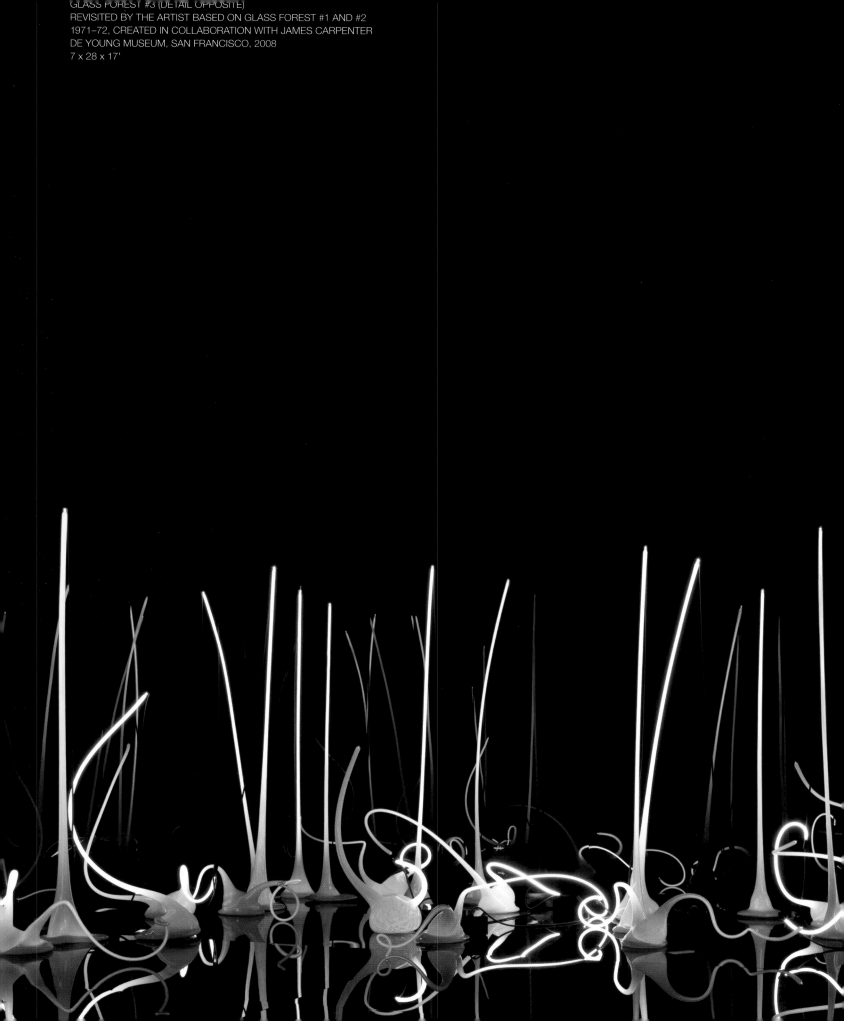

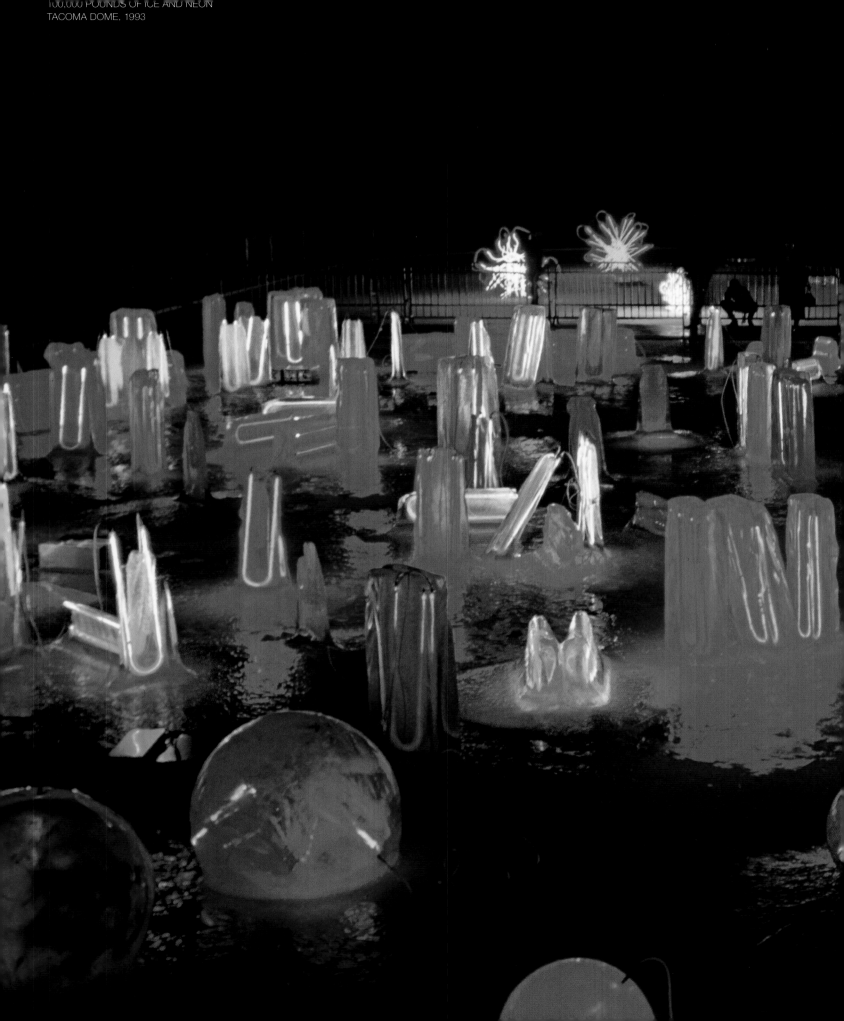

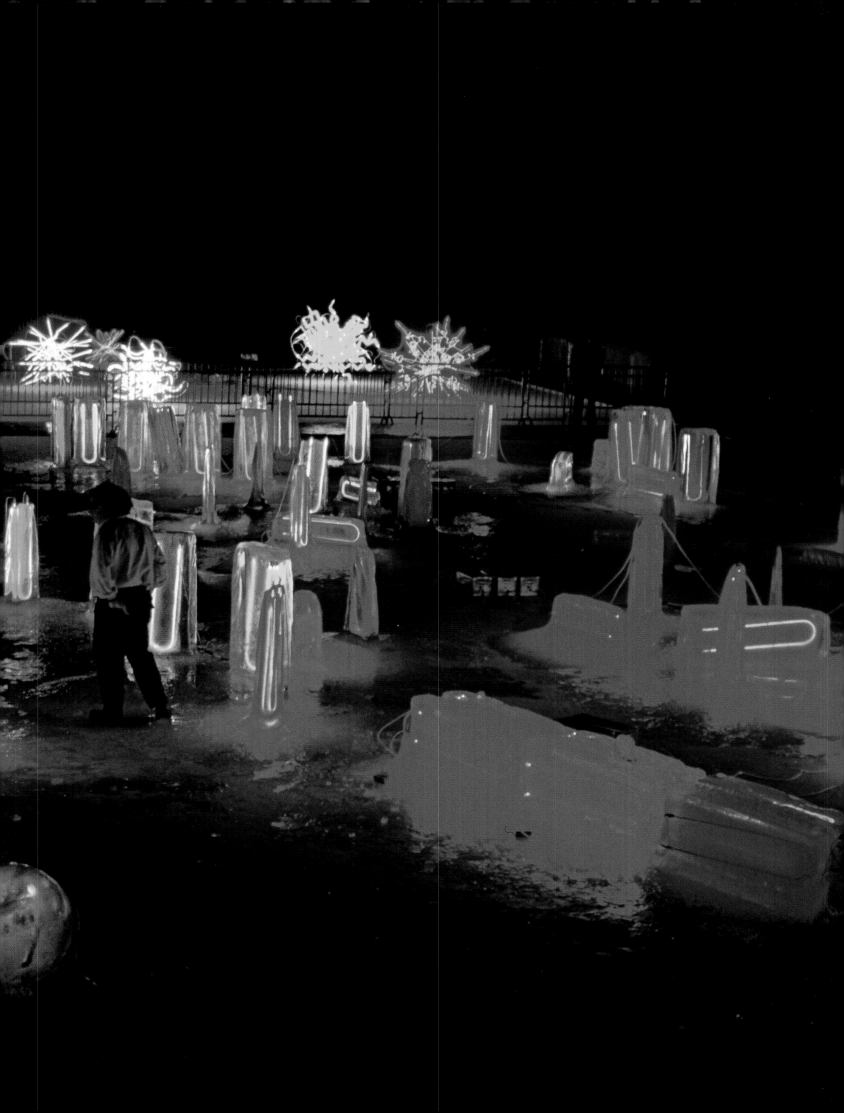

BOATHOUSE NEON II (DETAIL), 2011
11 x 98 x 8'

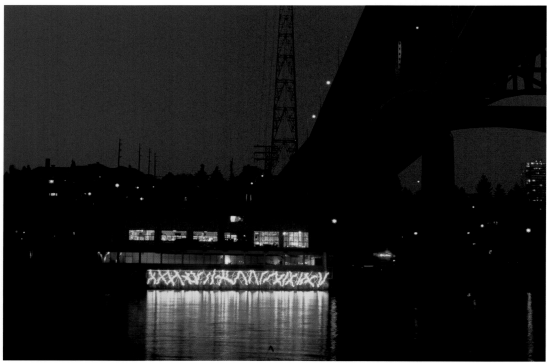

NEON INSTALLATION AT THE BOATHOUSE
SEATTLE, 1993

SAFFRON TOWER
DE YOUNG MUSEUM
SAN FRANCISCO, 2008
30 x 6 x 6'

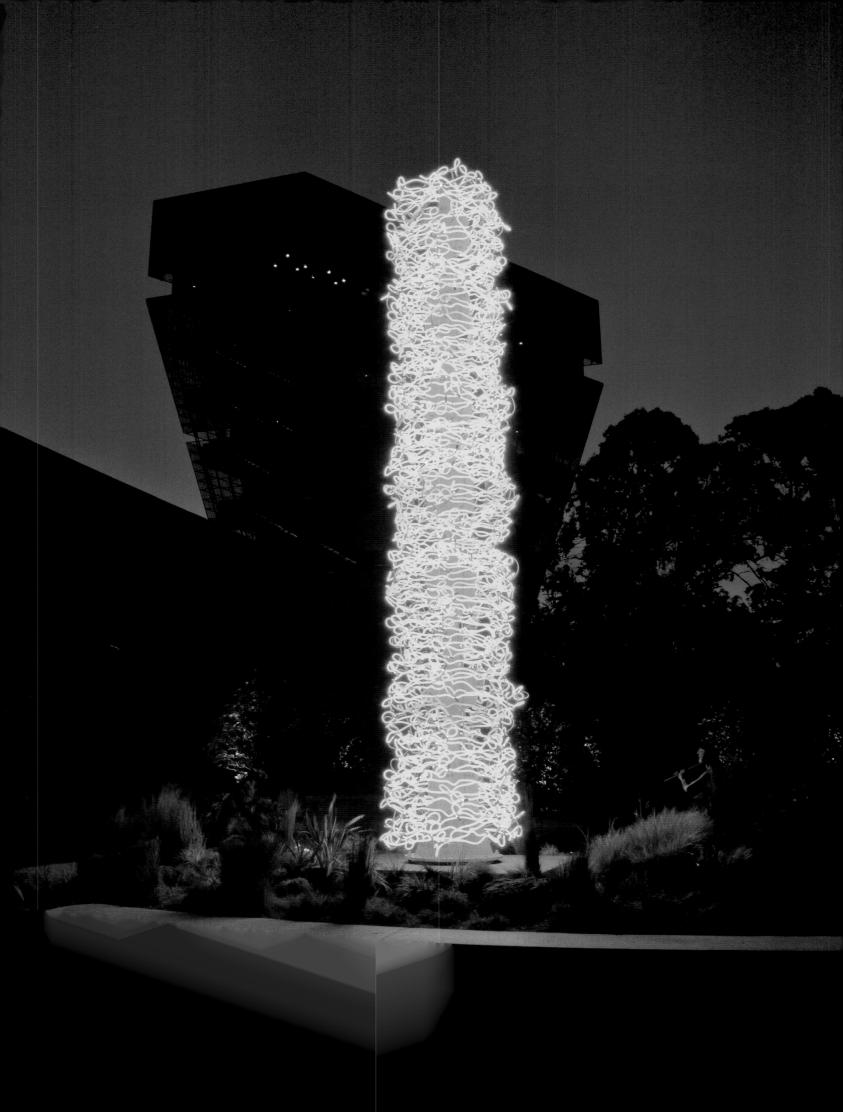

NORTHWEST
ROOM

Over time I developed the most organic, natural way of working with glass, using the least number of tools I could.

CHIHULY

FIRST BASKETS
SEATTLE ART MUSEUM, 1977

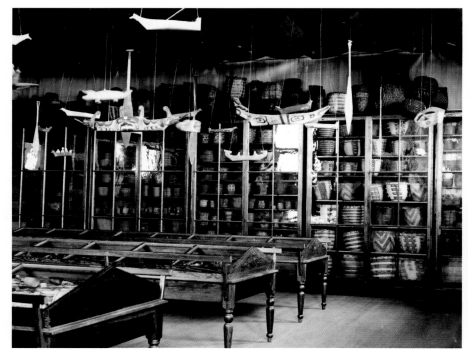

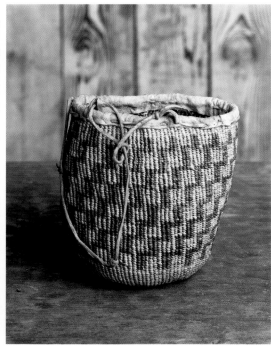

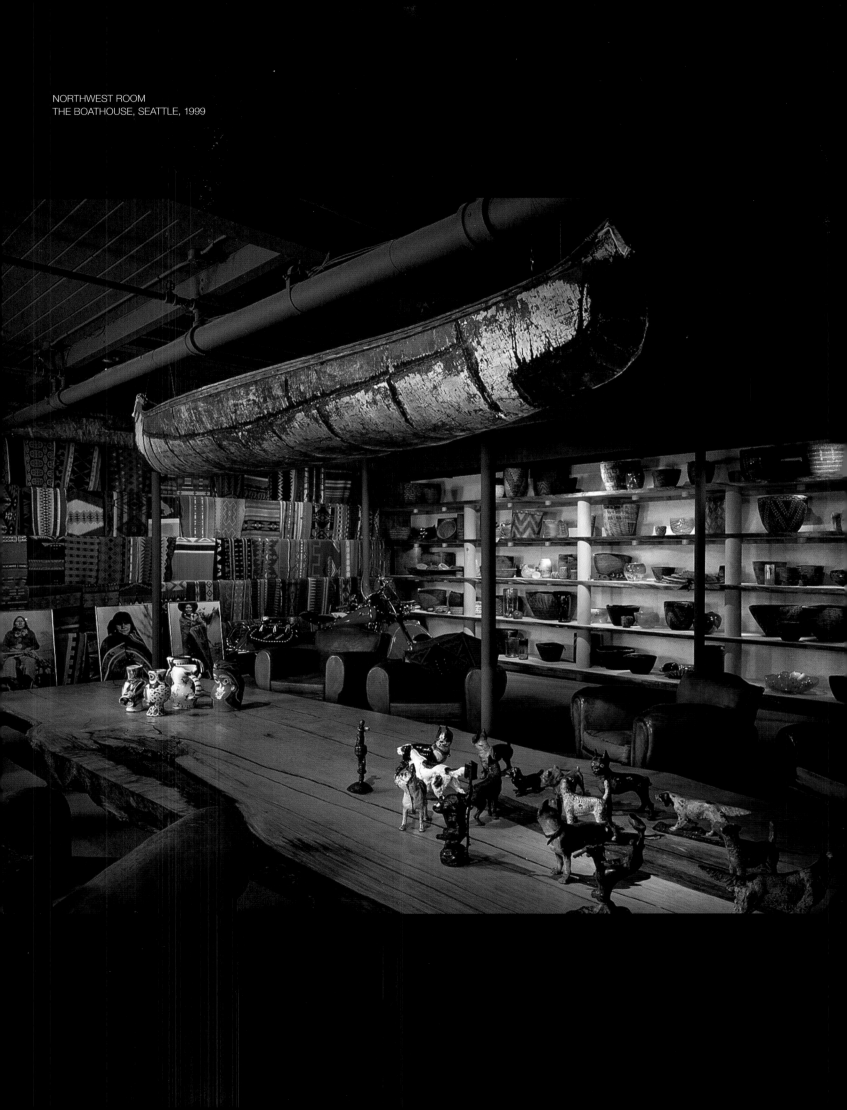

NORTHWEST ROOM
THE BOATHOUSE, SEATTLE, 1999

EDWARD S. CURTIS PHOTOGRAVURES
AND CARVED BENCH BY DUANE PASCO
THE BOATHOUSE, SEATTLE

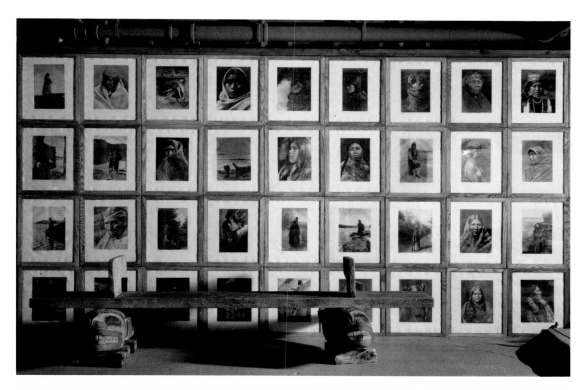

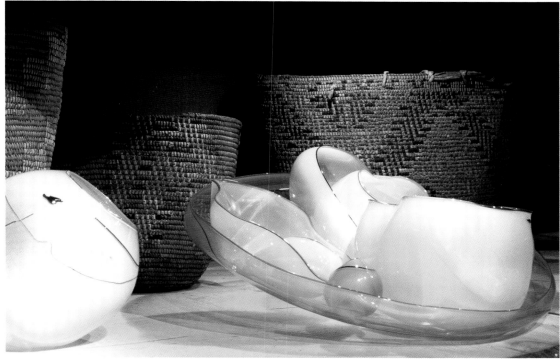

CHIHULY BASKETS
NORTHWEST COAST BASKETS
THE BOATHOUSE, SEATTLE

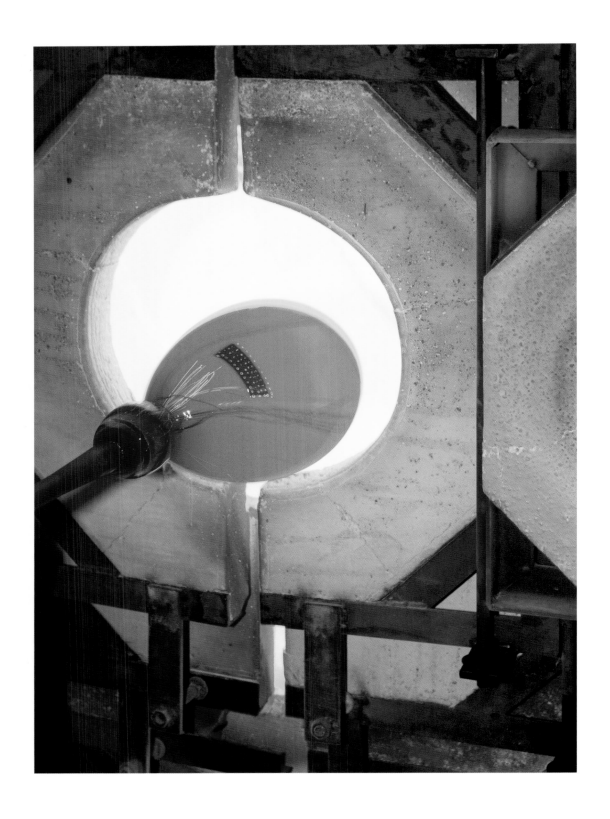

TABAC BASKETS (DETAIL), 2008

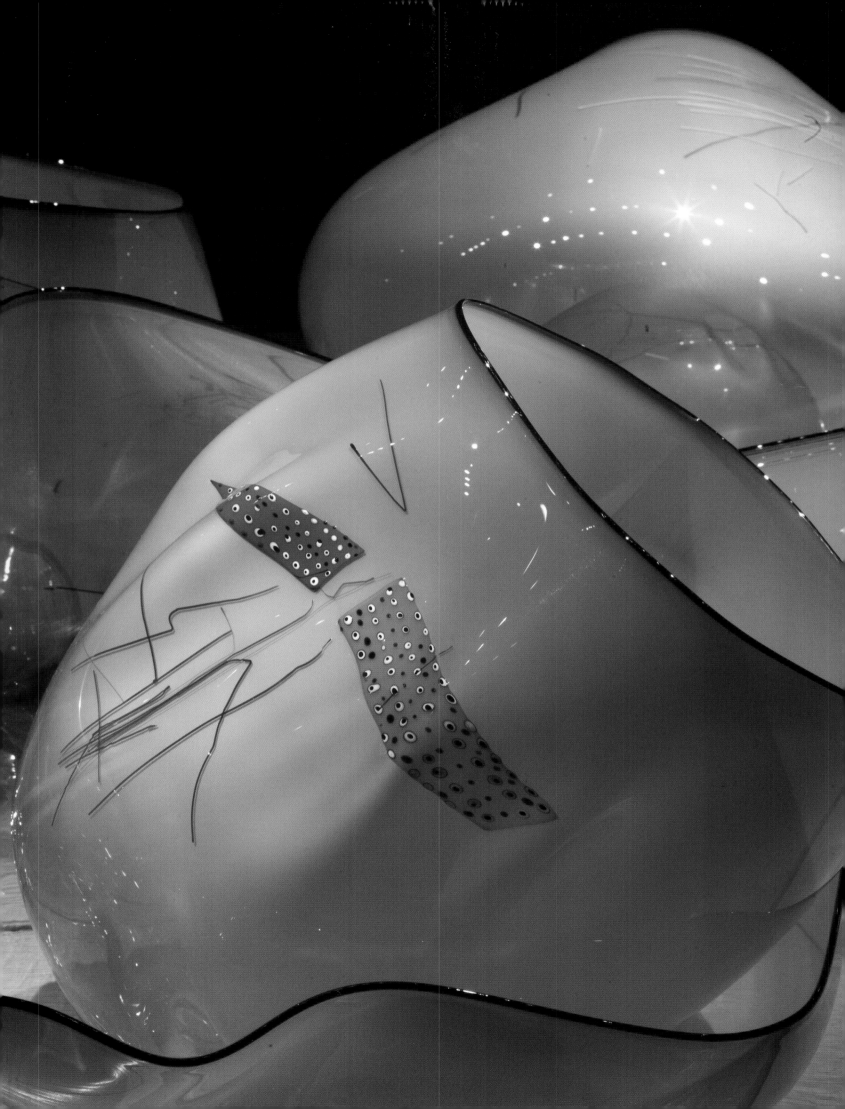

TABAC BASKETS
DE YOUNG MUSEUM, SAN FRANCISCO, 2008

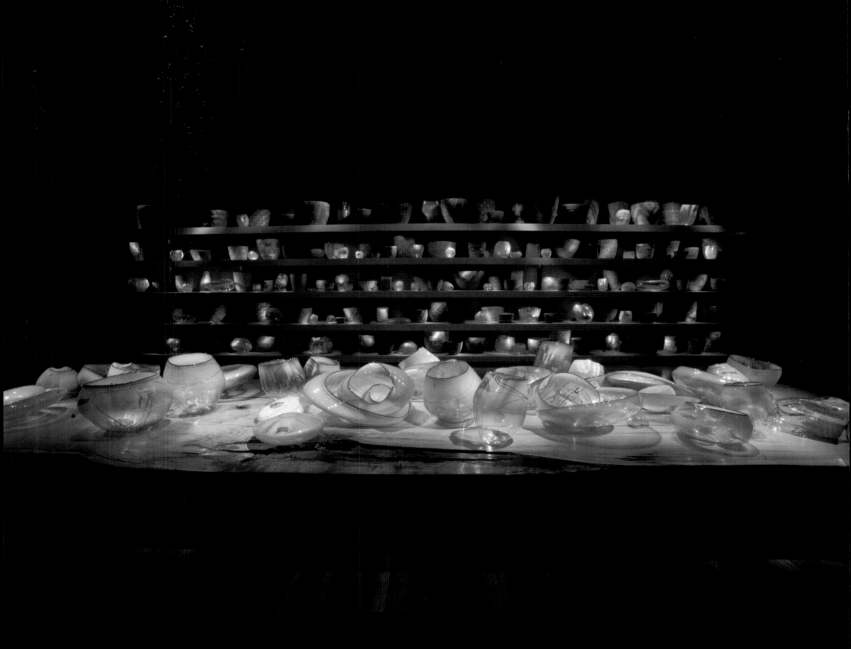

BURNED BASKETS DRAWING, 2008
30 x 22"

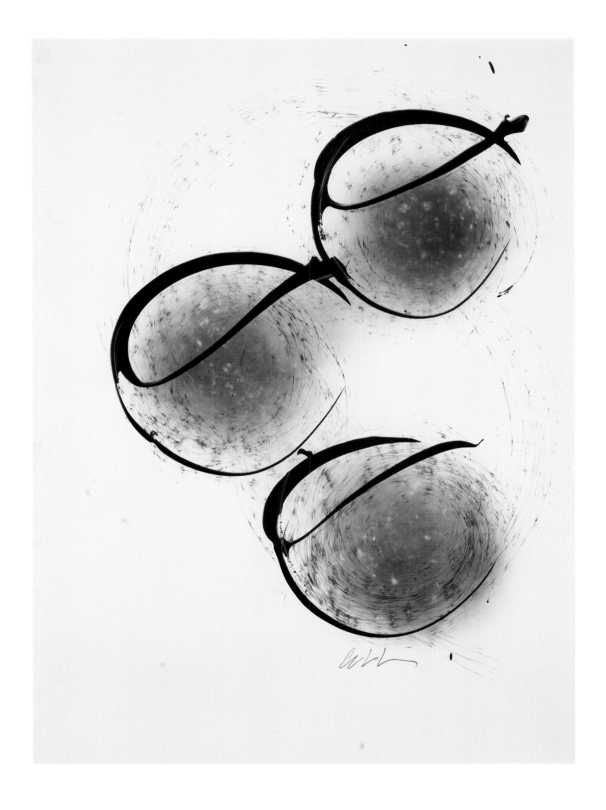

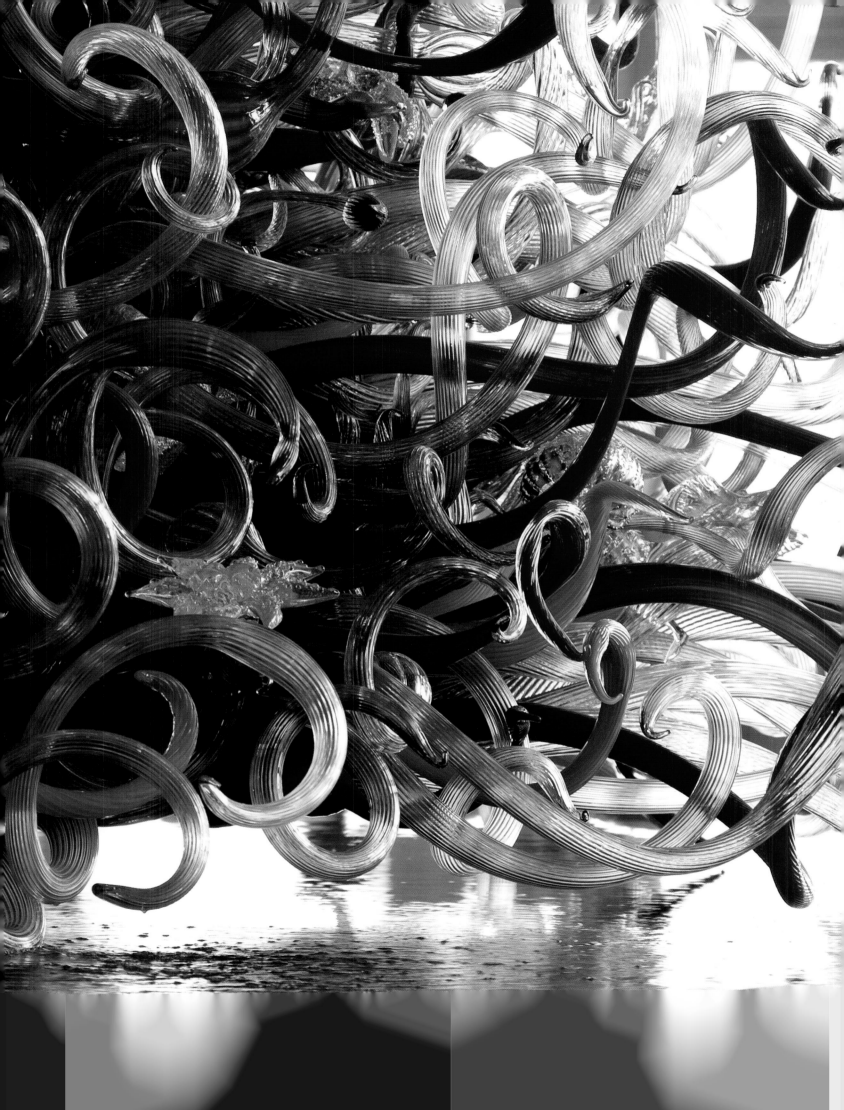

I think water inspires
extraordinary creativity.

CHIHULY

ATLANTIS SEALIFE TOWER (DETAIL)
ATLANTIS, THE PALM, DUBAI, UNITED ARAB EMIRATES, 2008
32 x 12½ x 12½'

SEALIFE TOWER, 2011
15 x 12 x 12'

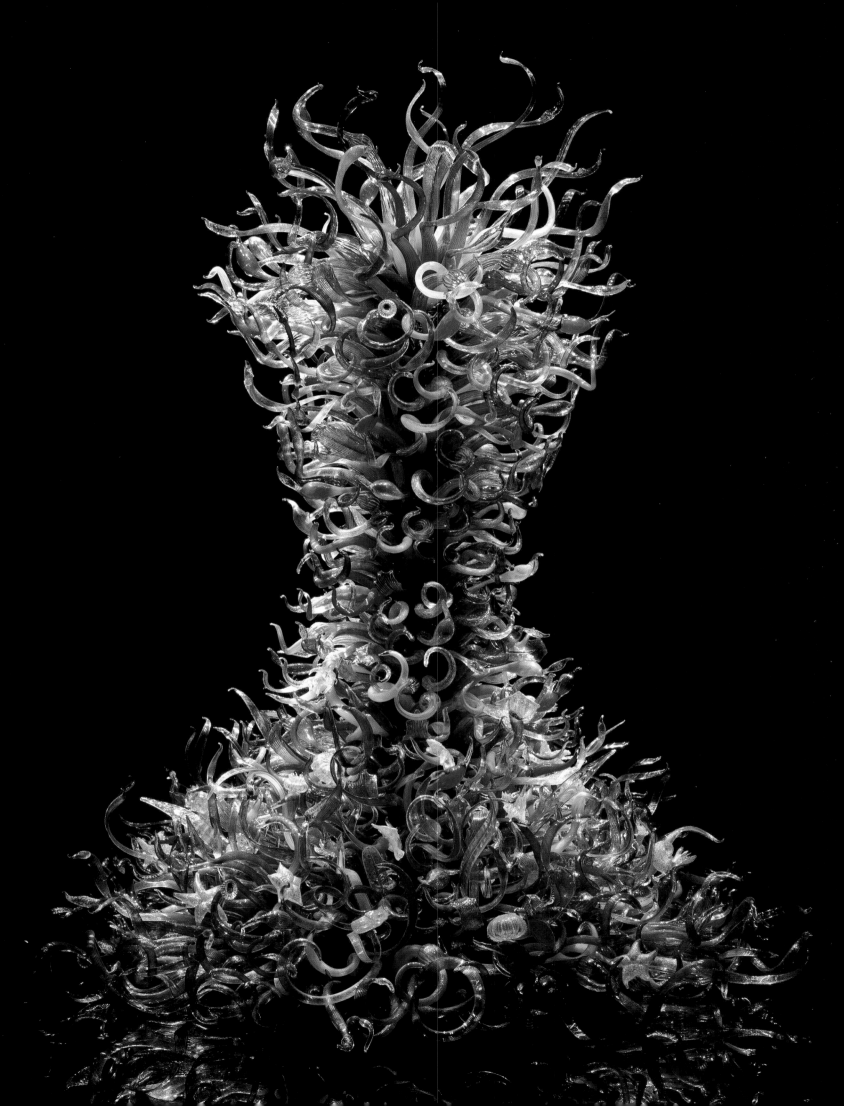

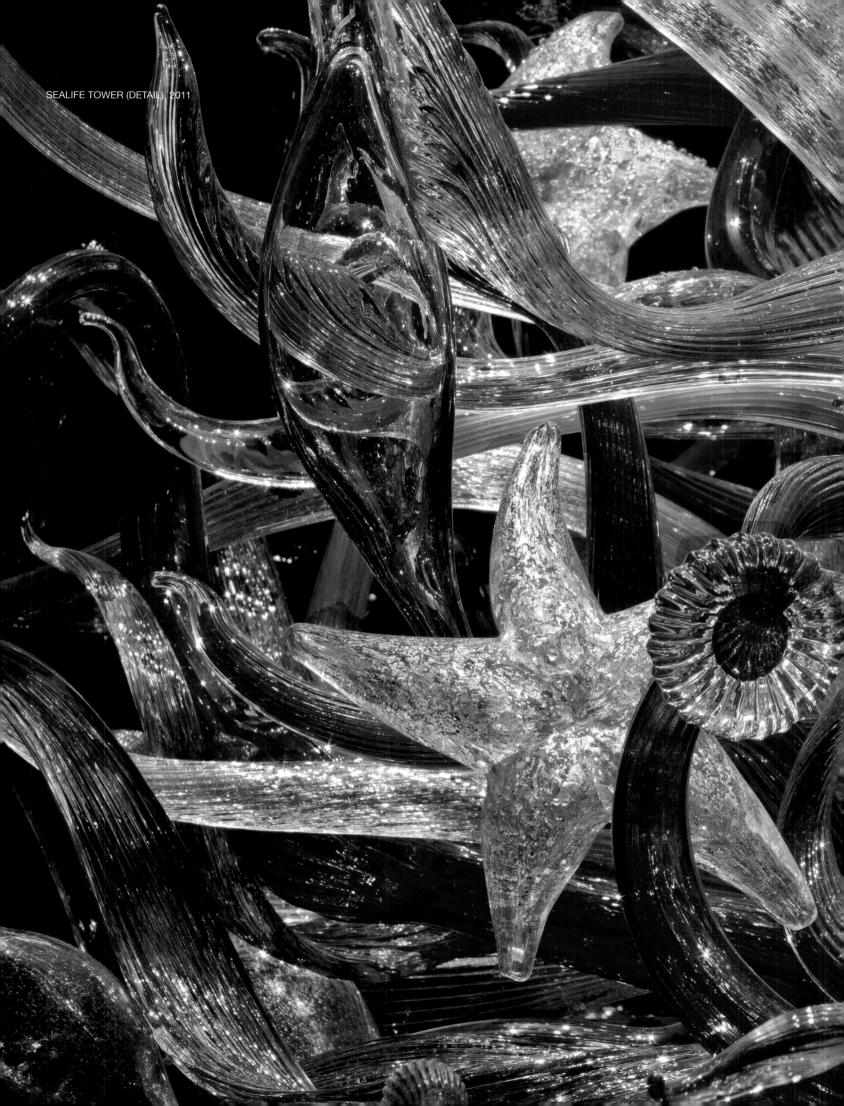

SEALIFE TOWER (DETAIL), 2011

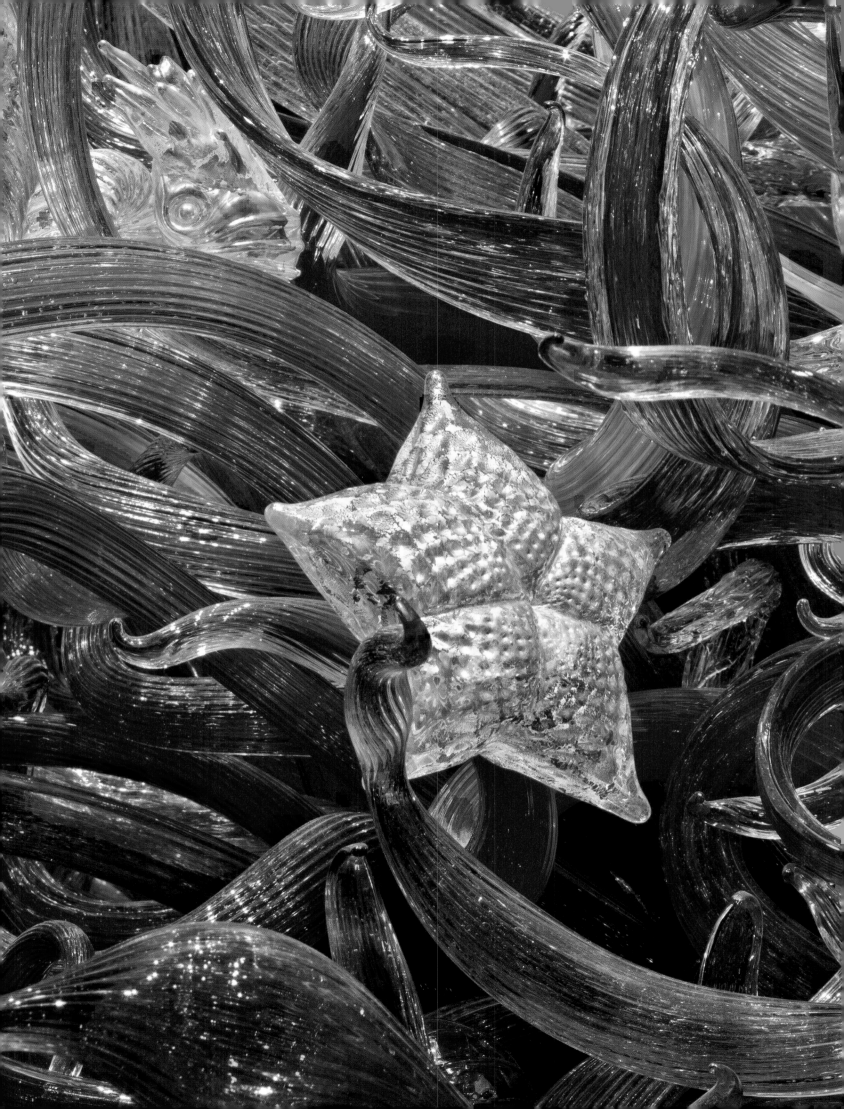

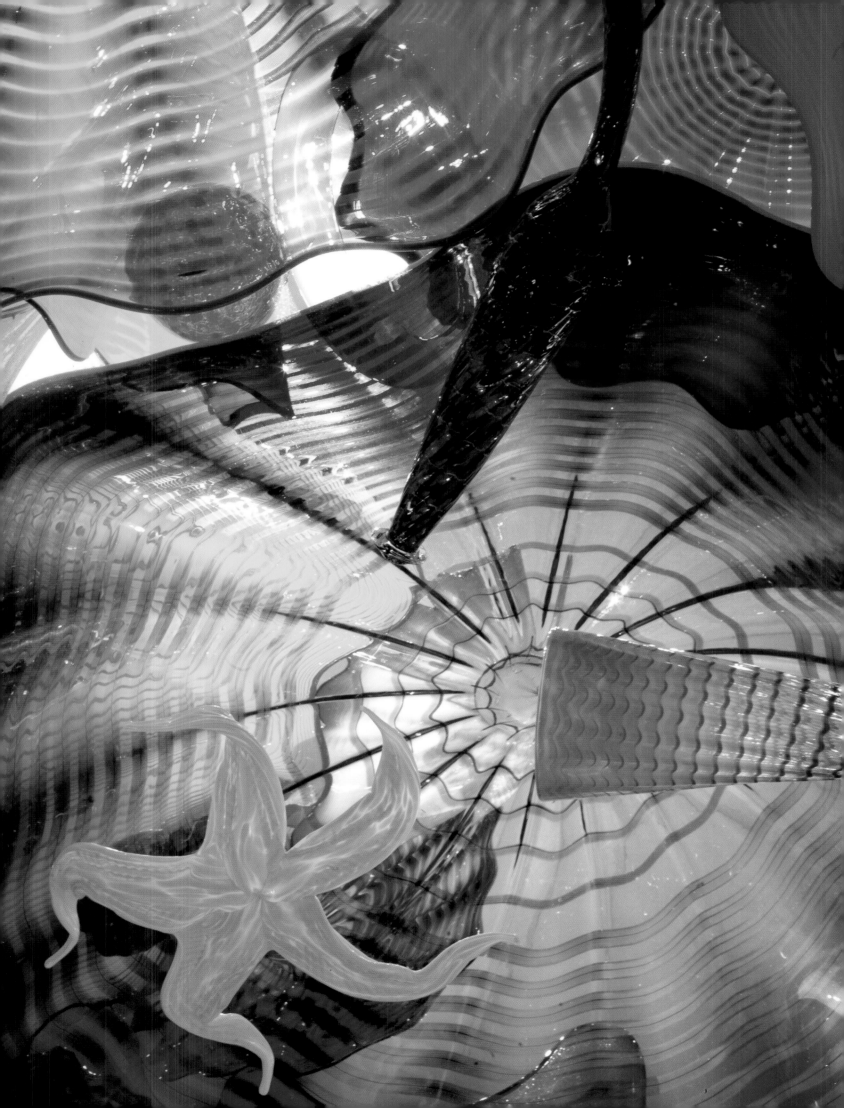

PERSIAN CEILING

I want my work to appear like it came from nature, so that if someone found it on a beach or in the forest, they might think it belonged there.

CHIHULY

PERSIAN CEILING (DETAIL)
DE YOUNG MUSEUM, SAN FRANCISCO, 2008

PERSIAN CEILING
DE YOUNG MUSEUM, SAN FRANCISCO, 2008
15 x 28'

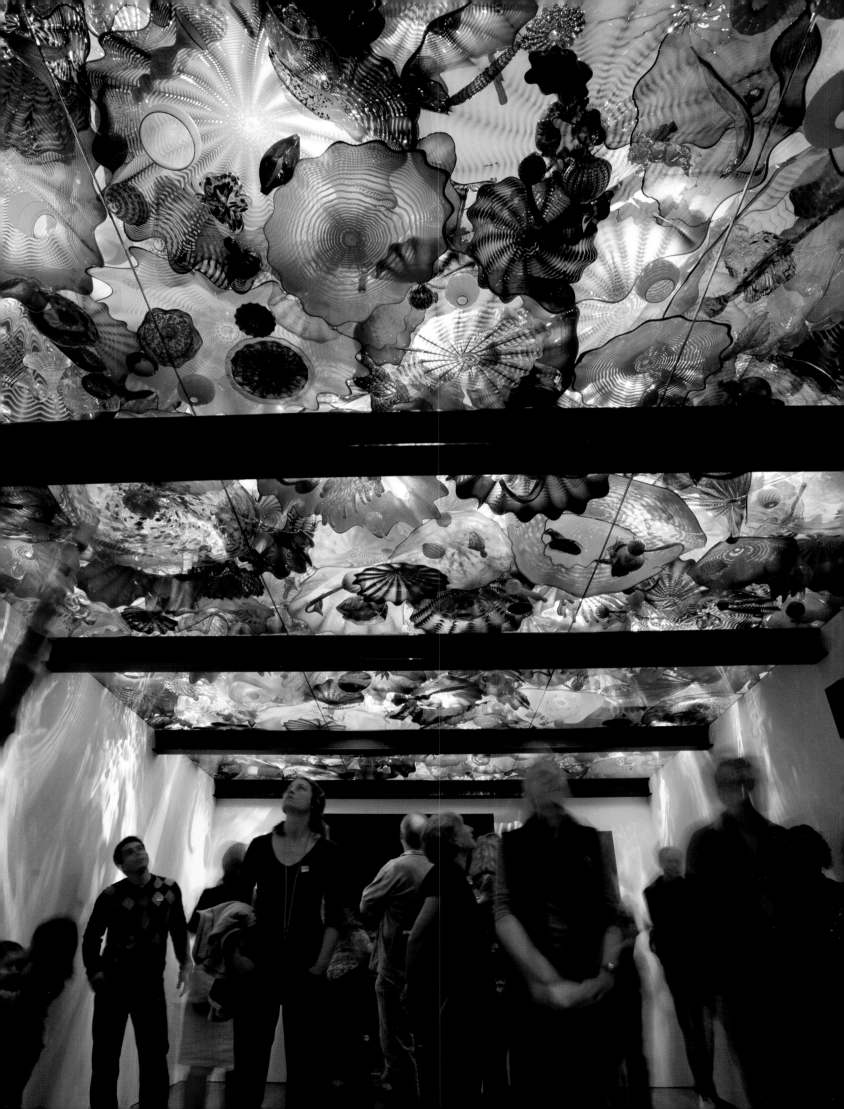

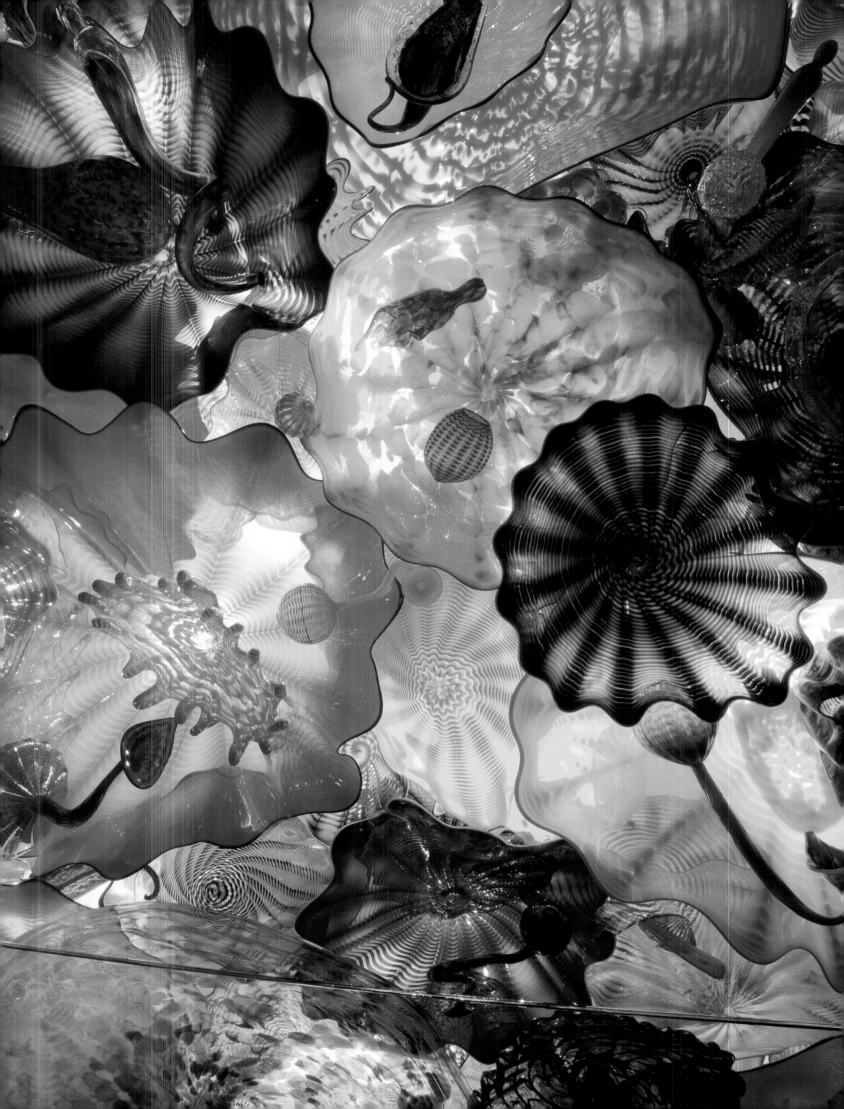

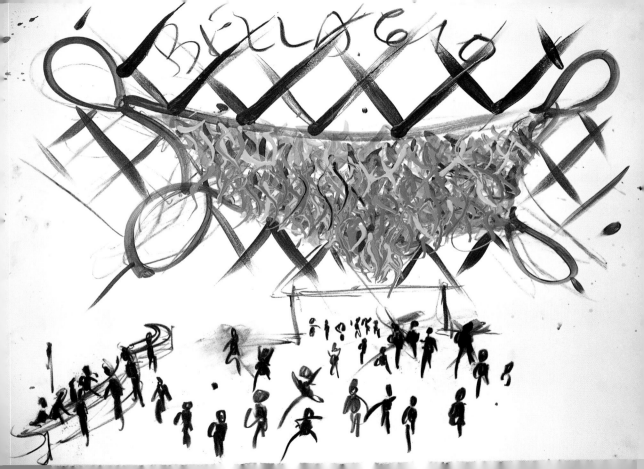

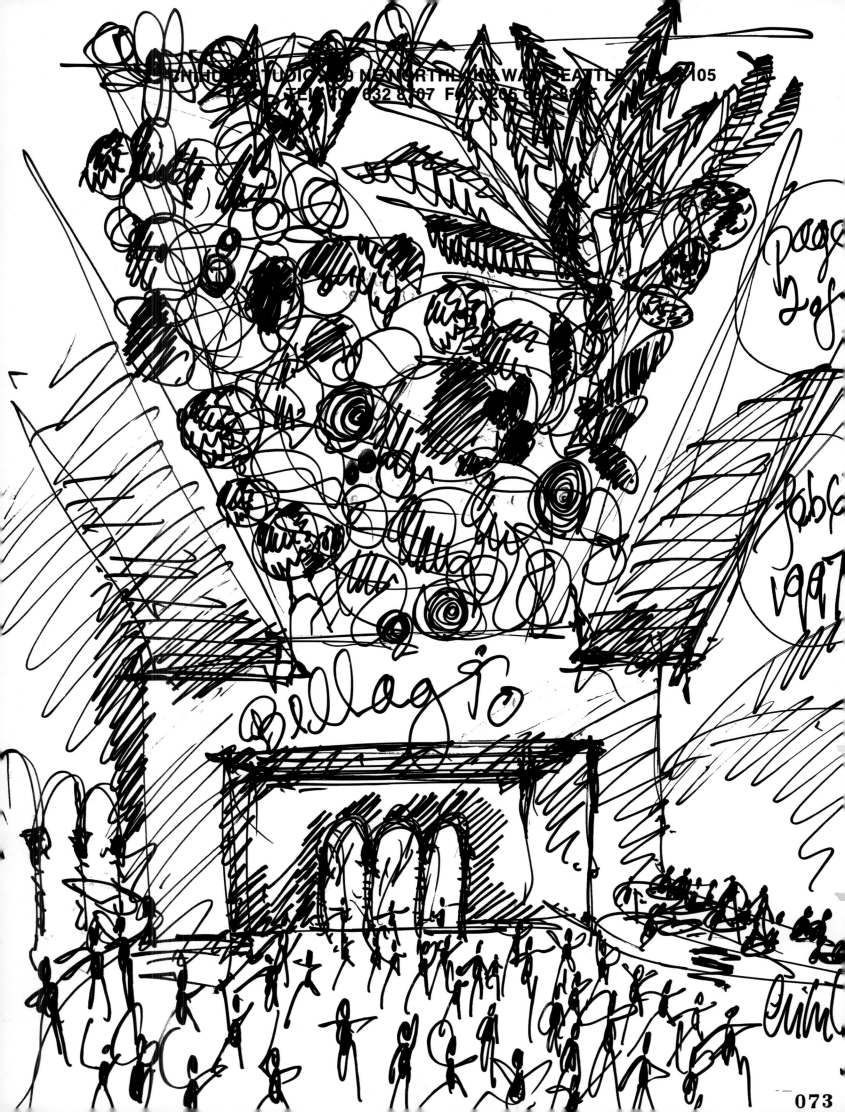

SUNHOUSE STUDIOS 619 NE NORTHLAKE WAY SEATTLE WA 98105
TEL 206 632 8707 FAX 206 632 8810

Page
2 of

Job 6
1997

Bellagio

FAX SKETCH OF FIORI DI COMO
BELLAGIO, LAS VEGAS, 1997

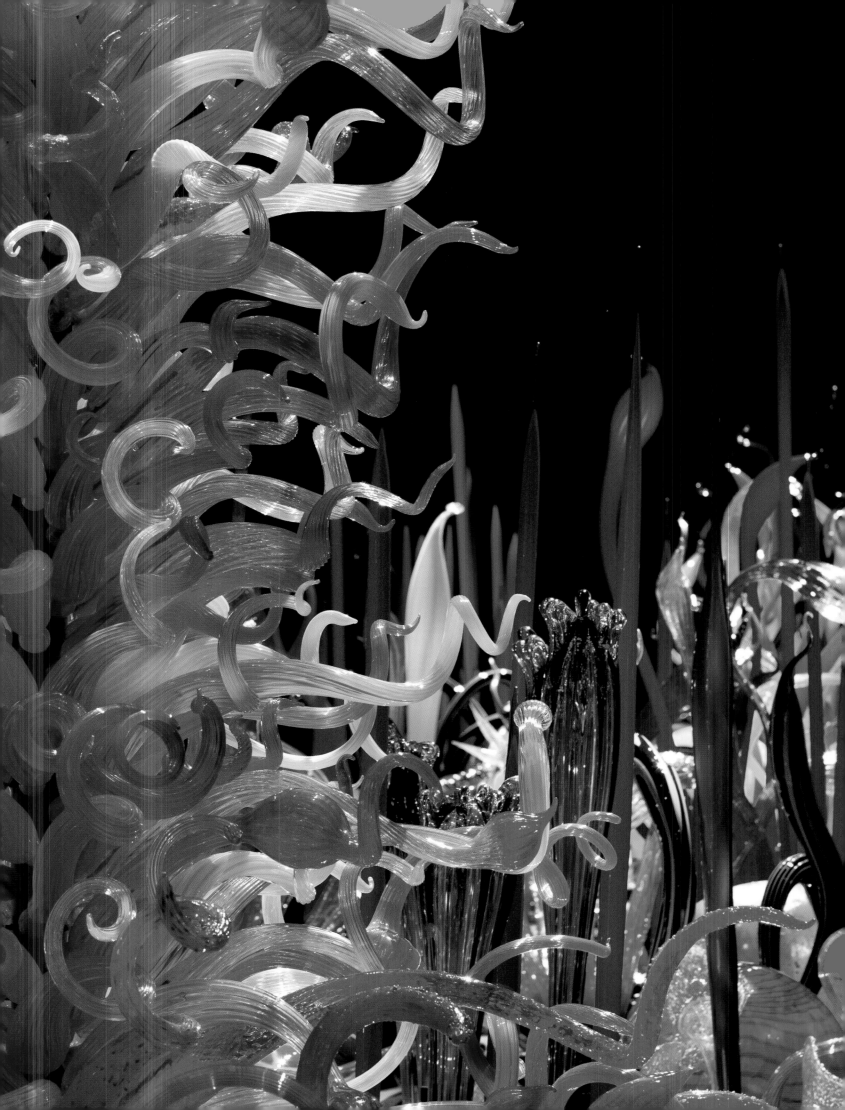

For centuries people have been
fascinated with glass. It's like a gem,
but fragile. Glass has history, it has
life, it's from the earth.

CHIHULY

MILLE FIORI (DETAIL), 2008

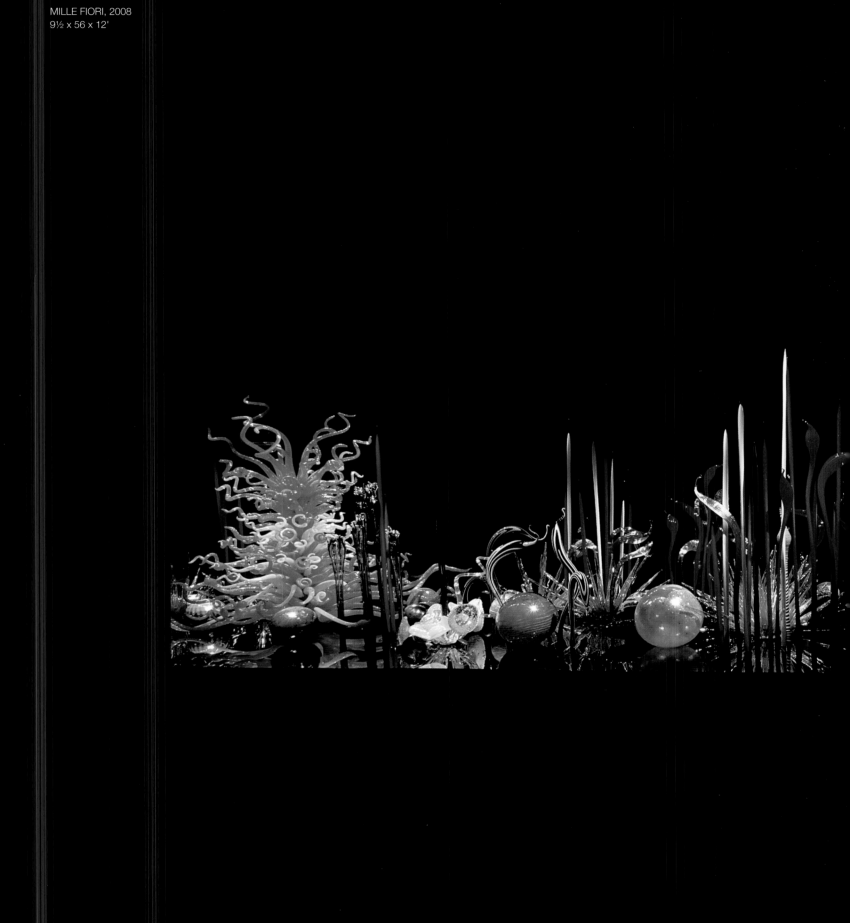

MILLE FIORI, 2008
9½ x 56 x 12'

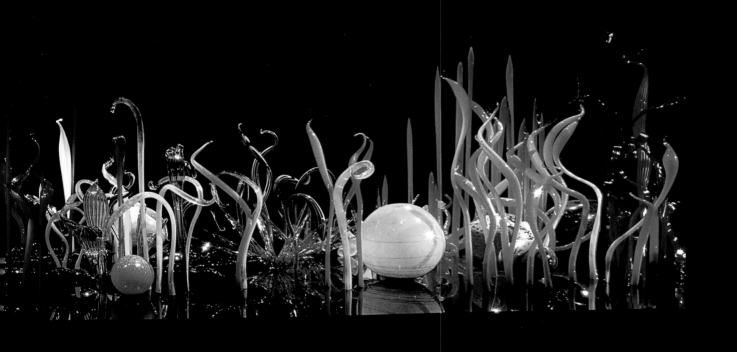

MILLE FIORI (DETAIL), 2008

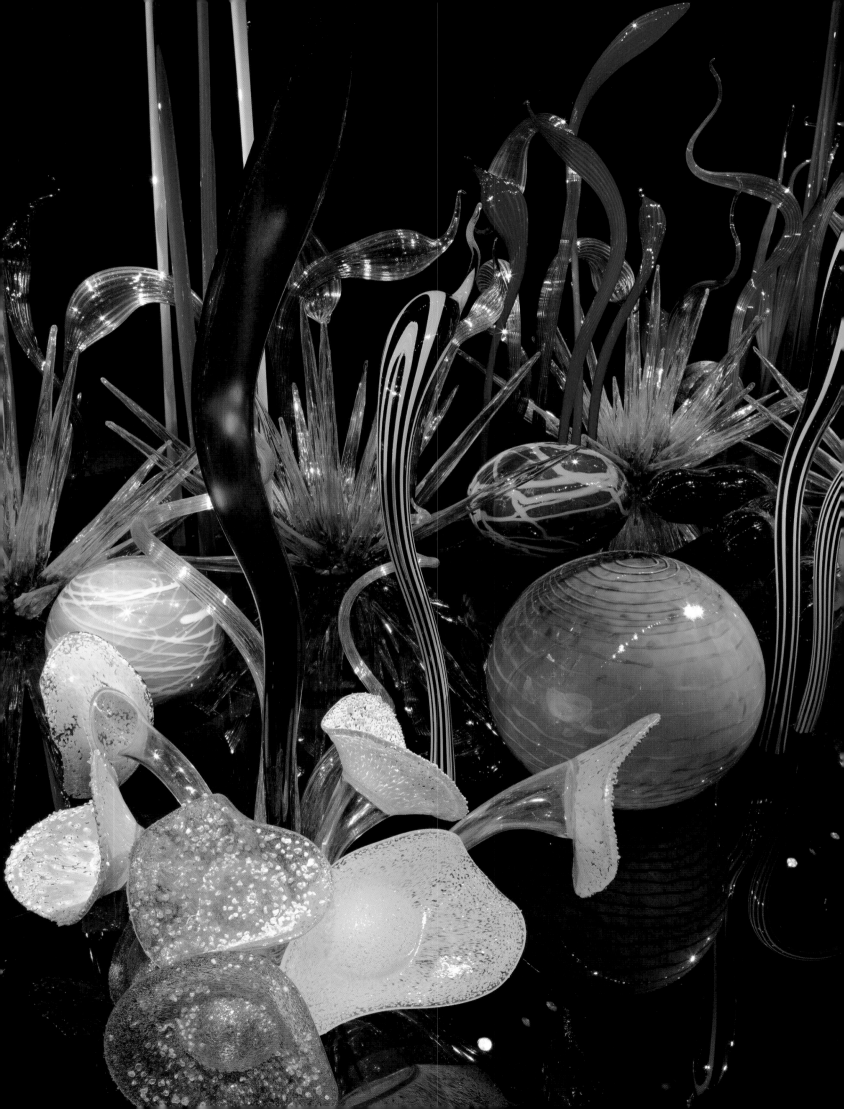

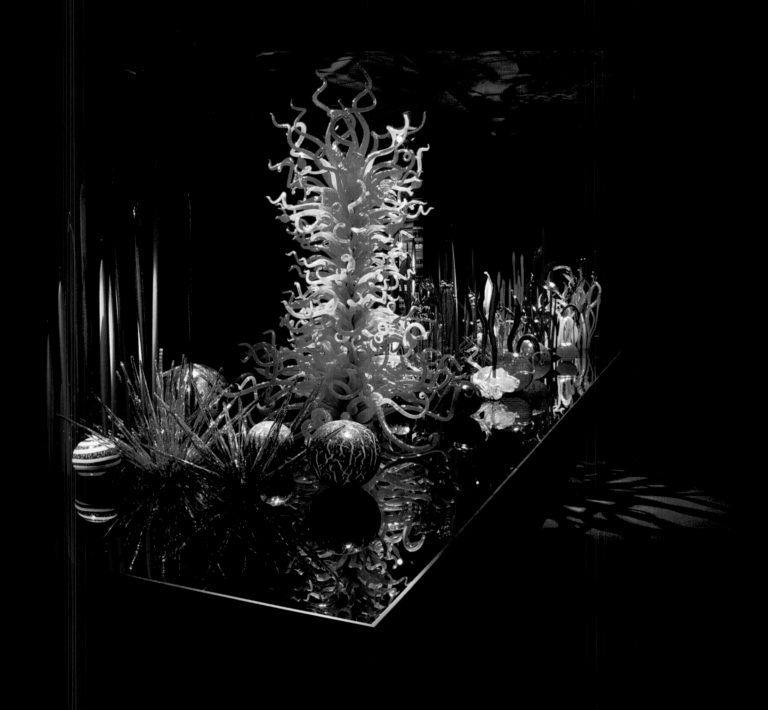

MILLE FIORI (DETAIL), 2008

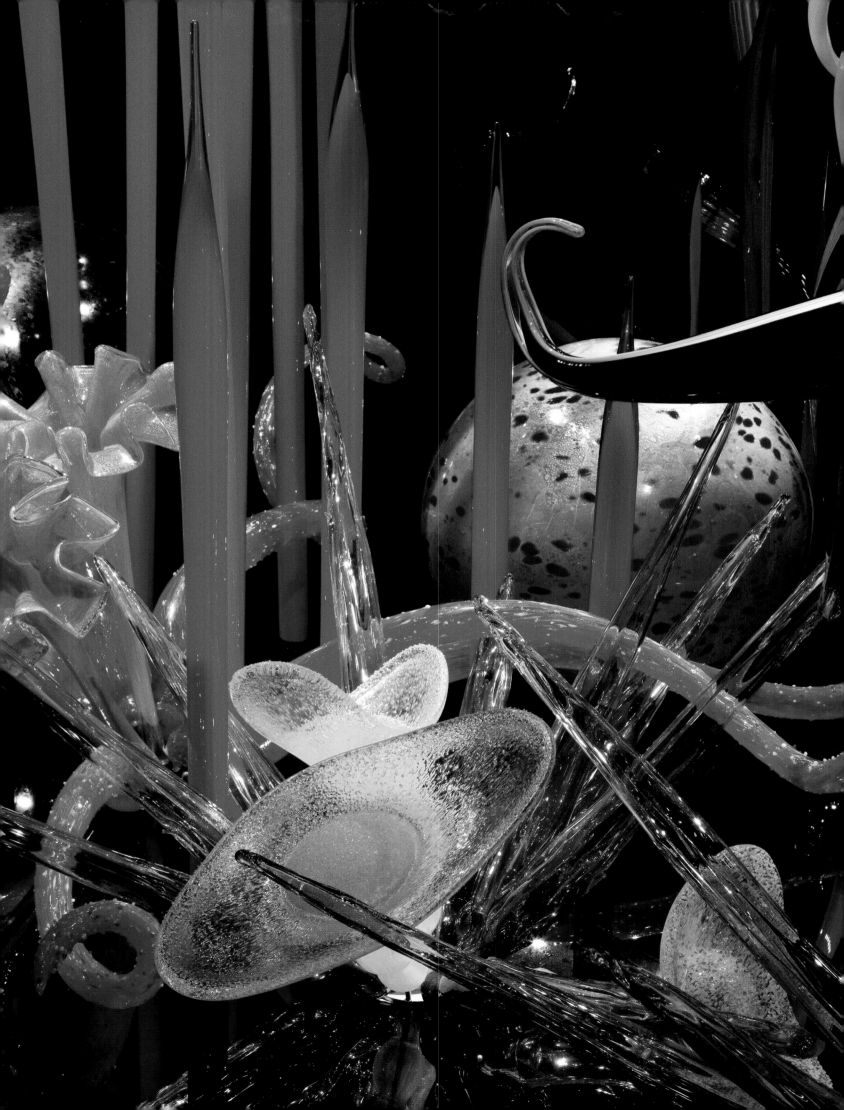

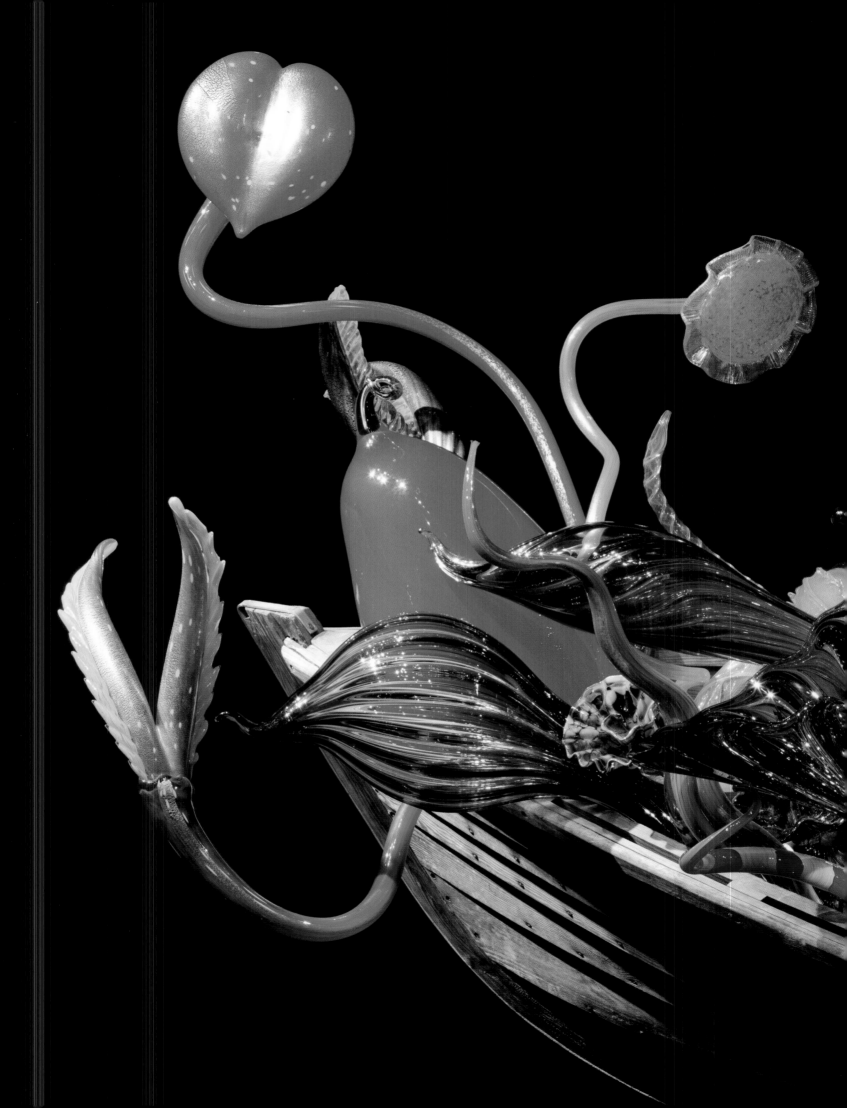

Glass itself is so much like water.
If you let it go on its own, it almost
ends up looking like something that
came from the sea.

CHIHULY

IKEBANA BOAT (DETAIL), 2008

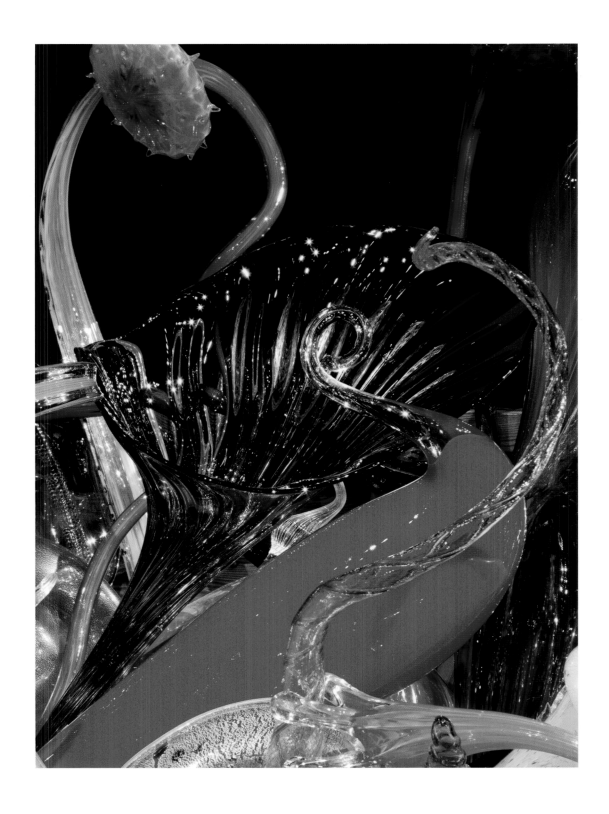

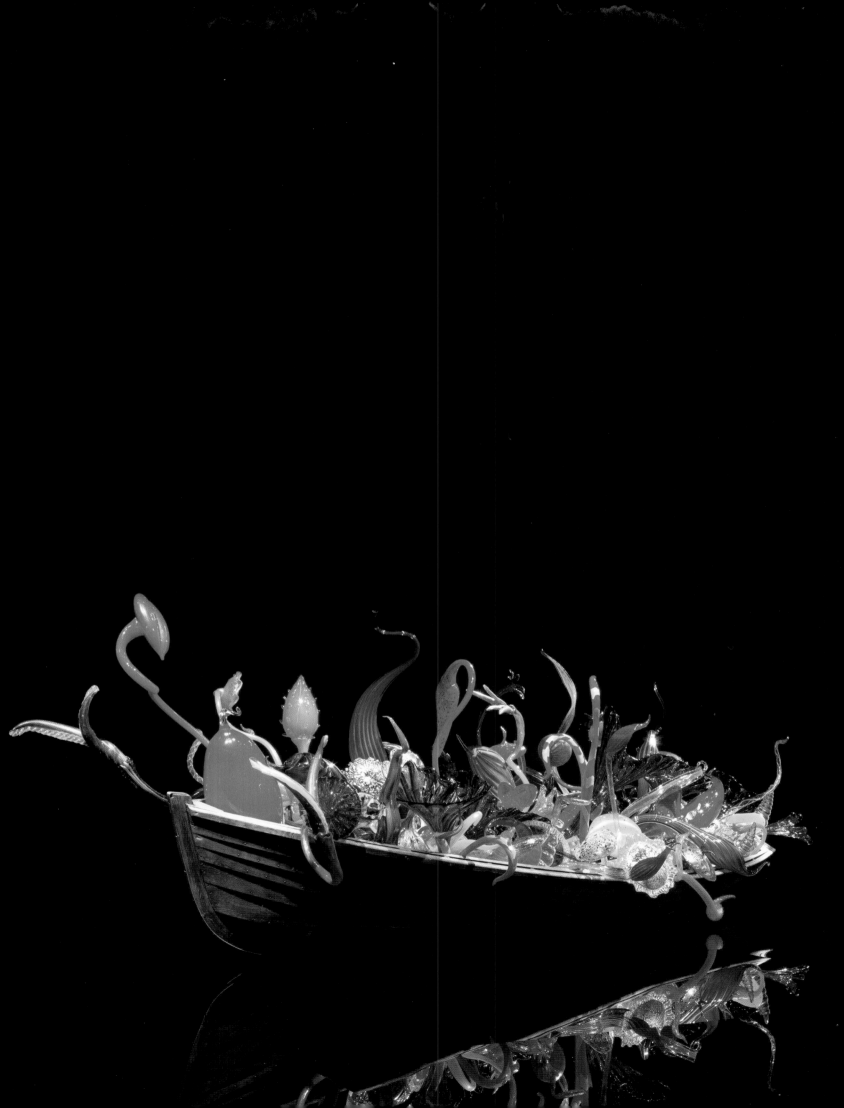

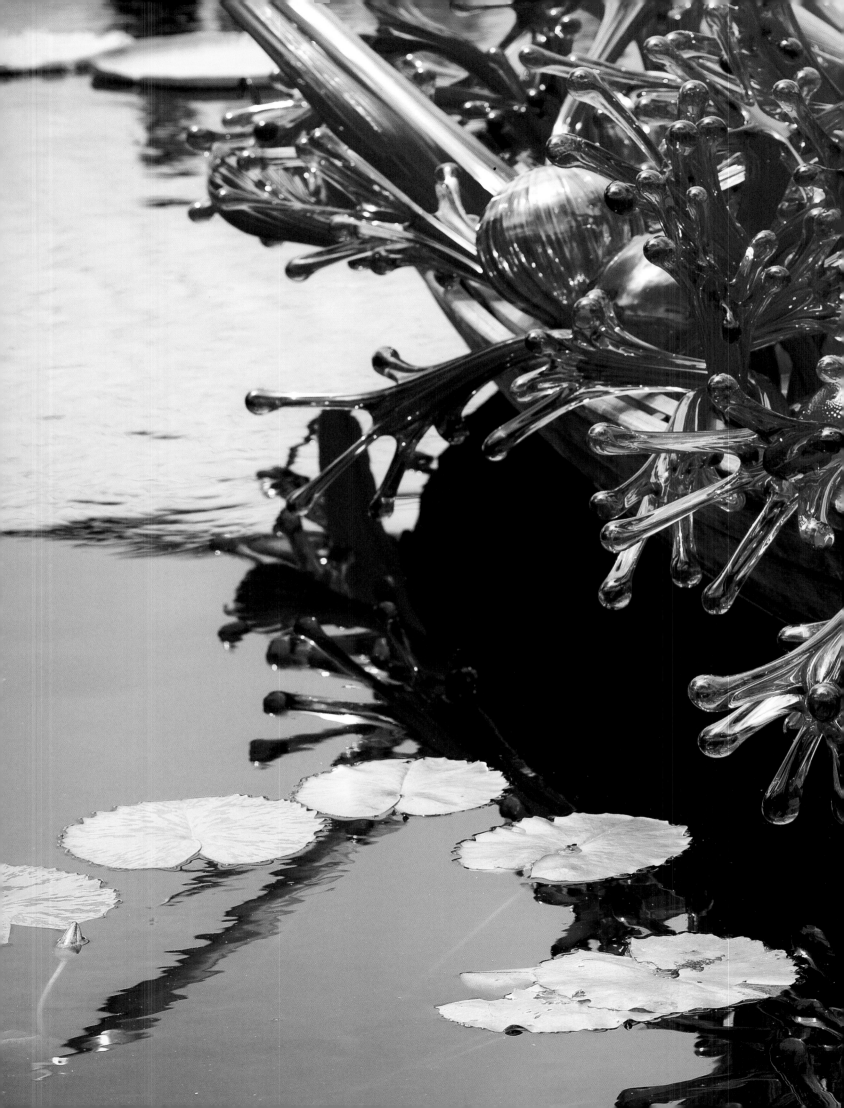

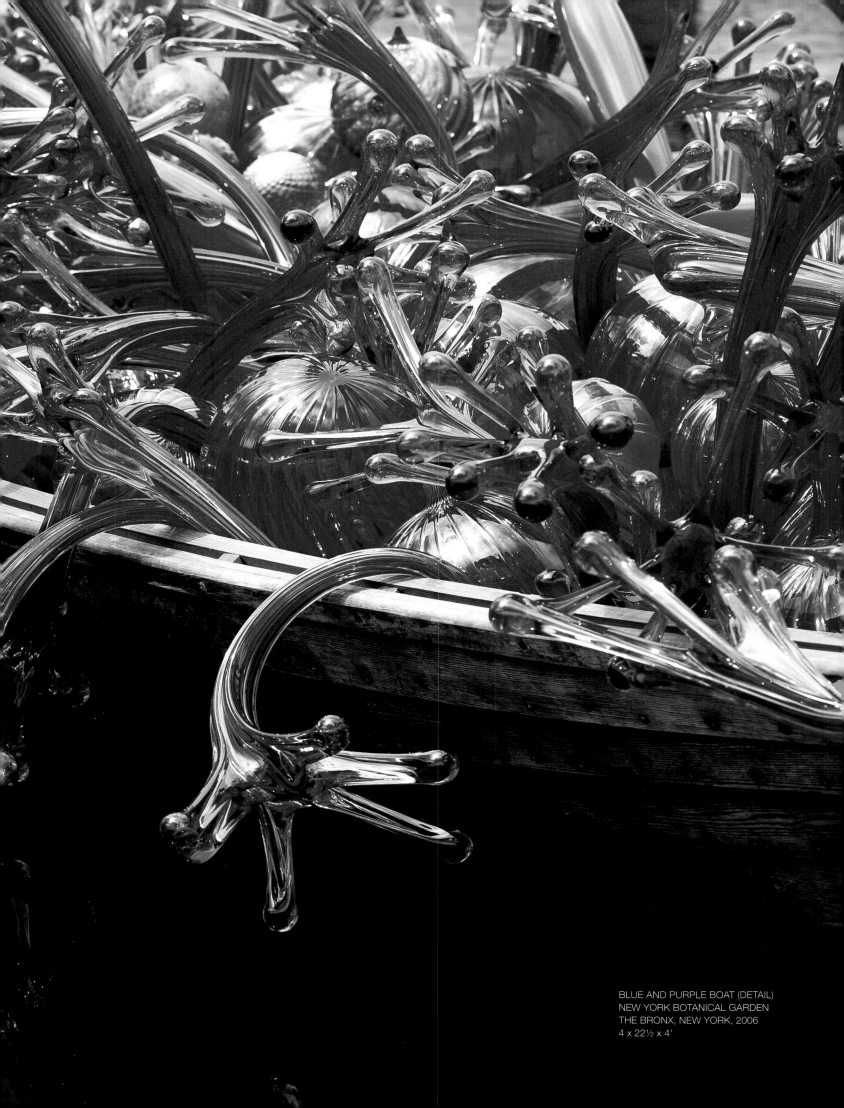

BLUE AND PURPLE BOAT (DETAIL)
NEW YORK BOTANICAL GARDEN
THE BRONX, NEW YORK, 2006
4 x 22½ x 4'

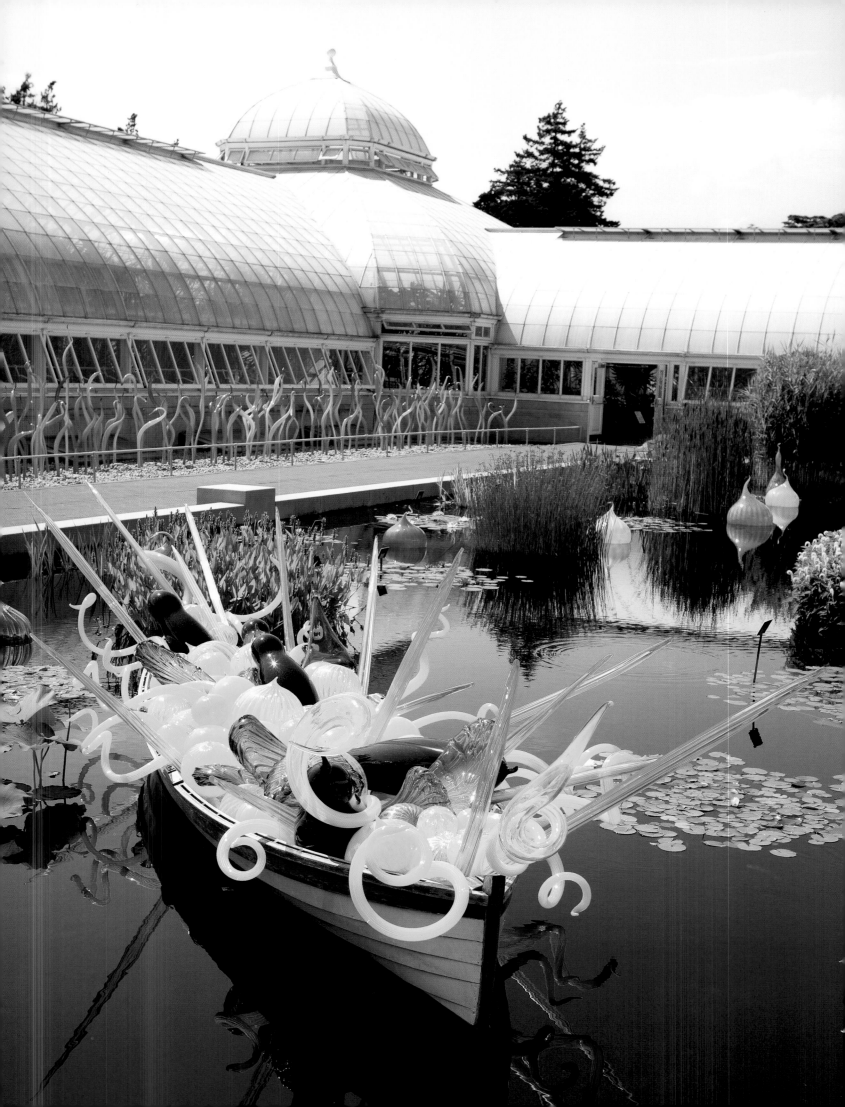

SUNSET BOAT
CHATSWORTH, ENGLAND, 2006
6½ x 23 x 9½'

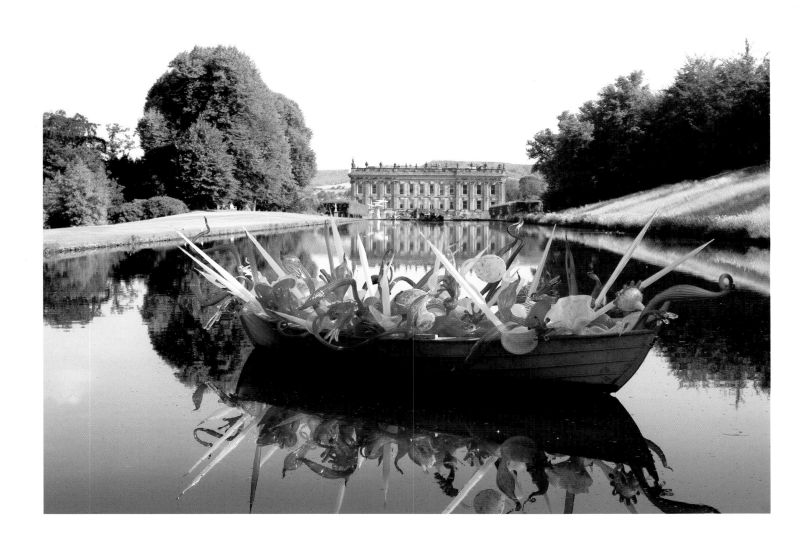

YELLOW BOAT
NEW YORK BOTANICAL GARDEN
THE BRONX, NEW YORK, 2006
5 x 7 x 21'

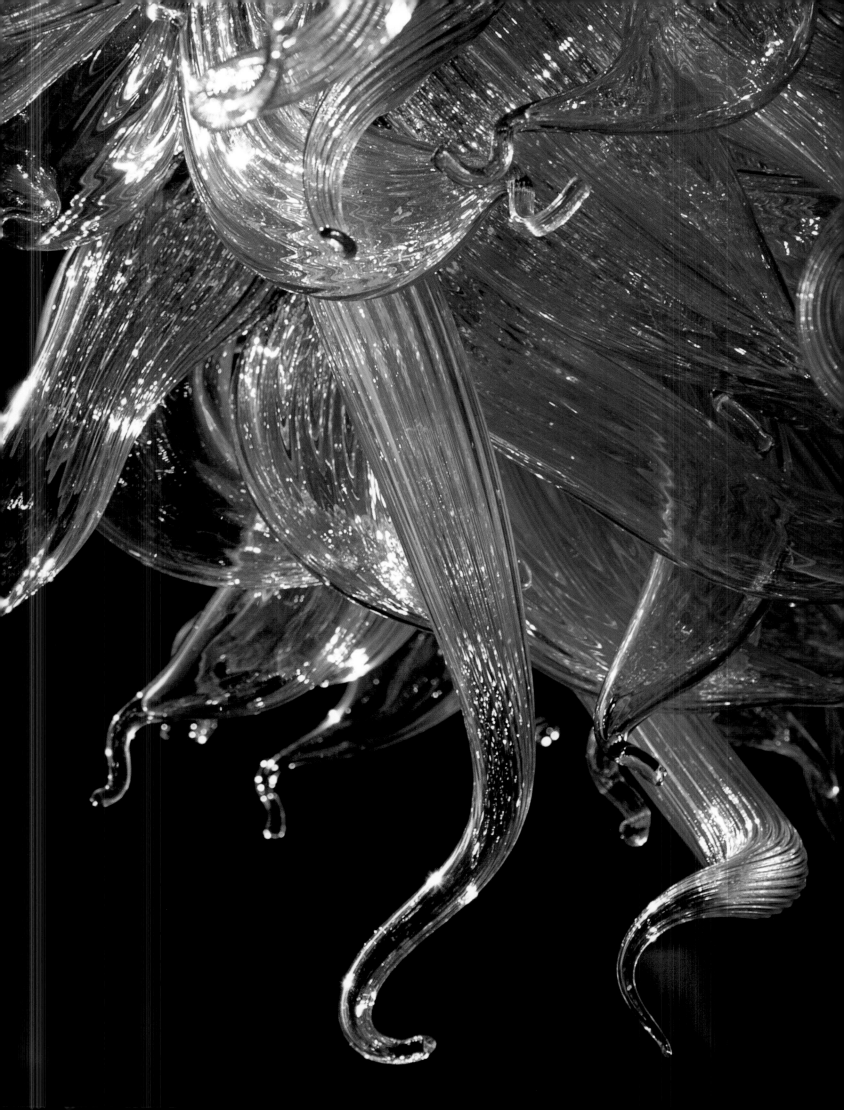

CHANDELIERS

Hang it in space and it becomes
mysterious, defying gravity or
seemingly out of place—like
something you have never
seen before.

CHIHULY

CHIOSTRO DI SANT'APOLLONIA CHANDELIER (DETAIL)
VENICE, 1996
5½ x 7½'

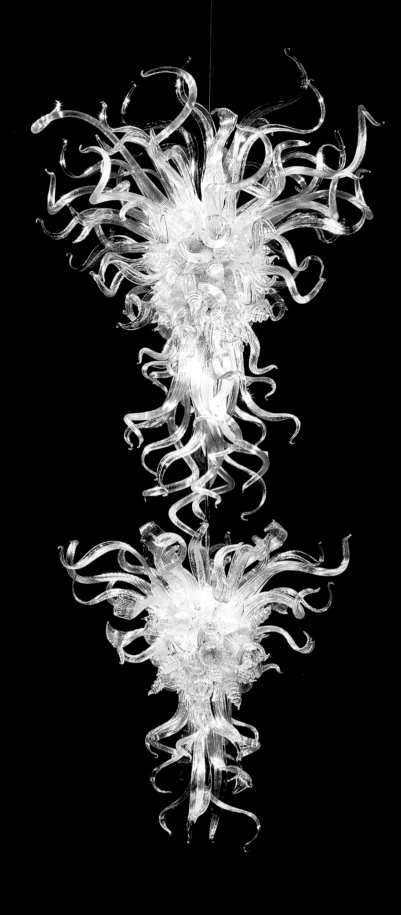

SILVERED CHRYSALIS TIERED CHANDELIER, 2010
(DETAIL OPPOSITE)
12 x 5½ x 5'

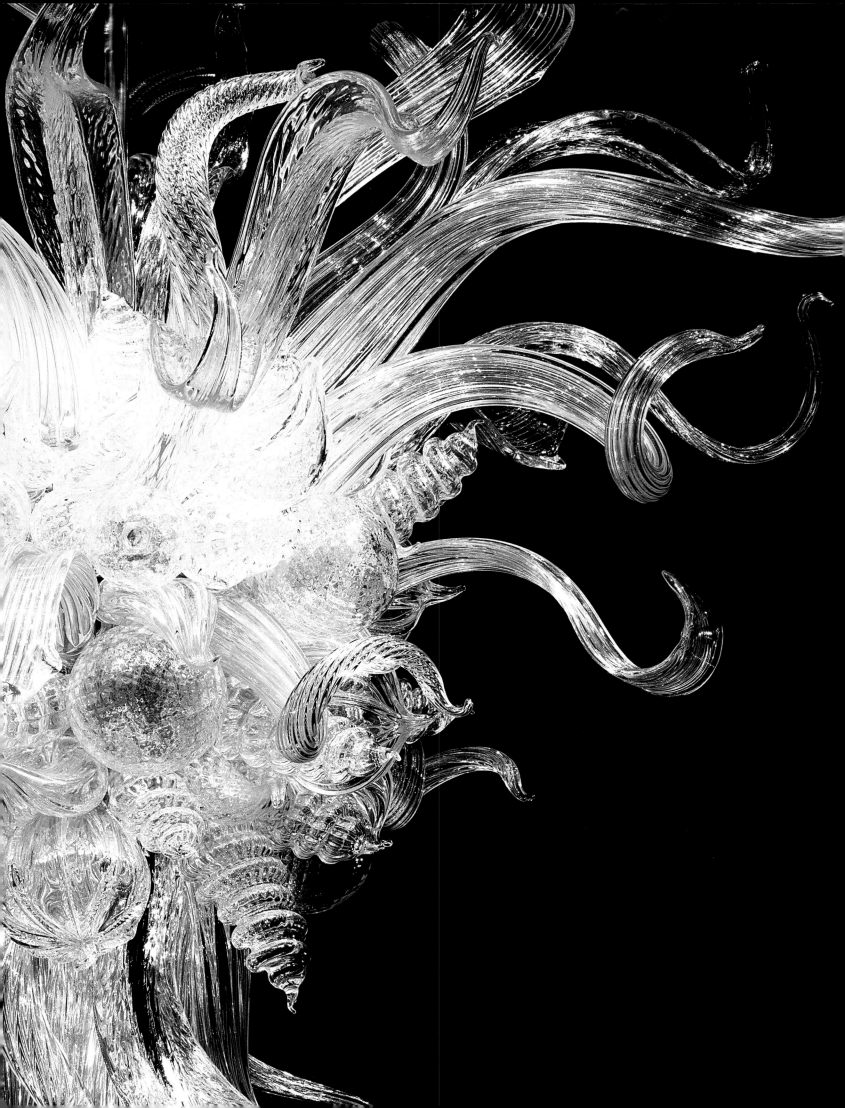

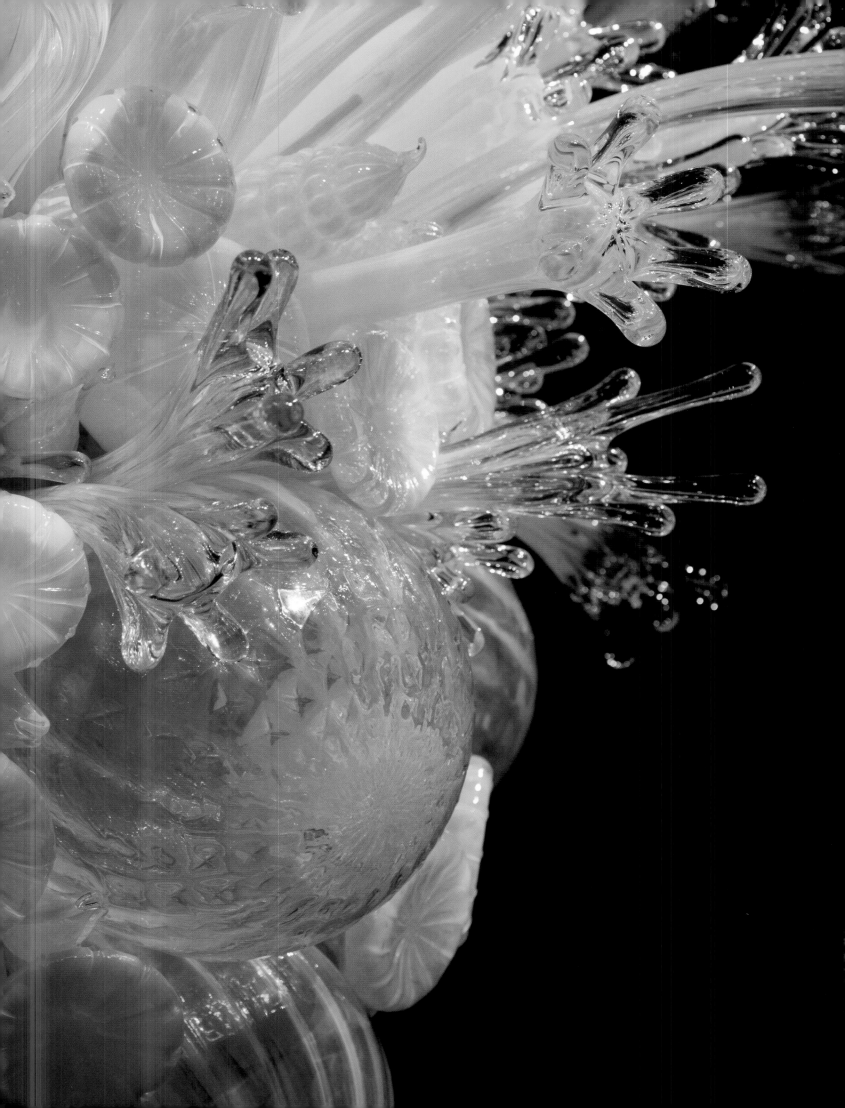

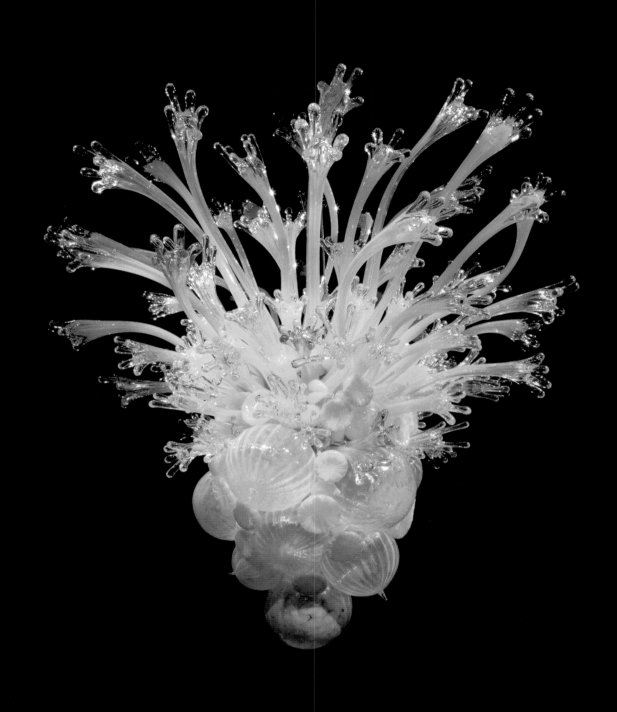

IRIS YELLOW FROG FOOT CHANDELIER (DETAIL OPPOSITE), 2011
6½ x 6 x 6'

PALAZZO DI LOREDANA BALBONI CHANDELIER
VENICE, 1996
11 x 6'

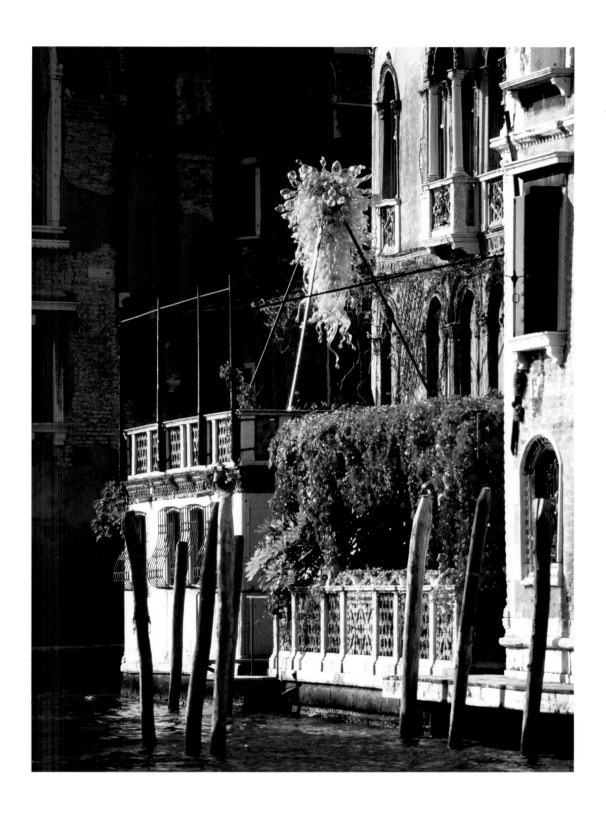

PALAZZO DI LOREDANA BALBONI CHANDELIER (DETAIL)
COLUMBUS MUSEUM OF ART, COLUMBUS, OHIO, 1998
10 x 7½'

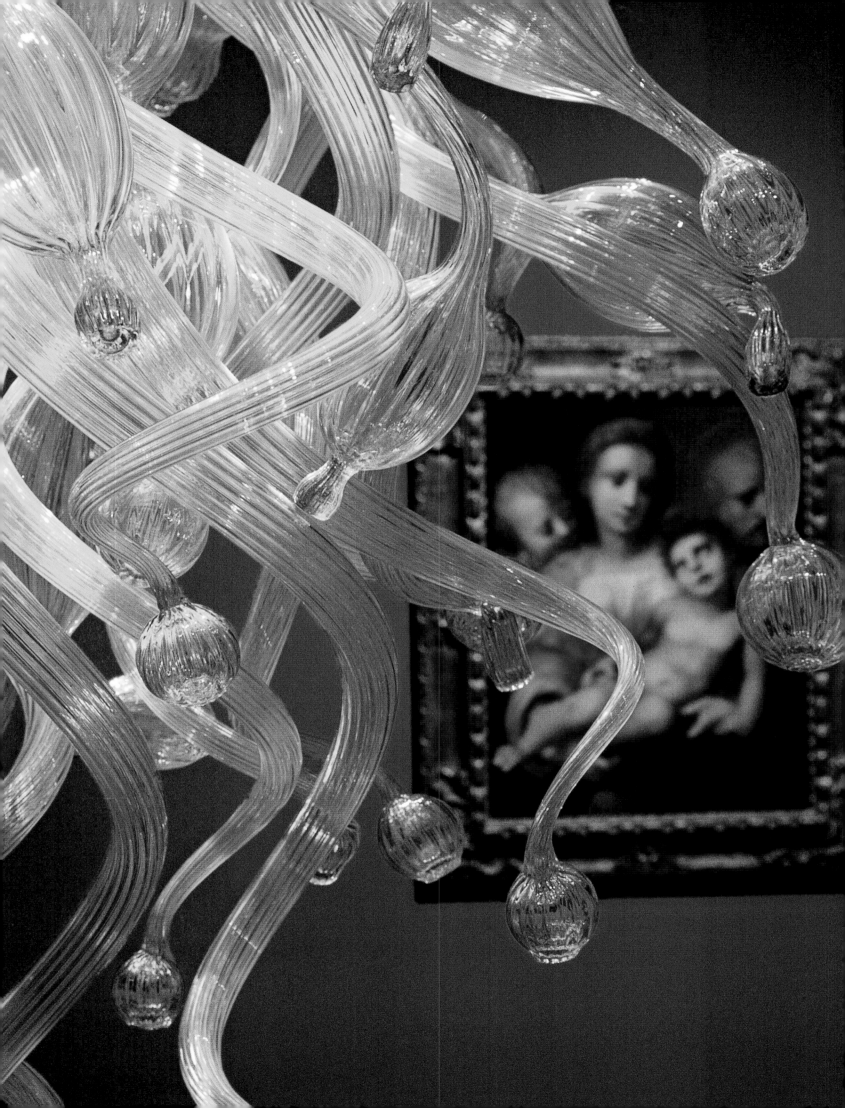

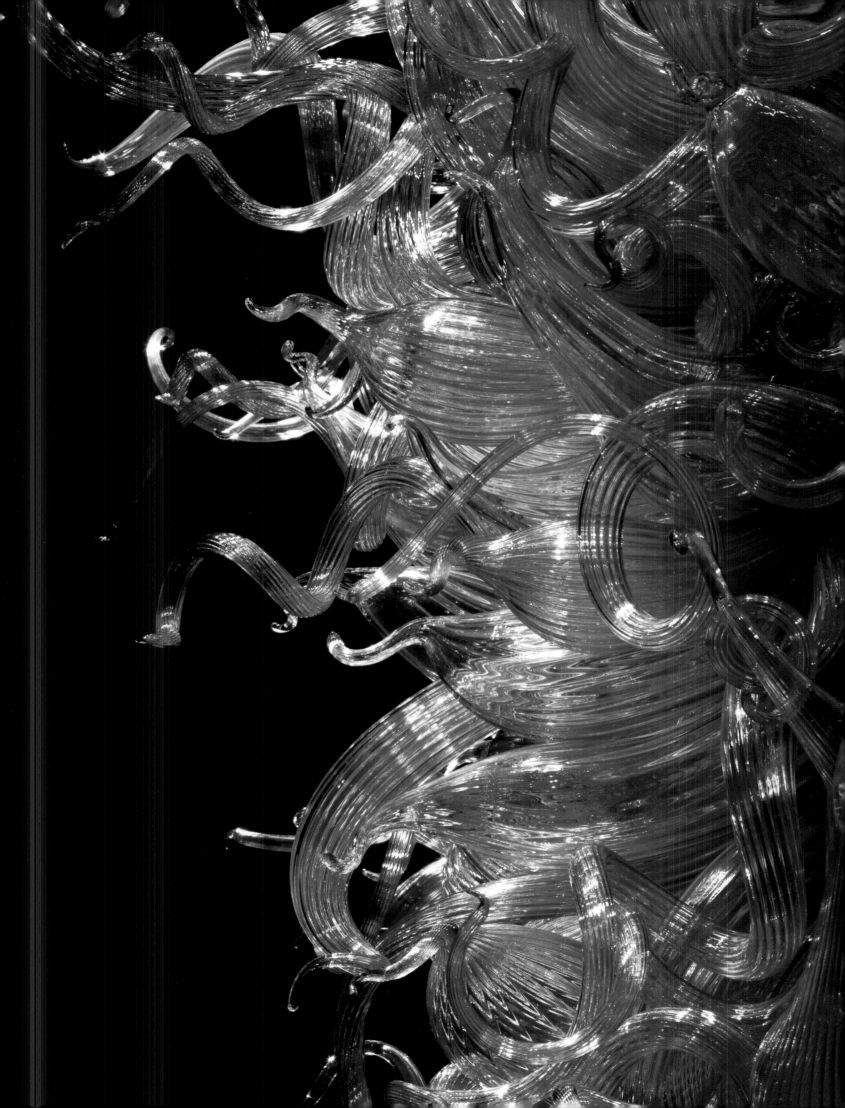

CHIOSTRO DI SANT'APOLLONIA CHANDELIER
VENICE, 1996
5½ x 7½'

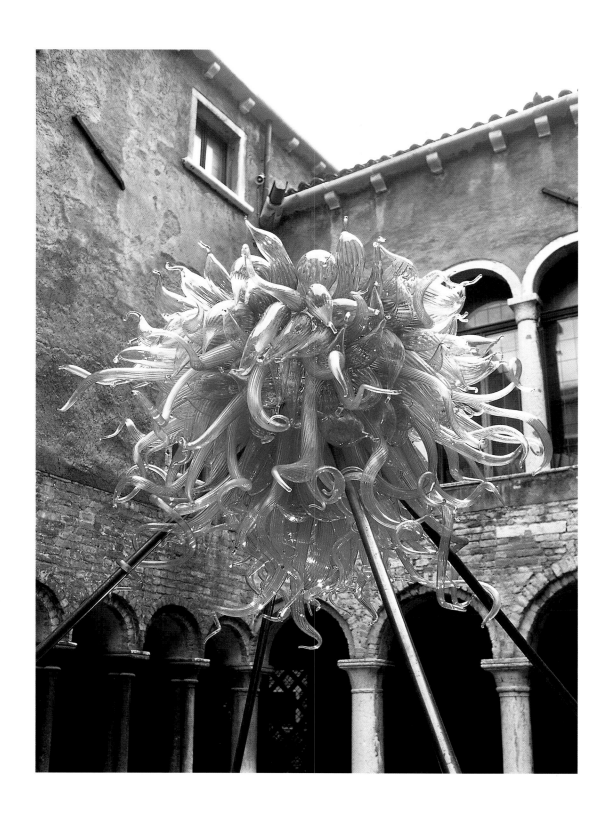

CHIOSTRO DI SANT'APOLLONIA CHANDELIER (DETAIL)
DE YOUNG MUSEUM, SAN FRANCISCO, 2008
13 x 7 x 6½'

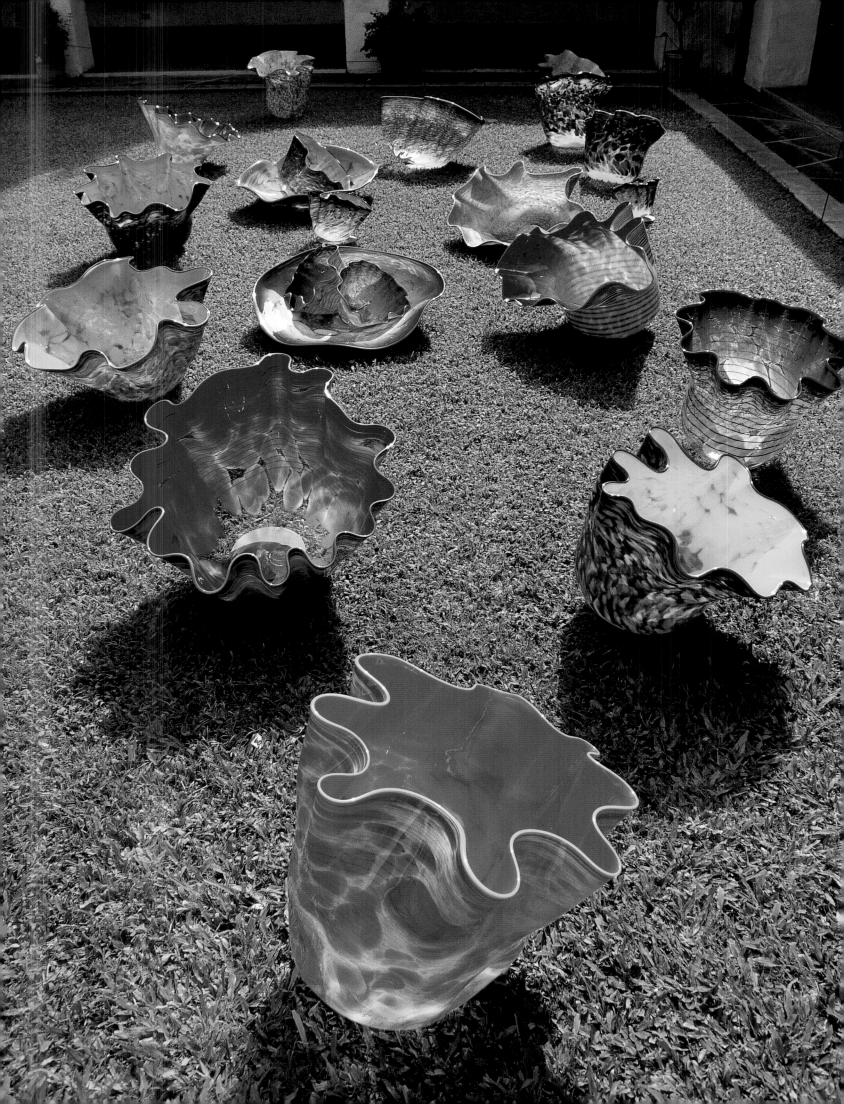

I don't know if something
can be too colorful.

CHIHULY

MACCHIA COURTYARD
HONOLULU ACADEMY OF ARTS, 1992

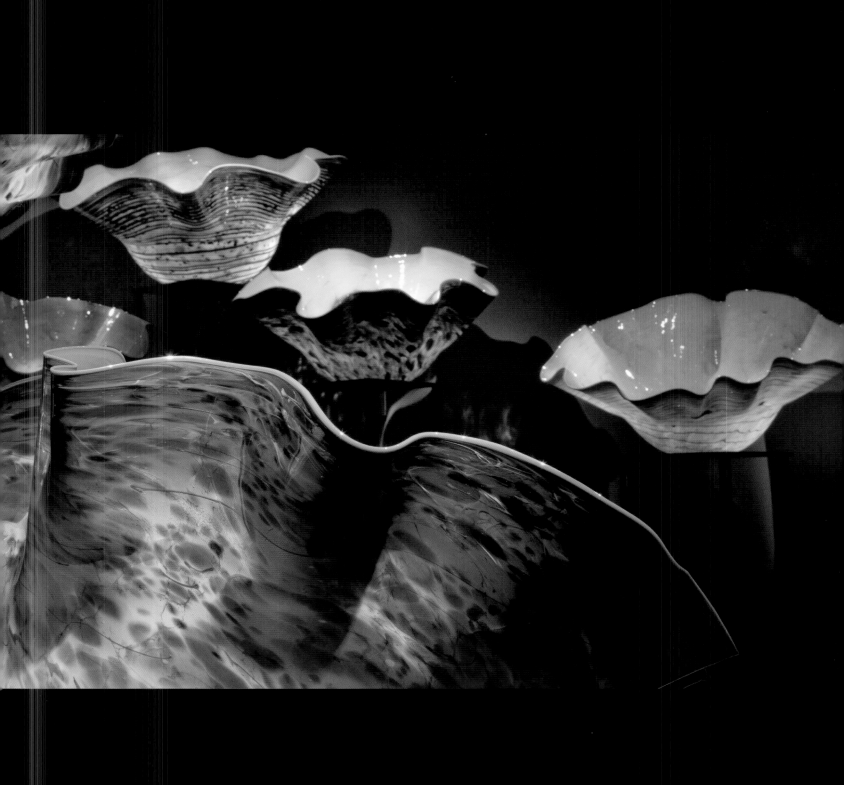

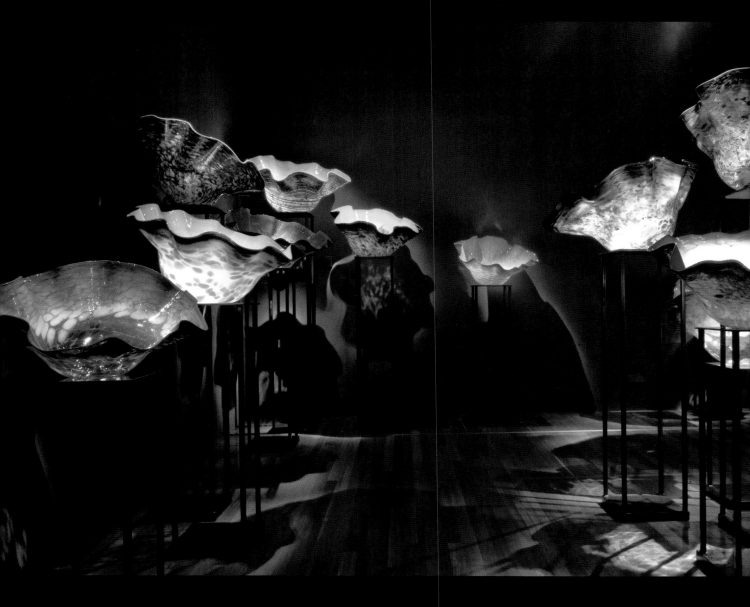

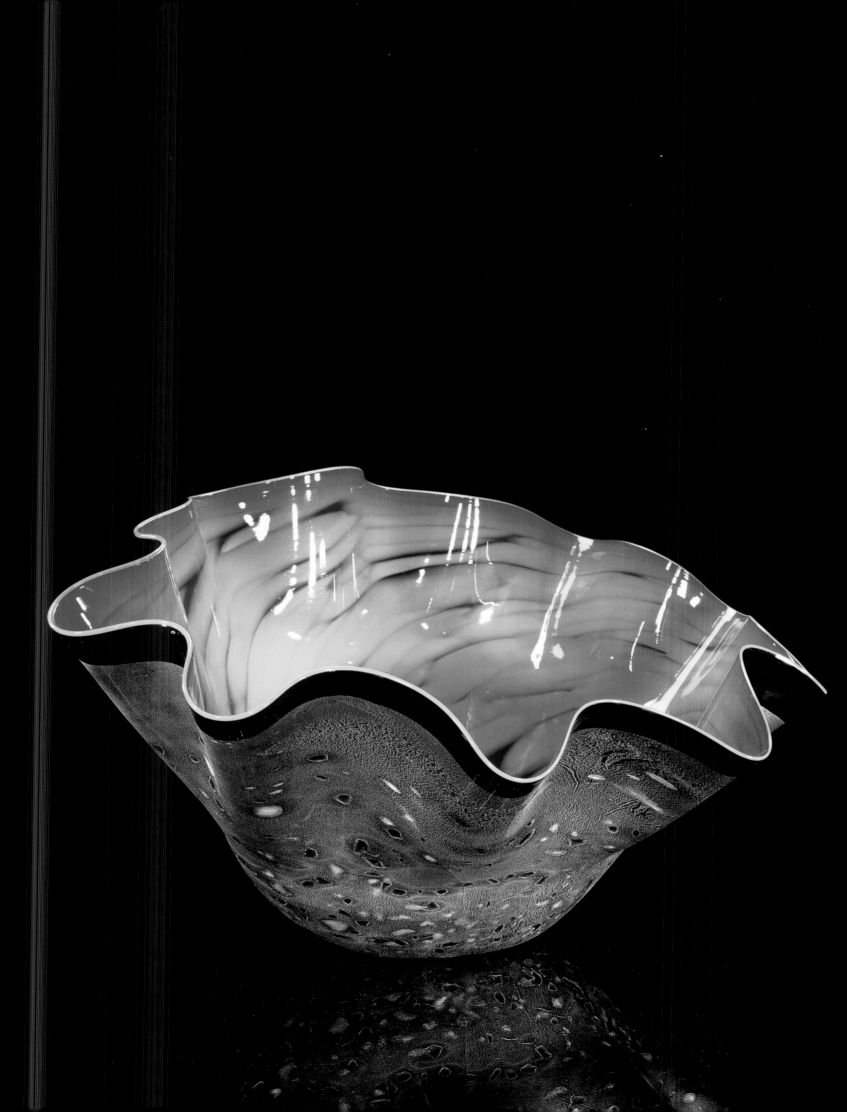

SATURN RED BLACK MACCHIA WITH ORANGE
CHROME LIP WRAP, 2006
26 x 41 x 28"

MACCHIA FOREST (DETAIL),
PHIPPS CONSERVATORY AND
BOTANICAL GARDENS, PITTSBURGH, 2007

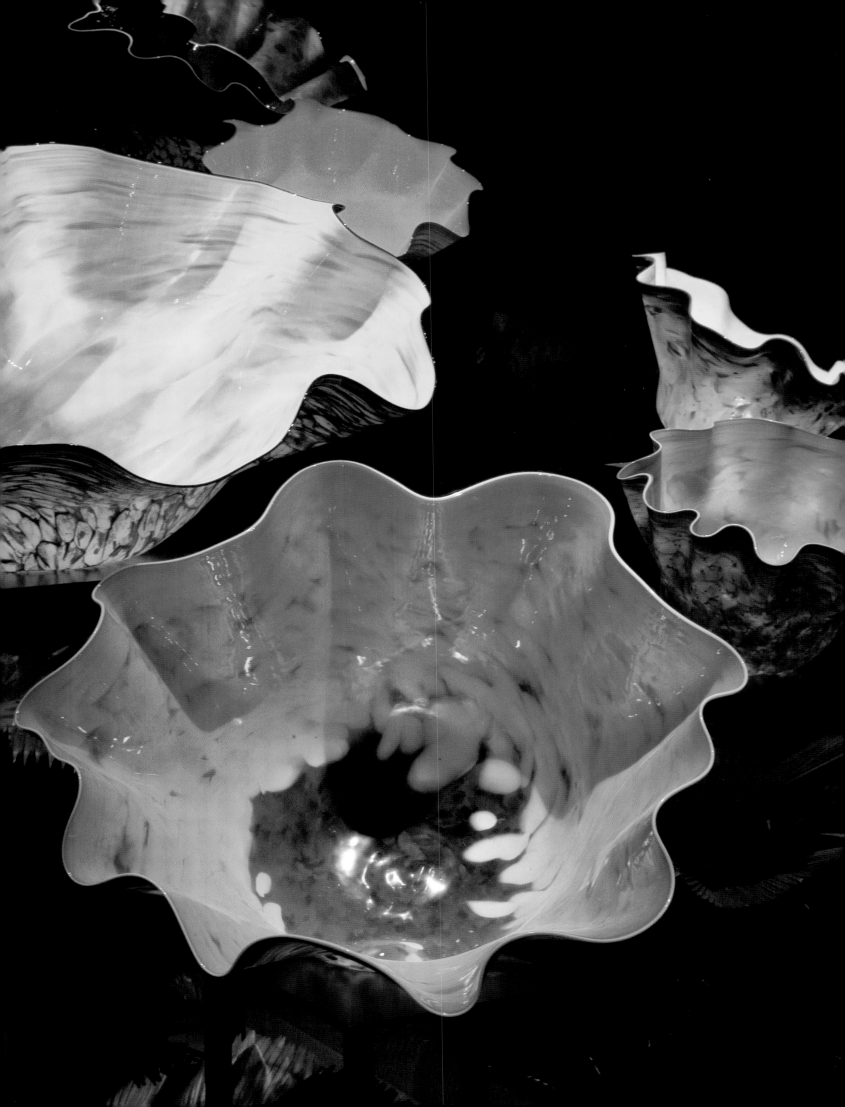

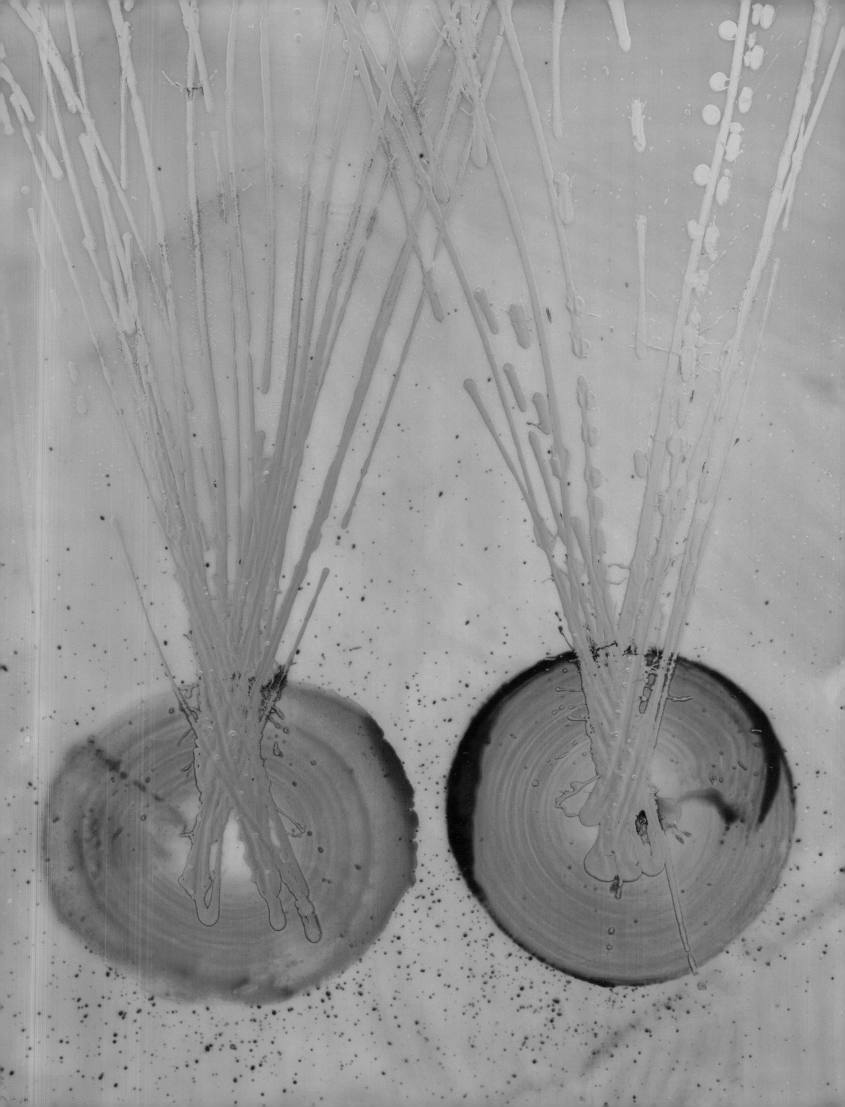

If I didn't draw, I don't think the work would have progressed at the rate or in the directions that the work has gone.

CHIHULY

DRAWING ON ACRYLIC, 2011
52 x 43"

VENETIAN DRAWING WALL
THE BOATHOUSE, SEATTLE, 1990

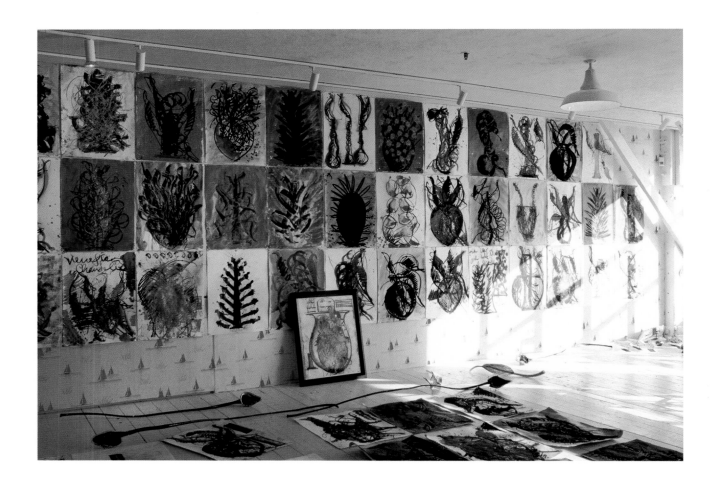

EBELTOFT DRAWING, 1991
30 x 22"

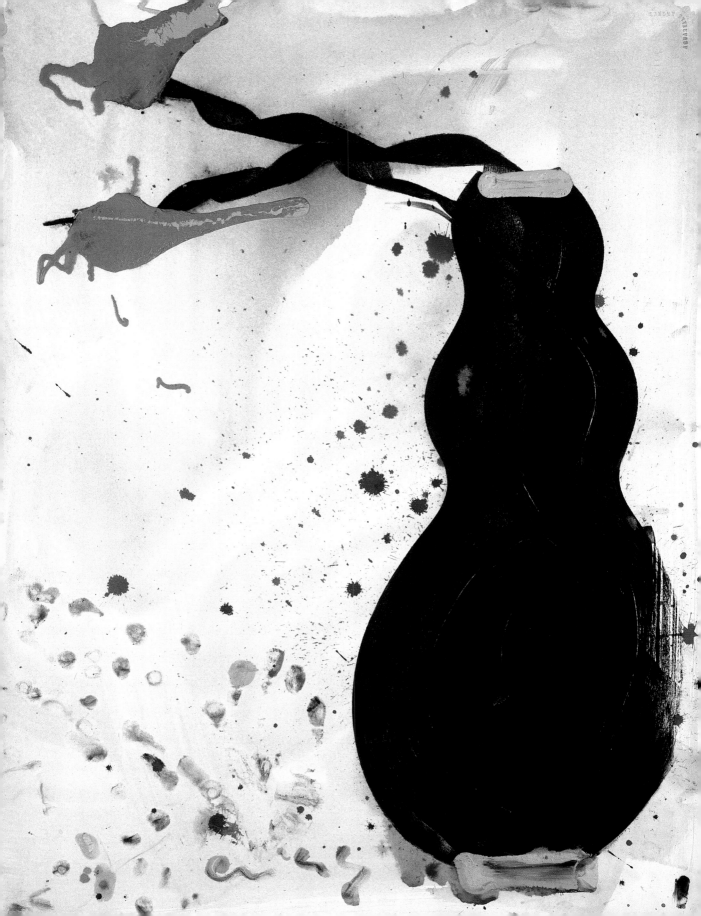

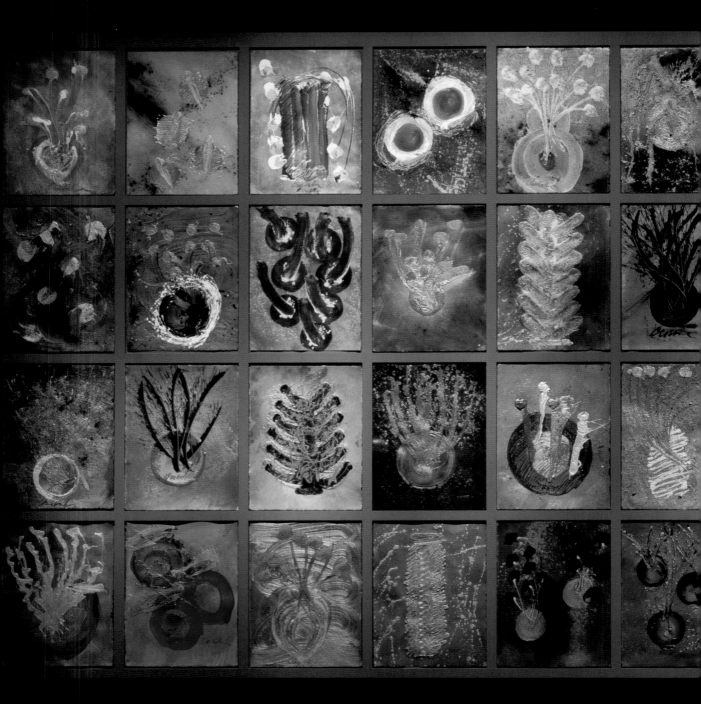

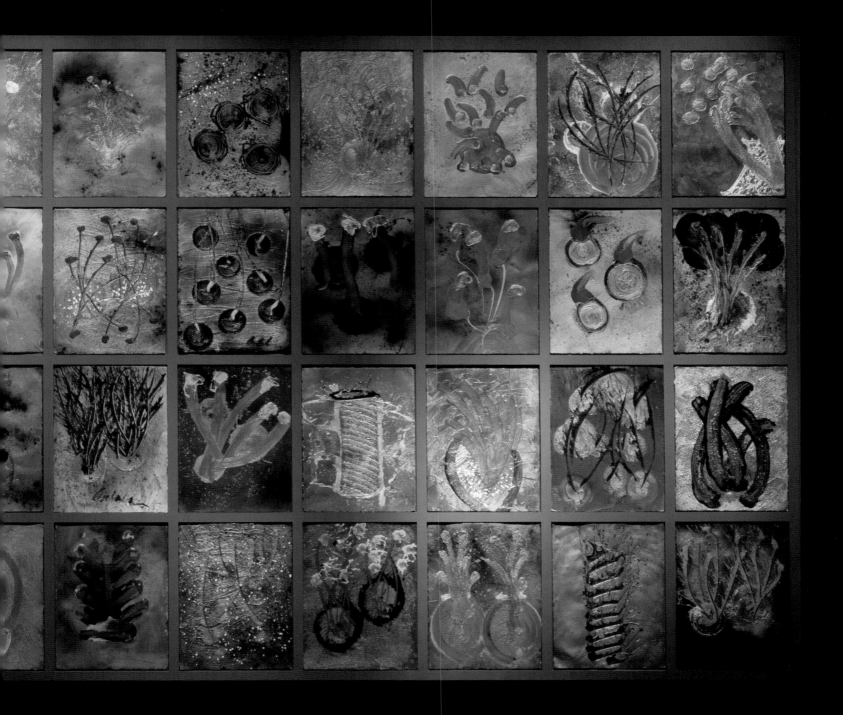

DRAWING WALL
COLUMBUS MUSEUM OF ART, COLUMBUS, OHIO, 2009

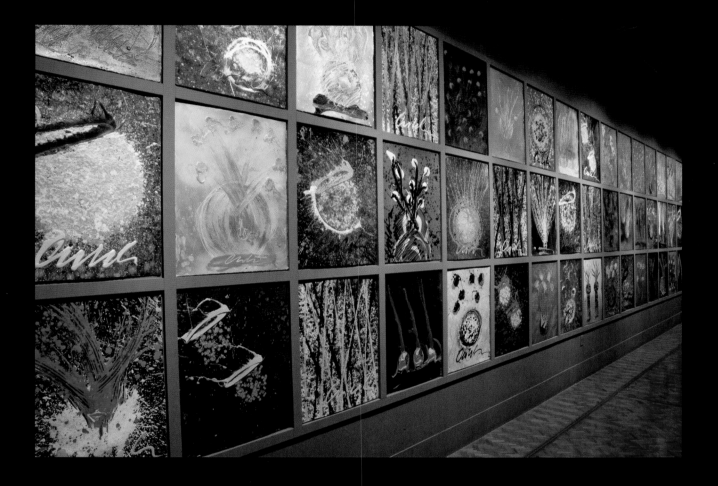

IKEBANA DRAWING, 2010
30 x 22"

GLASSHOUSE

I've always had an interest in glasshouses, and so the idea of being able to bring my work inside but yet in nature at the same time was really an ideal background for my work.

CHIHULY

VOLUNTEER PARK CONSERVATORY
SEATTLE, 1914

POSTCARD OF CONSERVATORY, GARFIELD PARK
CHICAGO

POSTCARD OF W. W. SEYMOUR BOTANICAL CONSERVATORY
TACOMA

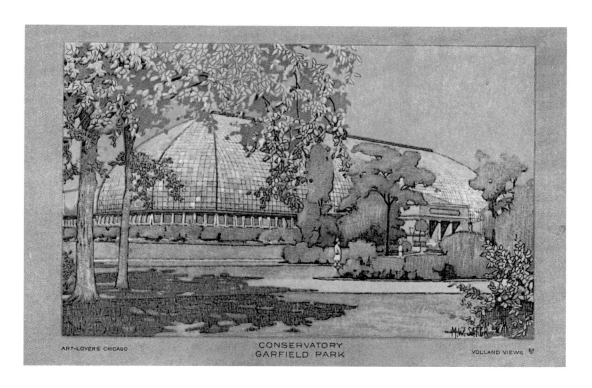

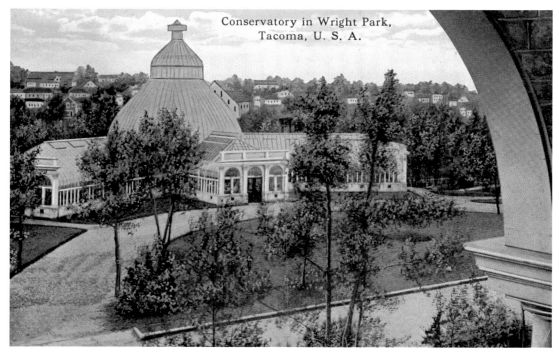

CHIHULY AT THE PALM HOUSE
ROYAL BOTANIC GARDENS, KEW, ENGLAND, 1976

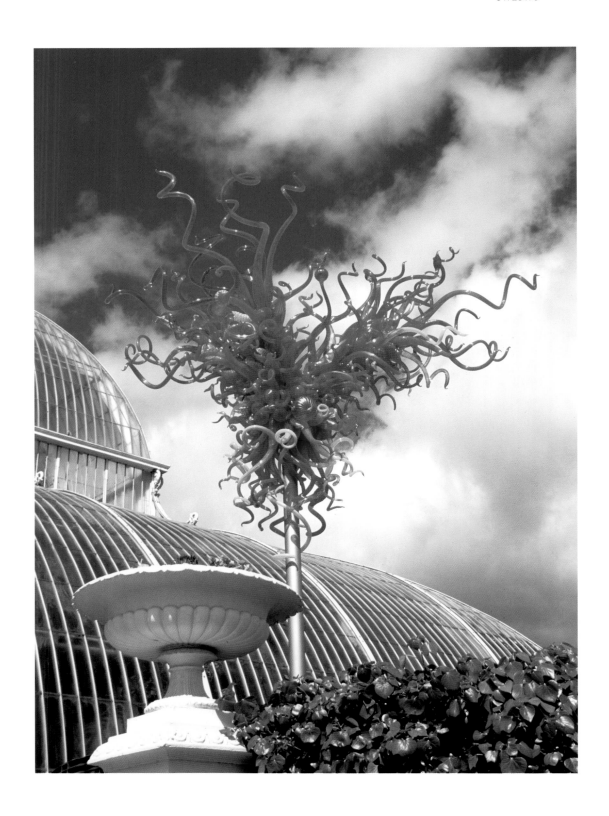

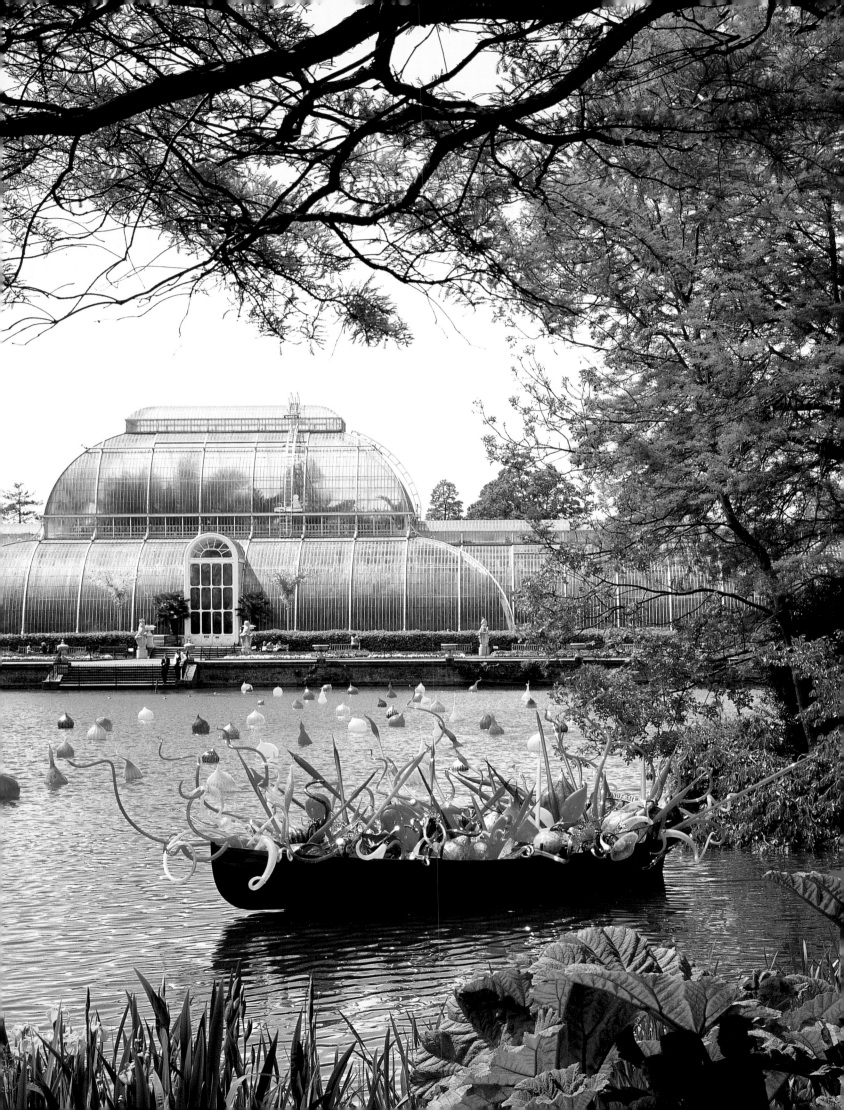

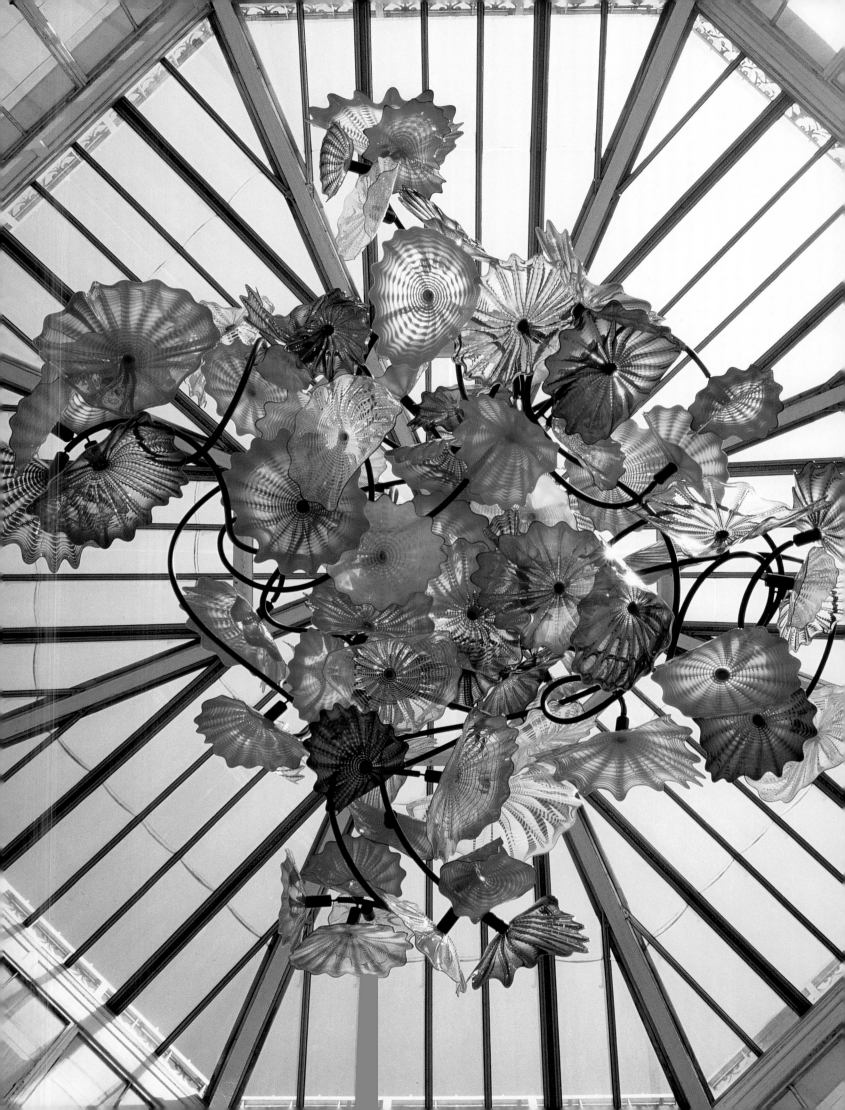

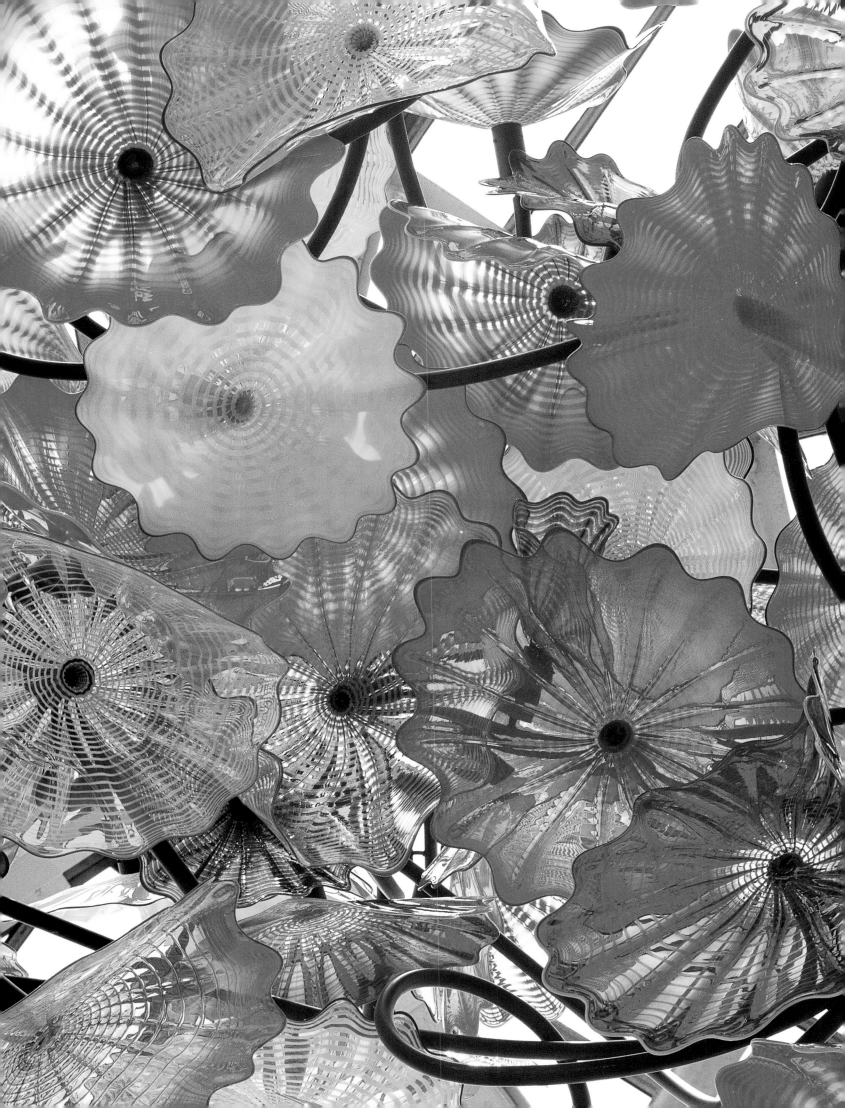

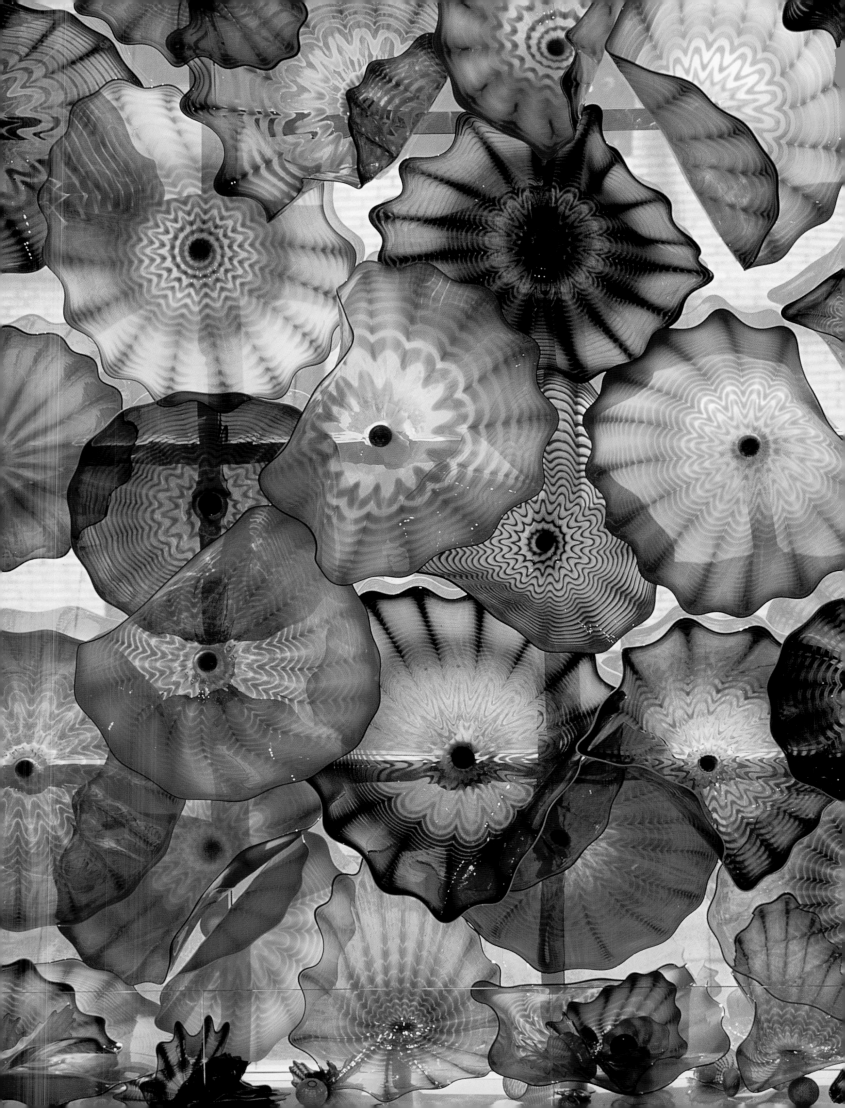

MONARCH WINDOW
UNION STATION, TACOMA, 1994
22 x 40 x 3'

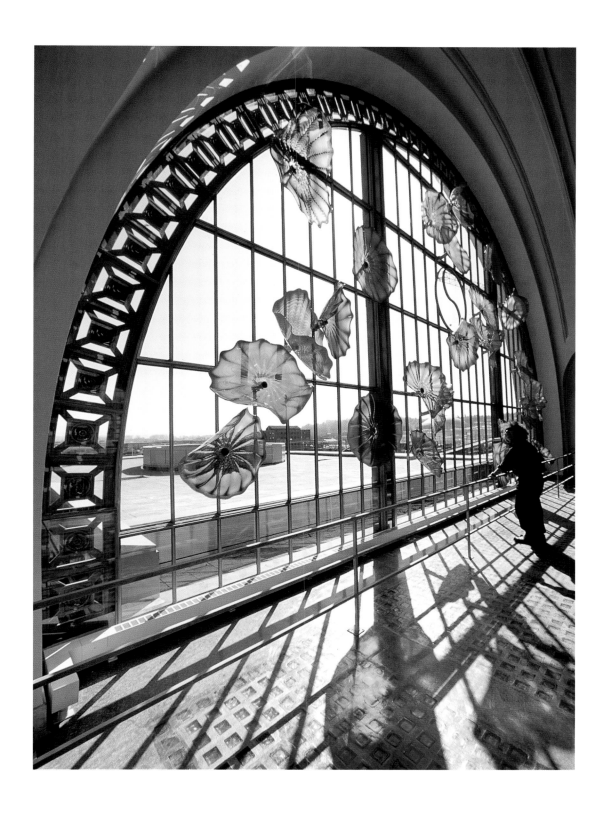

MALINA WINDOW (DETAIL)
DETROIT, 1993
16 x 16'

CAVALCADE
OF CHANDELIERS

What makes the chandeliers work
for me is the massing of color. If
you take hundreds or thousands
of blown pieces of one color, put
them together, and then shoot light
through them, now that's going
to be something to look at!

CHIHULY

U.S. SCIENCE PAVILION ARCHES
SEATTLE WORLD'S FAIR, 1962

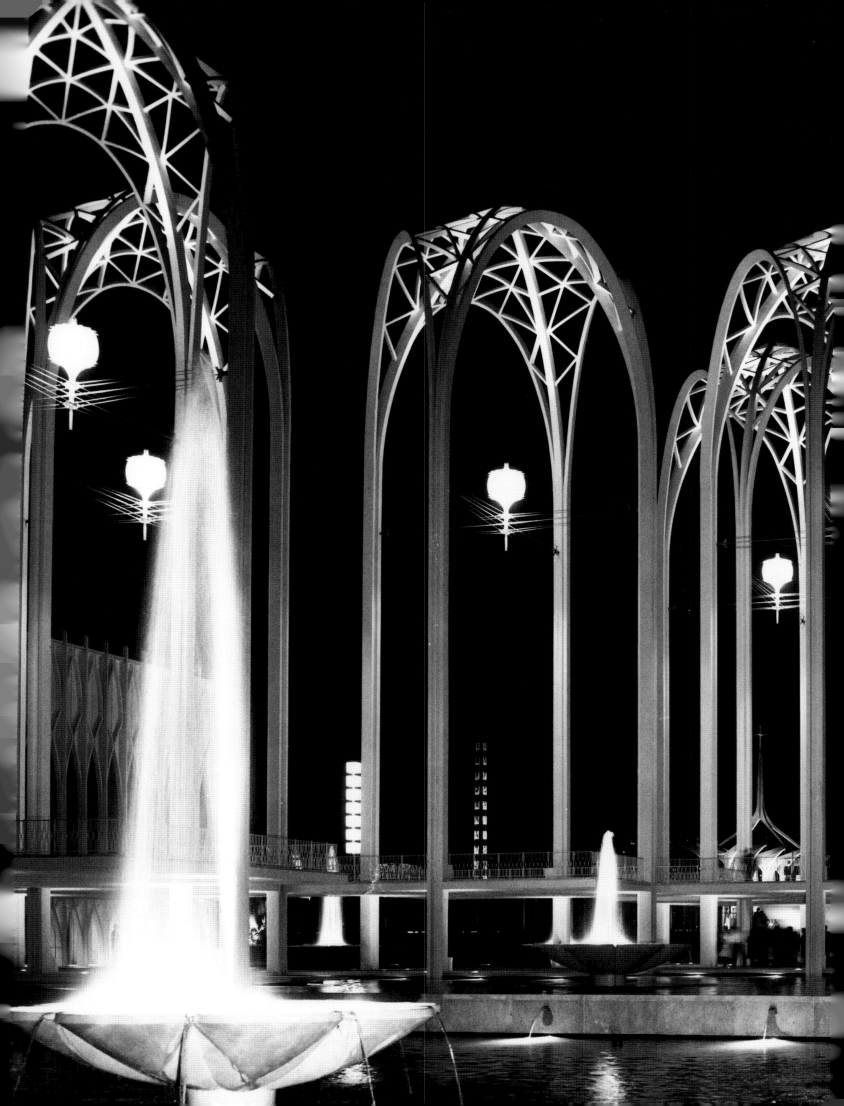

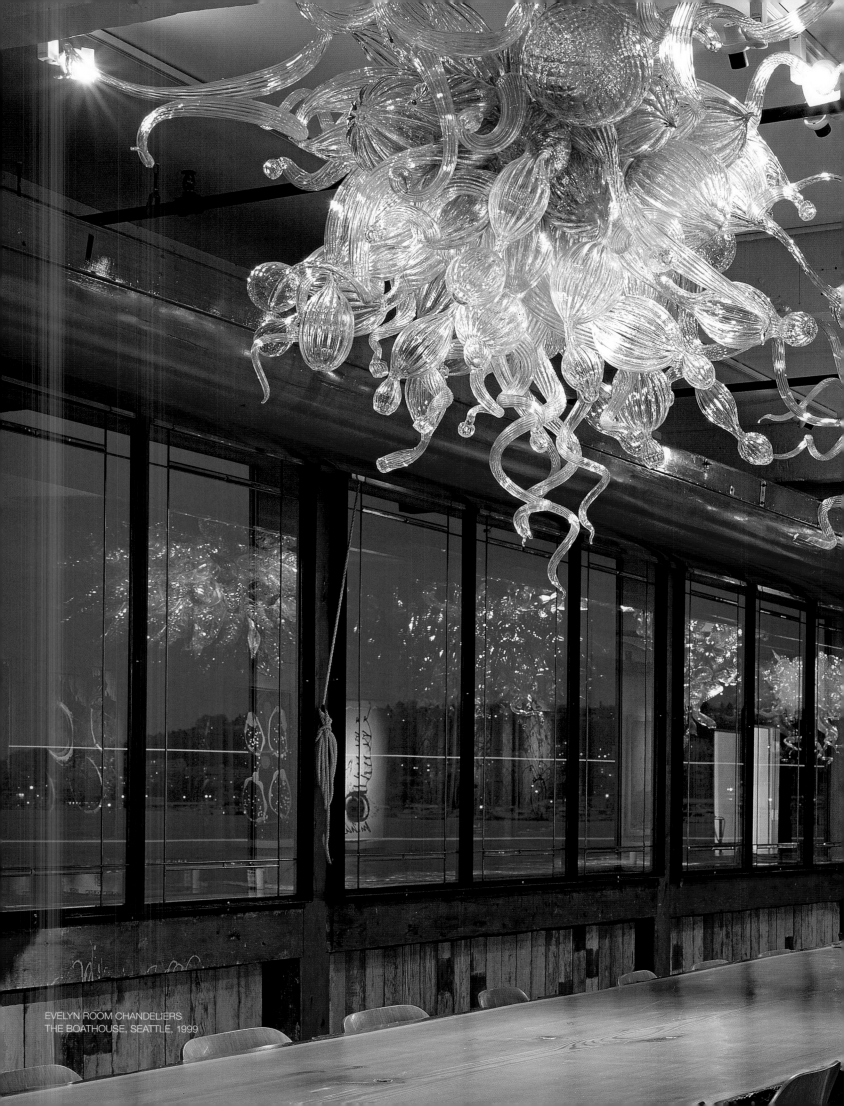

EVELYN ROOM CHANDELIERS
THE BOATHOUSE, SEATTLE, 1999

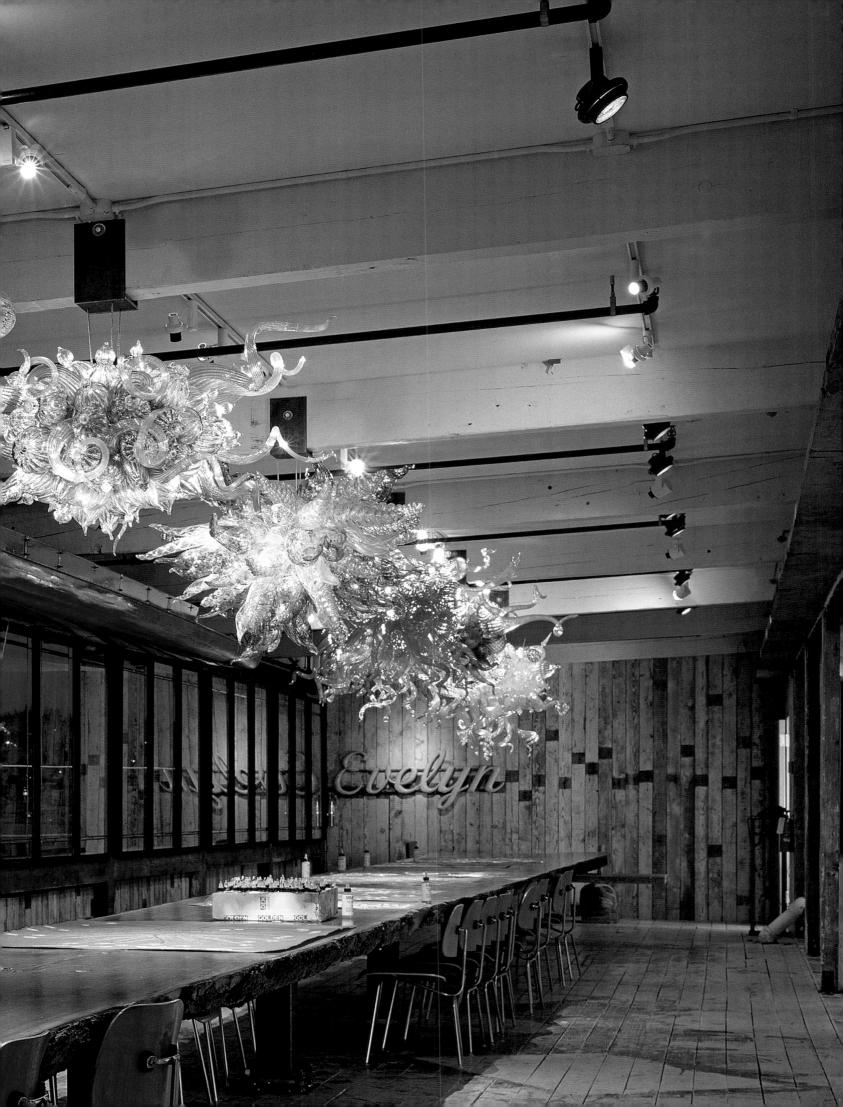

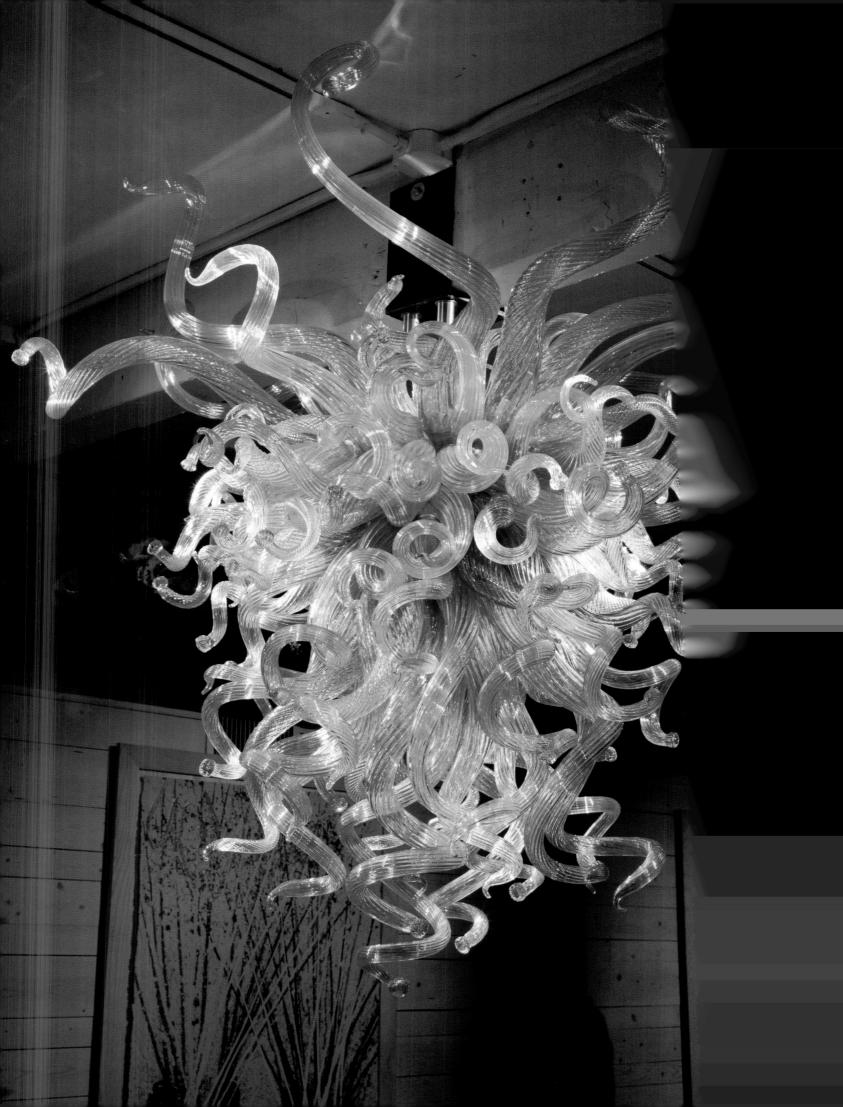

CRANBERRY AND ICE CHANDELIER
EVELYN ROOM, THE BOATHOUSE, SEATTLE
5 x 5 x 5'

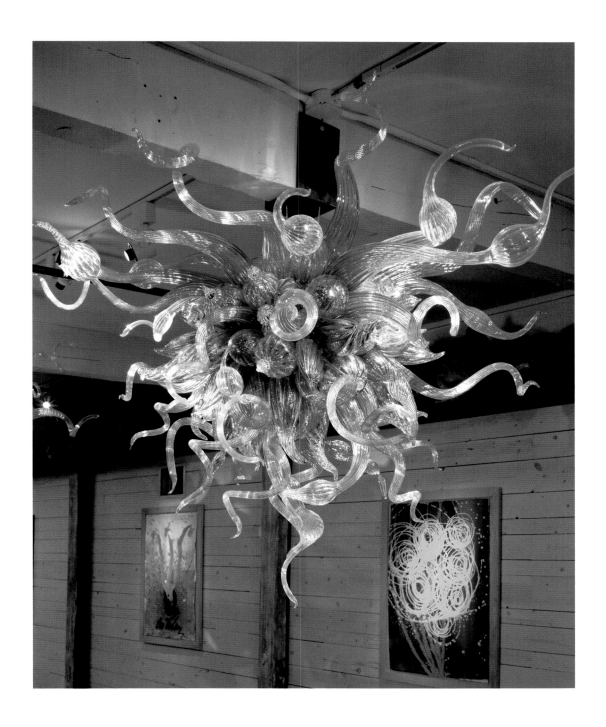

AMBER AND OXBLOOD CHANDELIER
EVELYN ROOM, THE BOATHOUSE, SEATTLE
5 x 4½ x 4'

EMERALD CHANDELIER (DETAIL OPPOSITE), 2011
4 x 5 x 5'

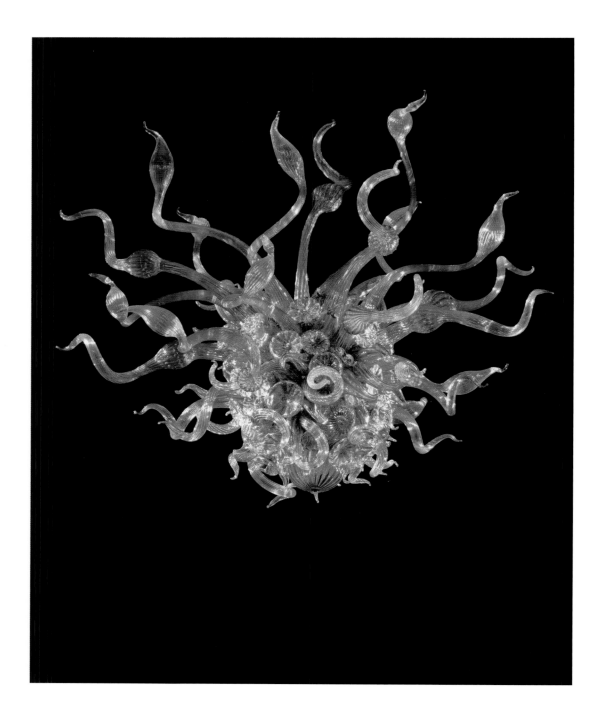

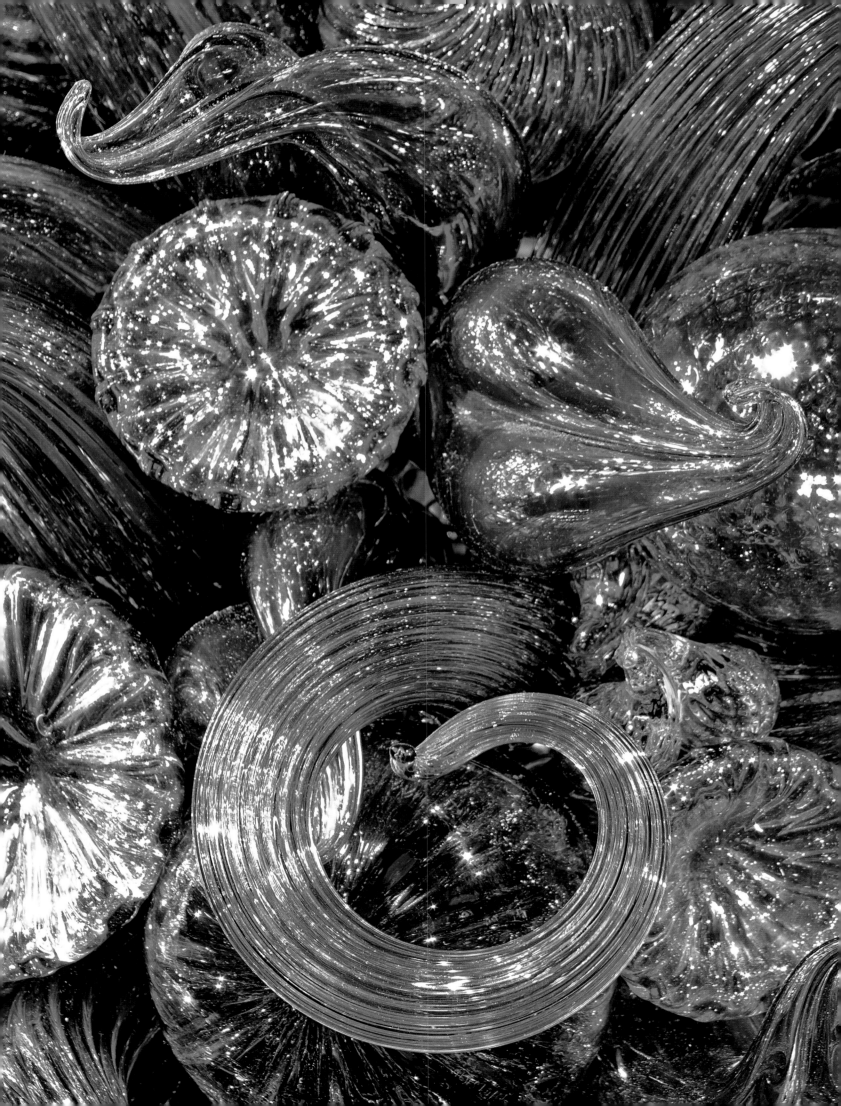

GARDENS

I love to work outside. I love to do
exhibitions that have courtyards or
gardens of glass. You can see it
throughout my work, even from
the very beginning.

CHIHULY

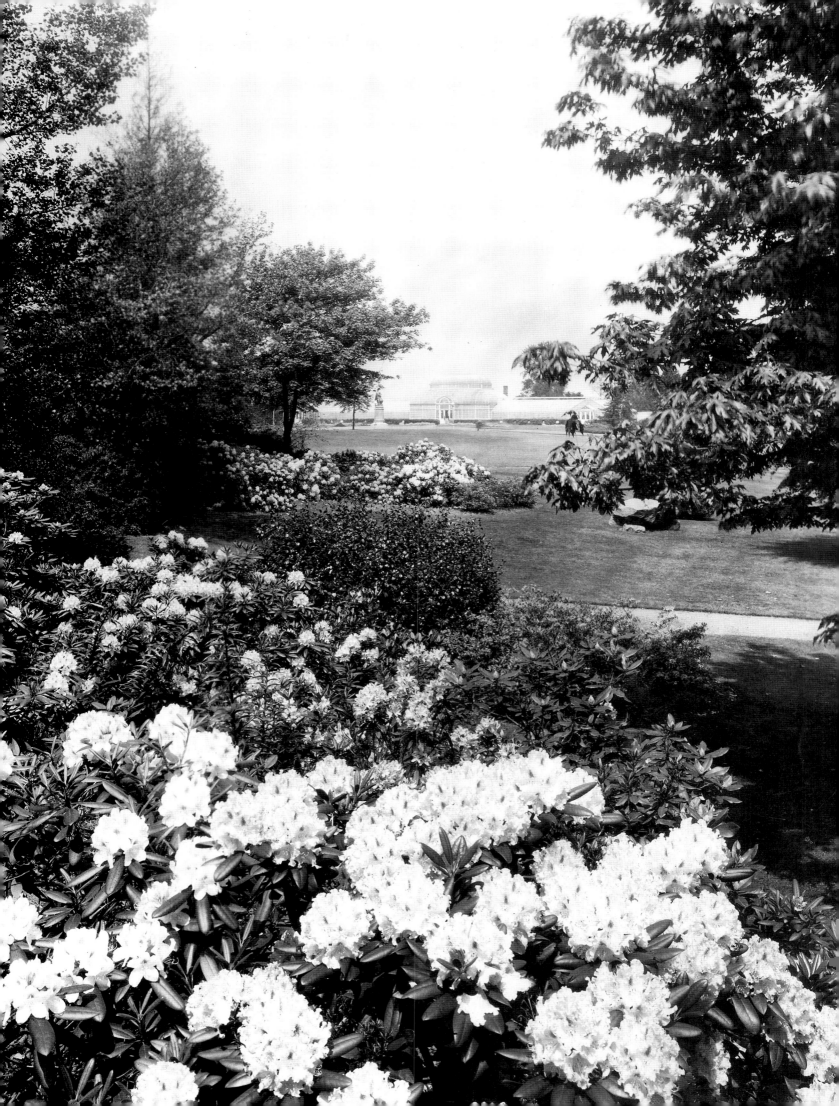

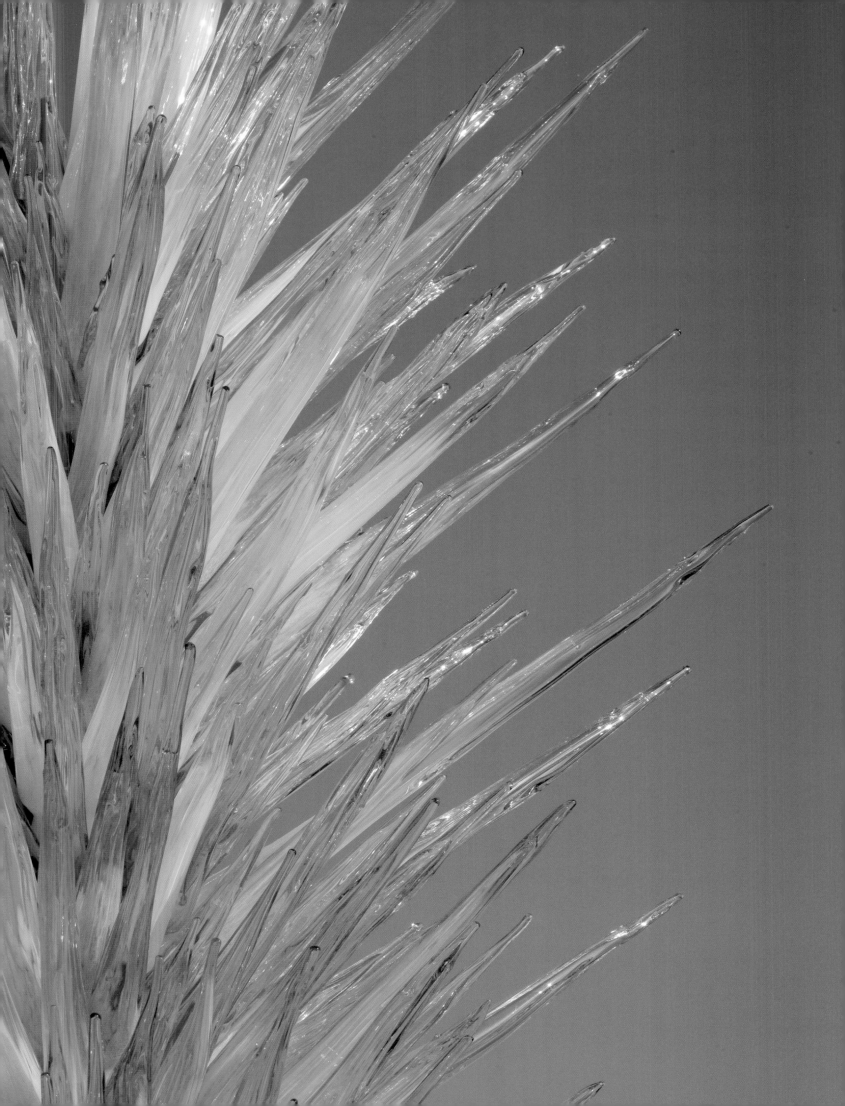

LIME GREEN ICICLE TOWER
MUSEUM OF FINE ARTS, BOSTON, 2011
41½ x 7½ x 7½'

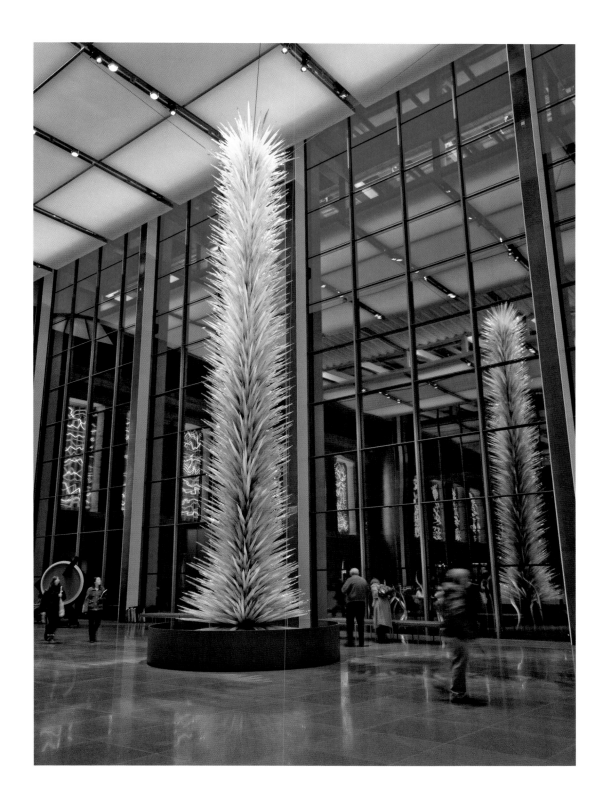

DESERT TOWER (DETAIL)
DESERT BOTANICAL GARDEN, PHOENIX, 2008

AMBER CATTAILS
CHEEKWOOD BOTANICAL GARDEN AND MUSEUM OF ART
NASHVILLE, 2010

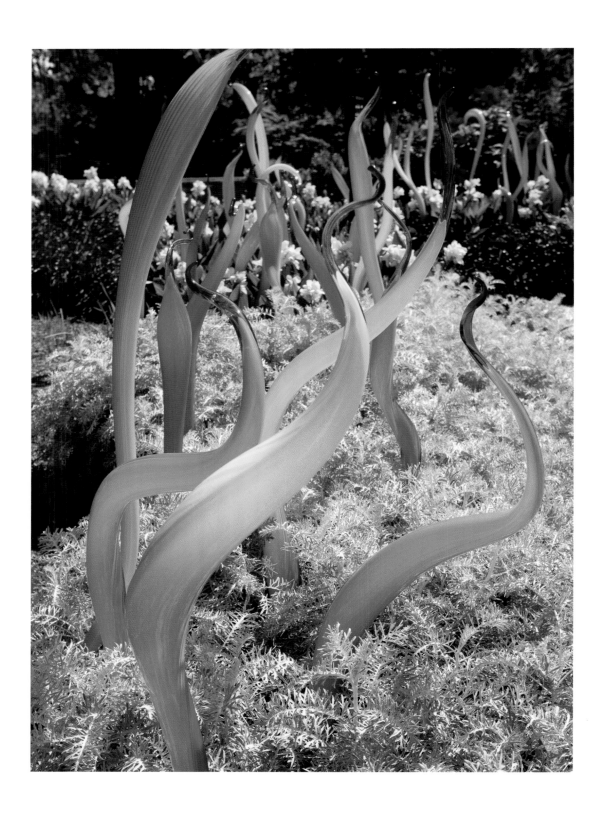

BLUE HERONS
ROYAL BOTANIC GARDENS
KEW, ENGLAND, 2005

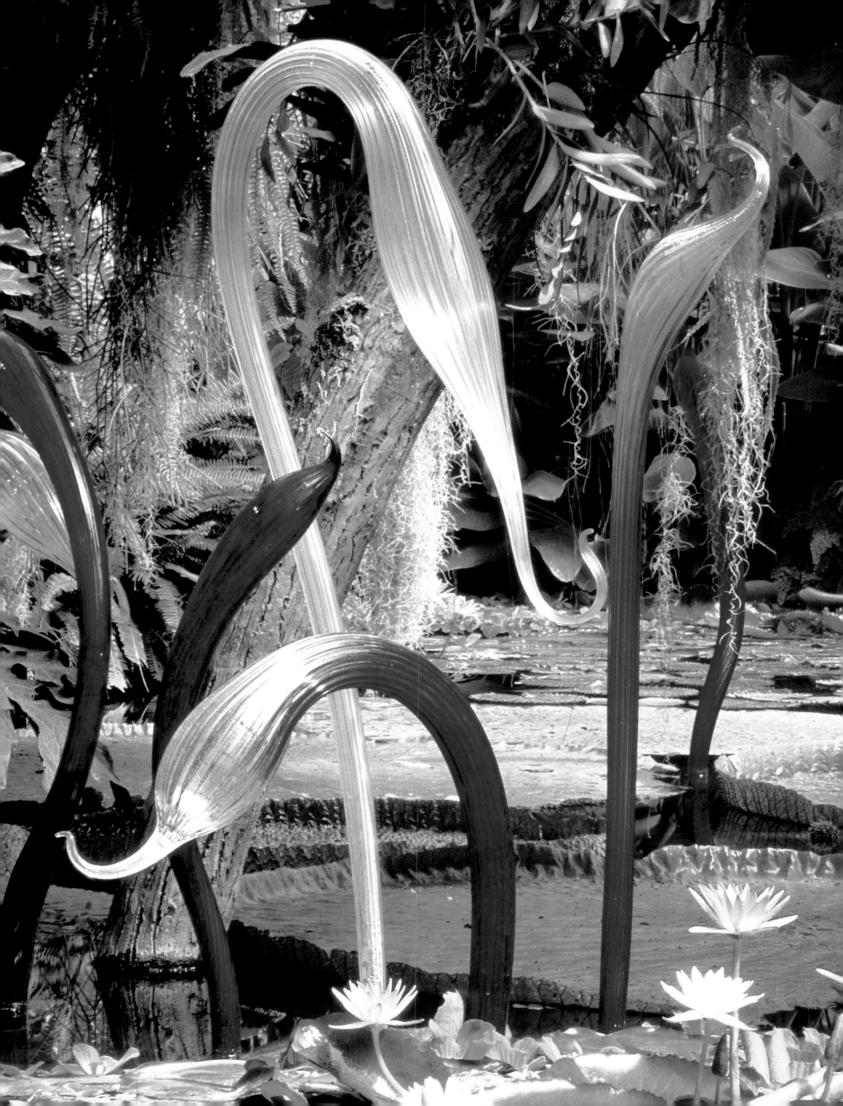

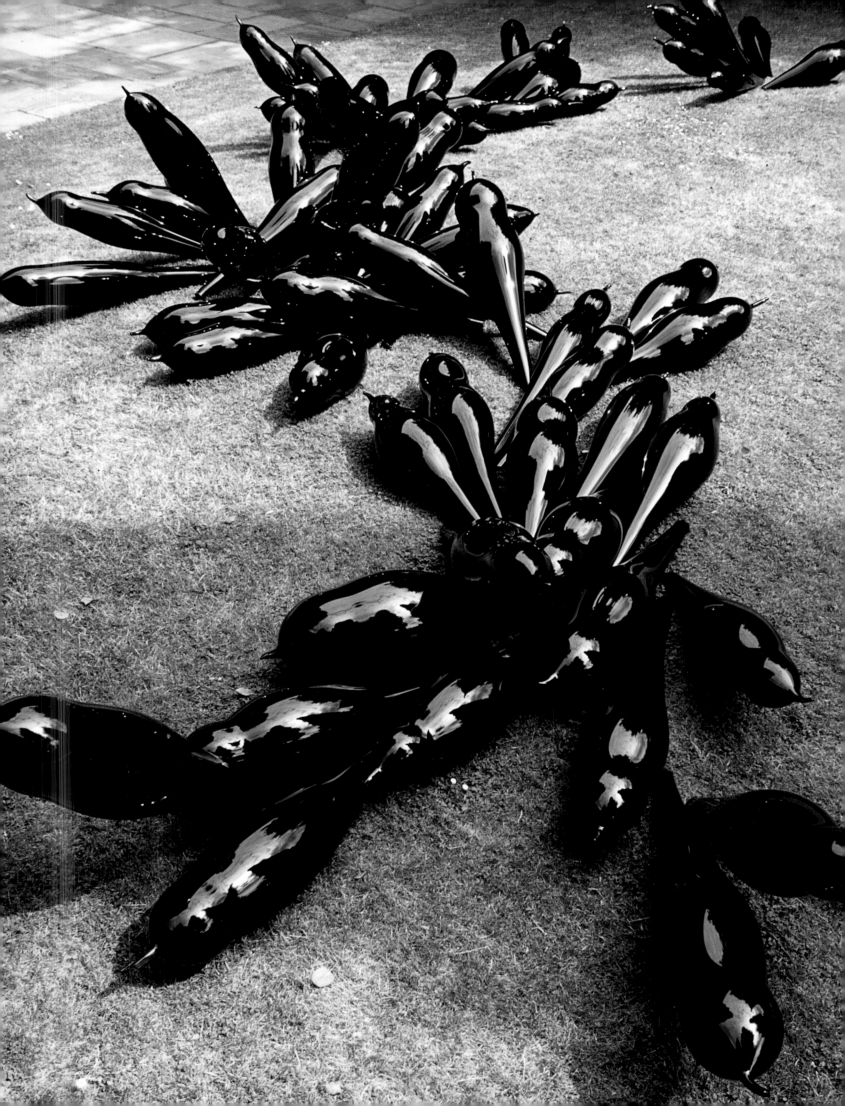

BLACK SEAL PUPS
VICTORIA AND ALBERT MUSEUM, LONDON, 2001

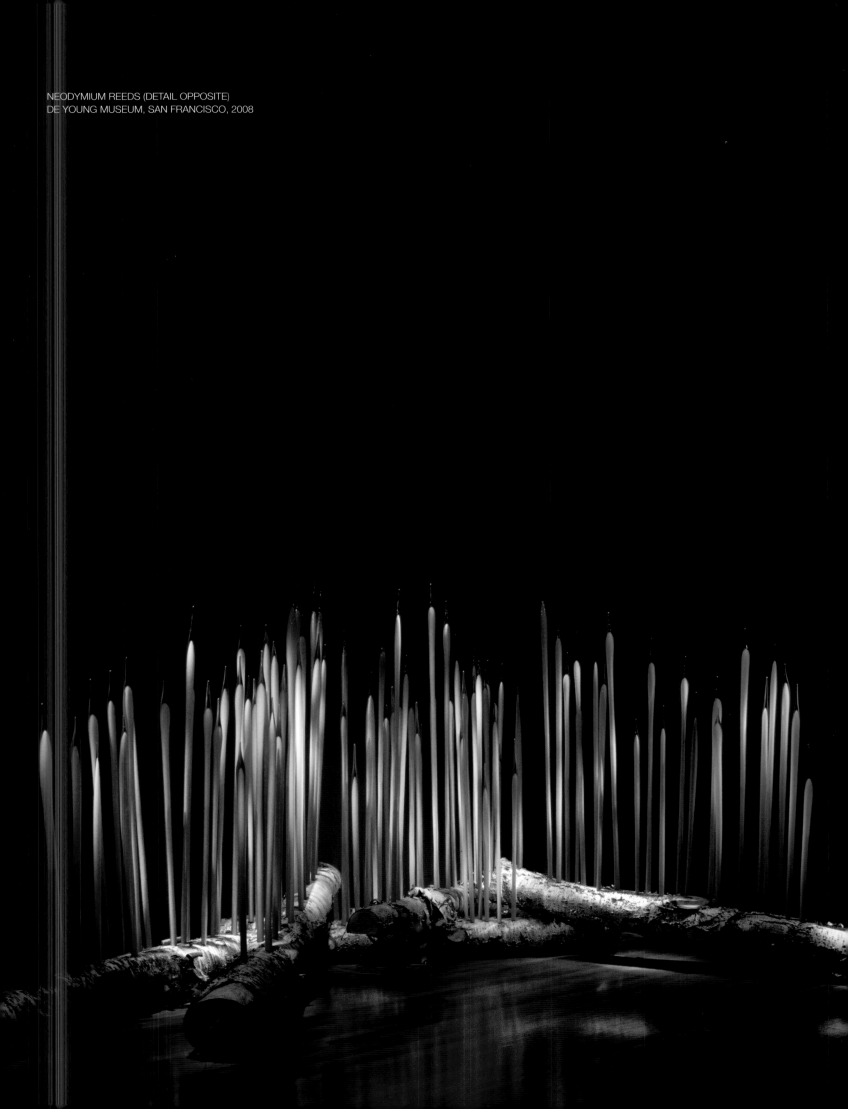

NEODYMIUM REEDS (DETAIL OPPOSITE)
DE YOUNG MUSEUM, SAN FRANCISCO, 2008

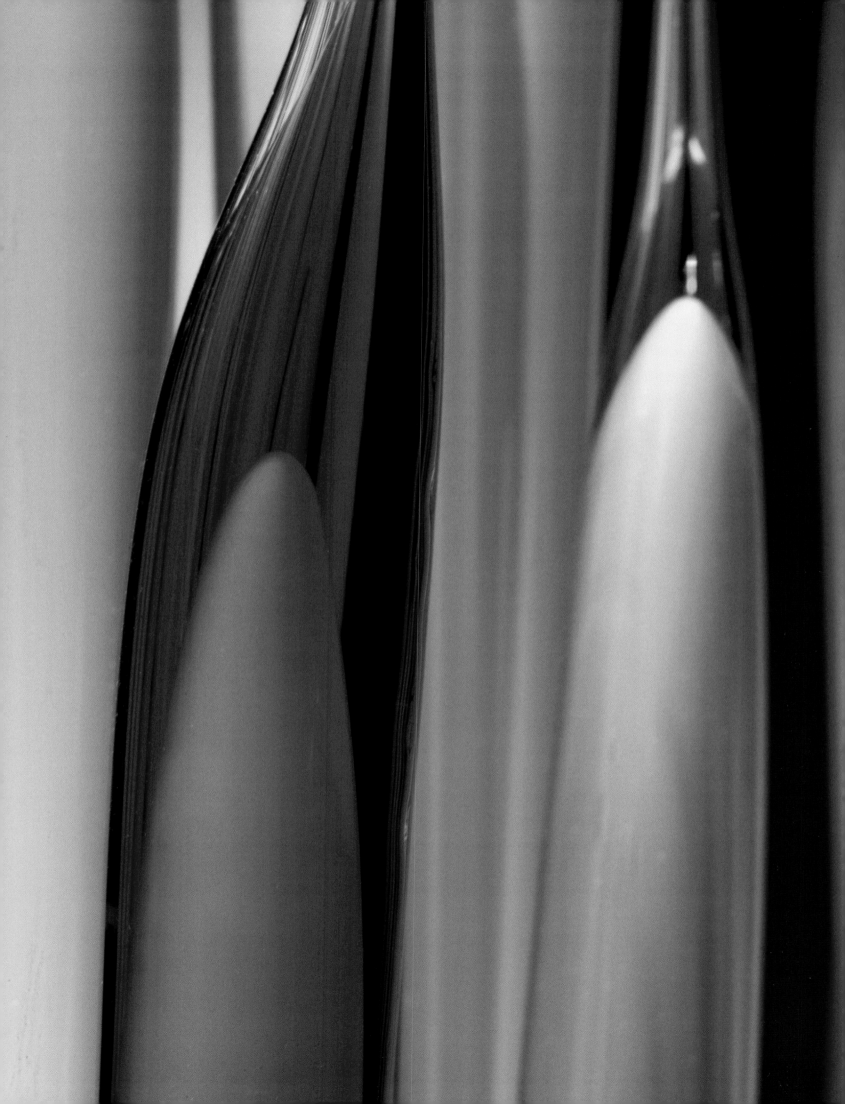

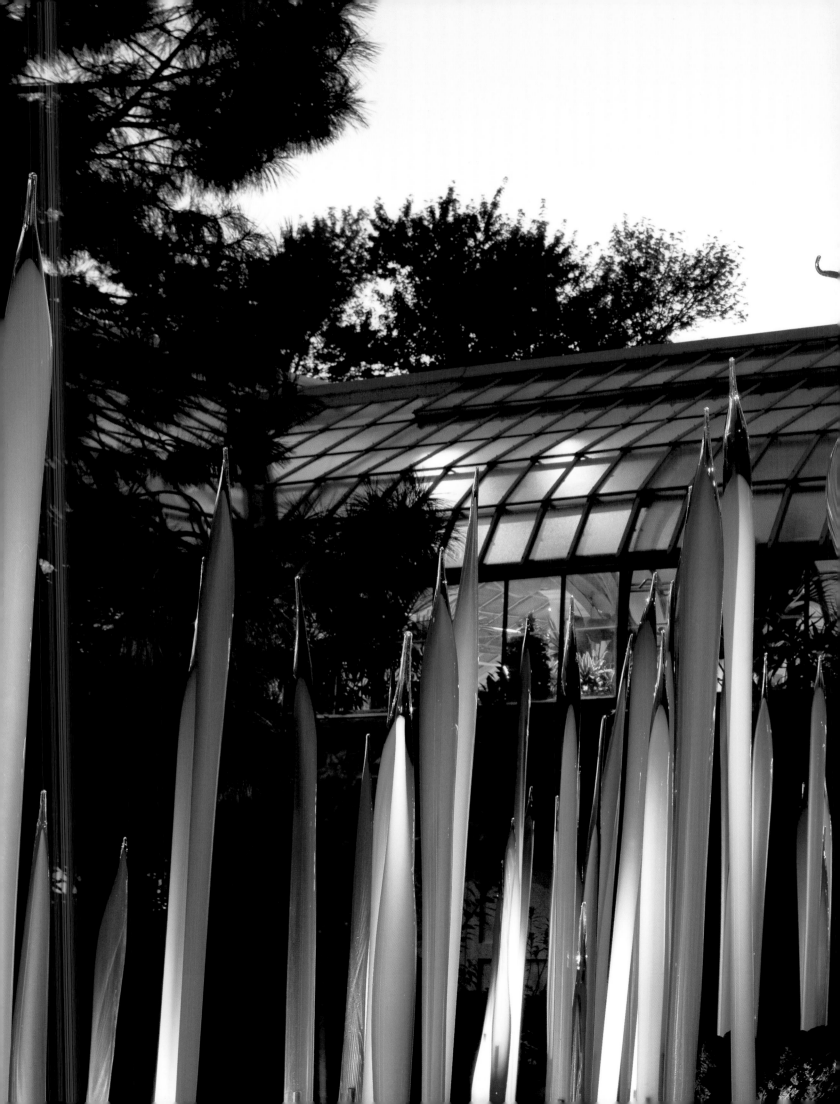

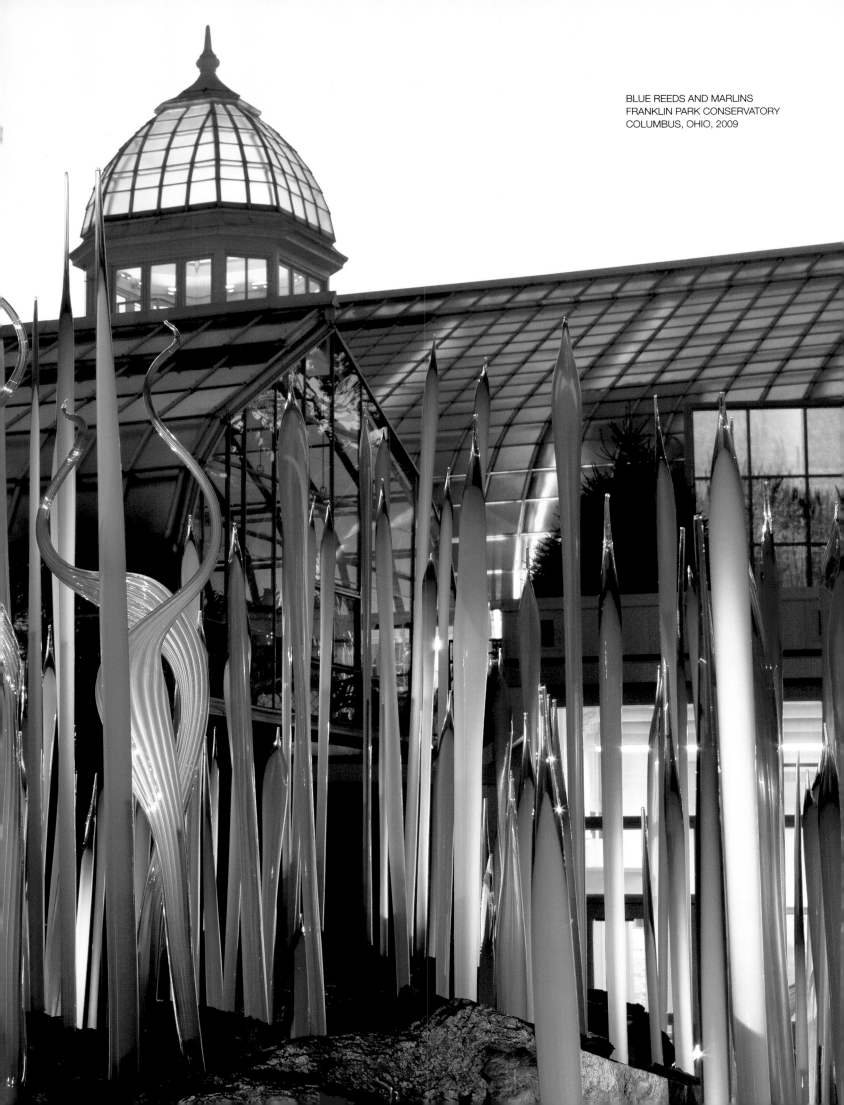

BLUE REEDS AND MARLINS
FRANKLIN PARK CONSERVATORY
COLUMBUS, OHIO, 2009

NIIJIMA FLOATS (DETAIL)
FAIRCHILD TROPICAL BOTANIC GARDE
CORAL GABLES, FLORIDA, 2005

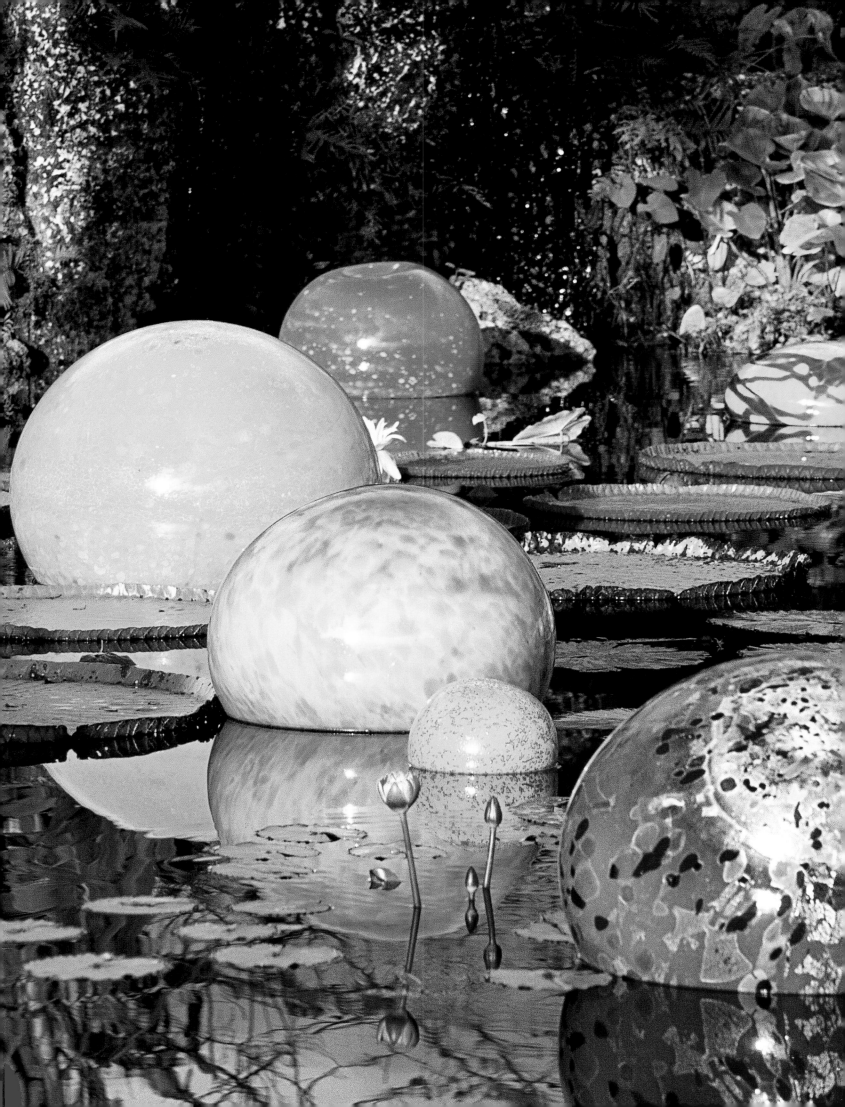

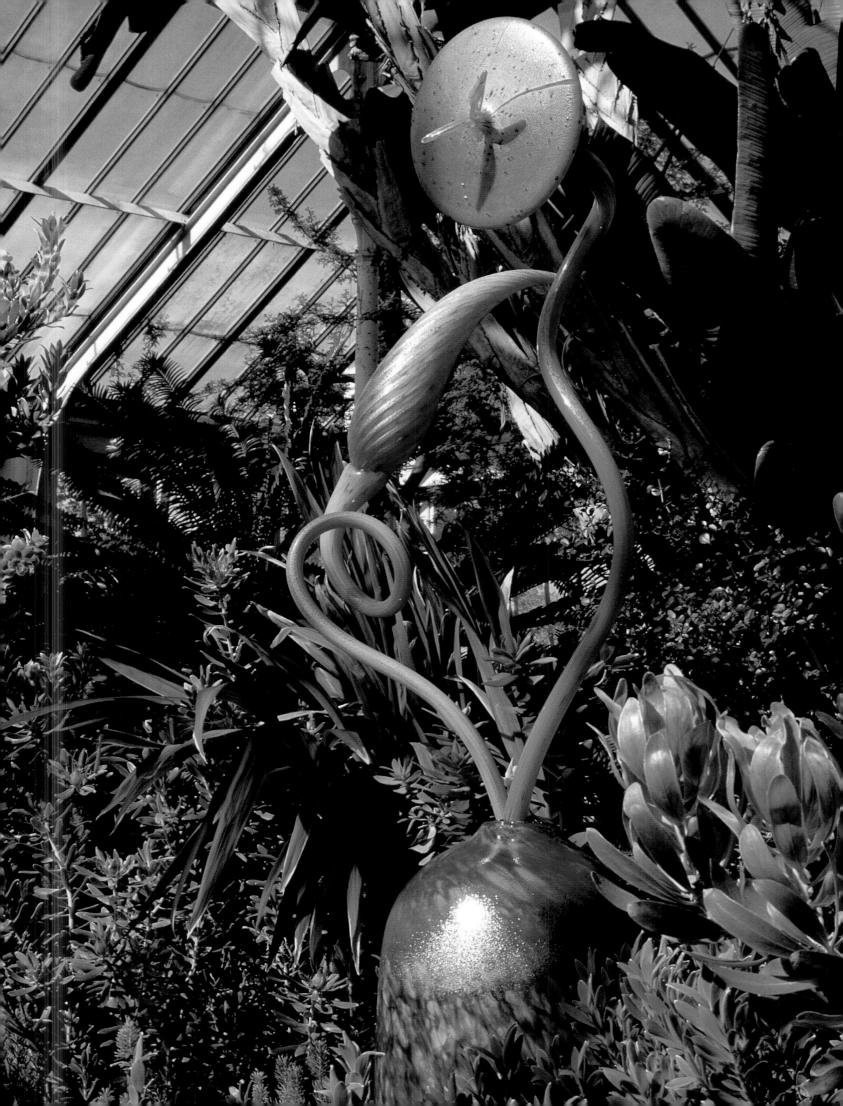

GREEN GRASS
TOWER OF DAVID MUSEUM OF THE HISTORY OF JERUSALEM
JERUSALEM, 1999

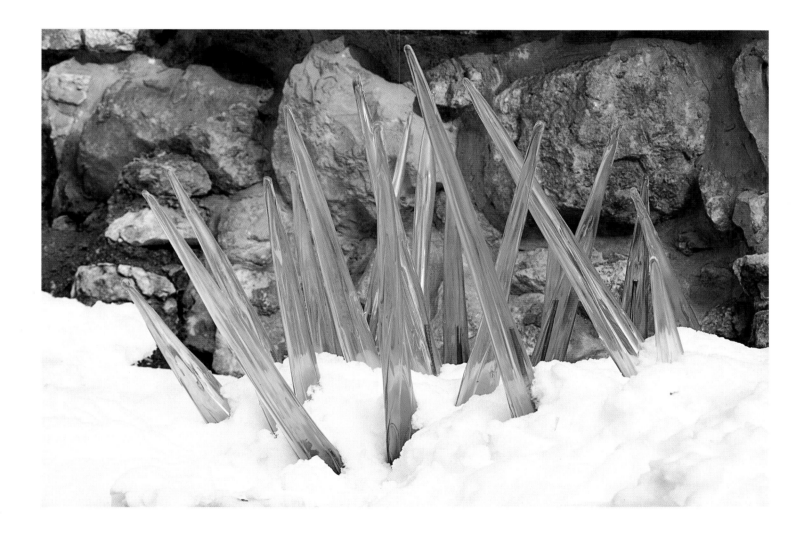

MOTTLED BRONZE IKEBANA WITH
APRICOT AND CHARTREUSE STEMS
ROYAL BOTANIC GARDENS, KEW, ENGLAND, 2005
68 x 28 x 14"

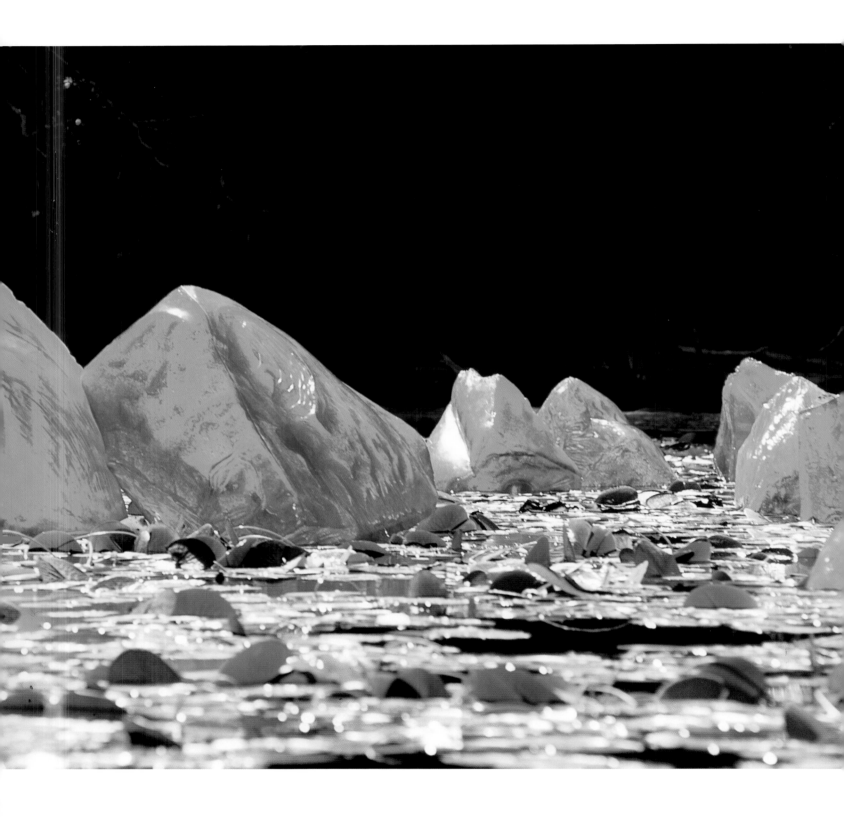

PINK CRYSTAL TOWER
FAIRCHILD TROPICAL BOTANIC GARDEN
CORAL GABLES, FLORIDA, 2005
9 x 5 x 5½'

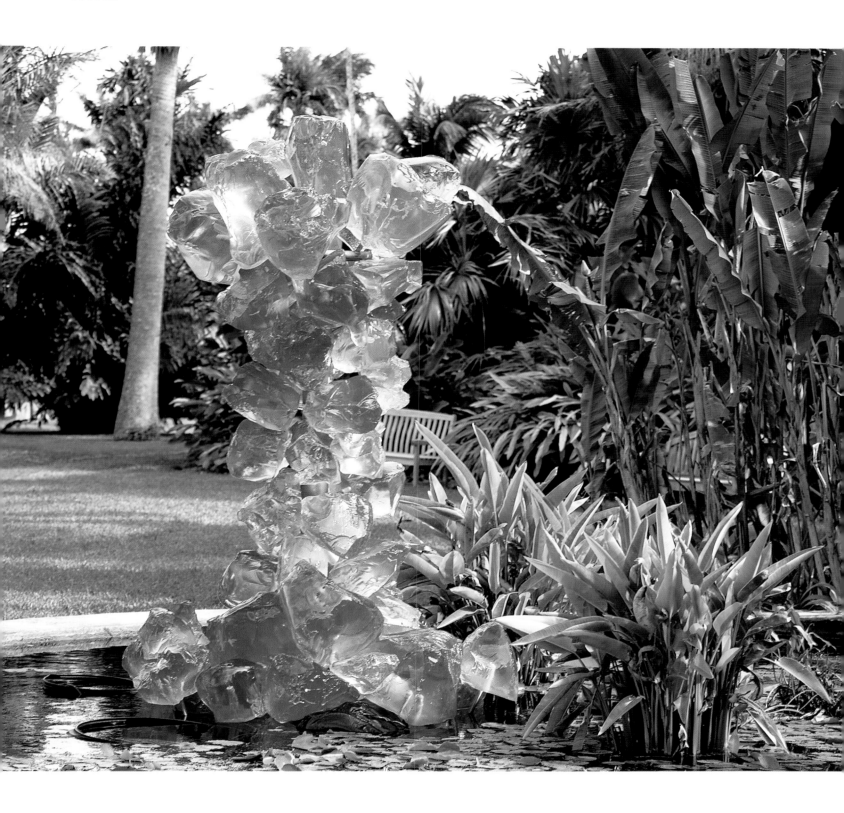

THE SUN (DETAIL AT BOTTOM)
SALK INSTITUTE FOR BIOLOGICAL STUDIES
LA JOLLA, CALIFORNIA, 2010
14 x 14 x 14'

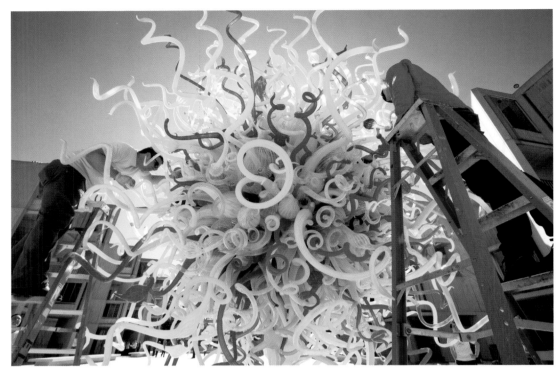

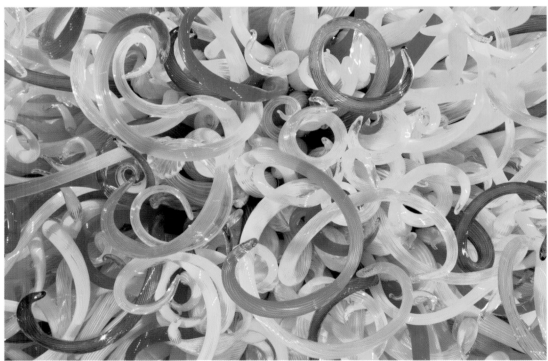

THE SUN
NEW YORK BOTANICAL GARDEN
THE BRONX, NEW YORK, 2006
14½ x 13½ x 13½'

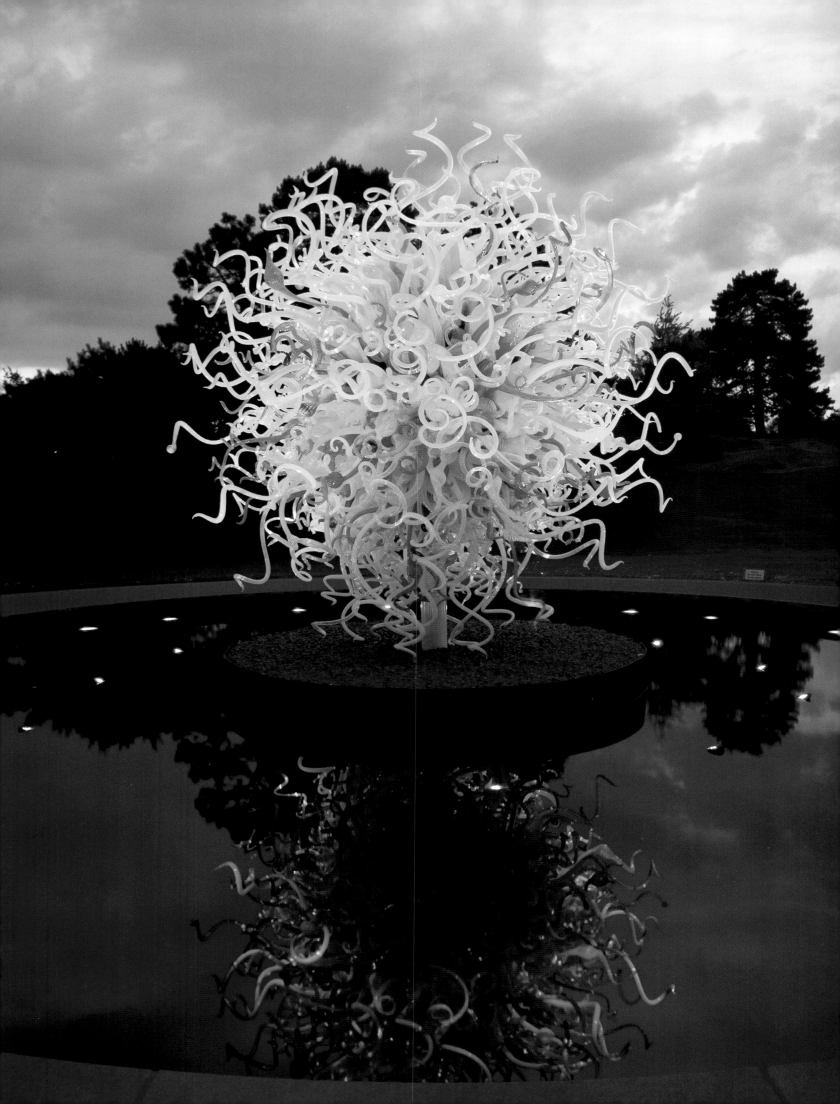

RED SPEARS
VIANNE, FRANCE, 1997

Akita Senshu Museum of Art, Akita, Japan
Akron Art Museum, Akron, Ohio
Albany Museum of Art, Albany, Georgia
Albright-Knox Art Gallery, Buffalo, New York
Allied Arts Association, Richland, Washington
Arizona State University Art Museum, Tempe, Arizona
Arkansas Arts Center, Little Rock, Arkansas
Art Gallery of Greater Victoria, Victoria,
 British Columbia, Canada
Art Gallery of Western Australia, Perth, Australia
Art Museum of Missoula, Missoula, Montana
Art Museum of South Texas, Corpus Christi, Texas
Art Museum of Southeast Texas, Beaumont, Texas
Arts Centre, Martinsburg, West Virginia
Asheville Art Museum, Asheville, North Carolina
Auckland Museum, Auckland, New Zealand
Austin Museum of Art, Austin, Texas
Azabu Museum of Arts and Crafts, Tokyo, Japan

Ball State University Museum of Art, Muncie, Indiana
Beach Museum of Art, Kansas State University,
 Manhattan, Kansas
Berkeley Art Museum, University of California,
 Berkeley, California
Birmingham Museum of Art, Birmingham, Alabama
Boca Raton Museum of Art, Boca Raton, Florida
Brauer Museum of Art, Valparaiso University,
 Valparaiso, Indiana
Brooklyn Museum, Brooklyn, New York

Cafesjian Center for the Arts, Yerevan, Armenia
Canadian Clay & Glass Gallery, Waterloo,
 Ontario, Canada
Canadian Craft Museum, Vancouver,
 British Columbia, Canada
Carnegie Museum of Art, Pittsburgh, Pennsylvania
Center for the Arts, Vero Beach, Florida
Charles H. MacNider Art Museum, Mason City, Iowa
Children's Museum of Indianapolis, Indianapolis, Indiana
Chrysler Museum of Art, Norfolk, Virginia
Cincinnati Art Museum, Cincinnati, Ohio
Cleveland Museum of Art, Cleveland, Ohio
Clinton Library and Archives, Little Rock, Arkansas
Colorado Springs Fine Arts Center,
 Colorado Springs, Colorado
Columbia Museum of Art, Columbia, South Carolina
Columbus Museum, Columbus, Georgia
Columbus Museum of Art, Columbus, Ohio
Contemporary Art Center of Virginia, Virginia Beach, Virginia
Contemporary Arts Center, Cincinnati, Ohio
Contemporary Crafts Association and Gallery,
 Portland, Oregon
Contemporary Museum, Honolulu, Hawaii
Cooper-Hewitt, National Design Museum,
 Smithsonian Institution, New York, New York

Corcoran Gallery of Art, Washington, D.C.
Corning Museum of Glass, Corning, New York
Crocker Art Museum, Sacramento, California
Currier Gallery of Art, Manchester, New Hampshire

Daiichi Museum, Nagoya, Japan
Dallas Museum of Art, Dallas, Texas
Danske Kunstindustrimuseum, Copenhagen, Denmark
Daum Museum of Contemporary Art, Sedalia, Missouri
David Winton Bell Gallery, Brown University,
 Providence, Rhode Island
Dayton Art Institute, Dayton, Ohio
de Young Museum, San Francisco, California
DeCordova Museum and Sculpture Park,
 Lincoln, Massachusetts
Delaware Art Museum, Wilmington, Delaware
Denver Art Museum, Denver, Colorado
Design museum Gent, Gent, Belgium
Detroit Institute of Arts, Detroit, Michigan
Dowse Art Museum, Lower Hutt, New Zealand

Eretz Israel Museum, Tel Aviv, Israel
Everson Museum of Art, Syracuse, New York
Experience Music Project, Seattle, Washington

Fine Arts Institute, Edmond, Oklahoma
Flint Institute of Arts, Flint, Michigan
Fonds Régional d'Art Contemporain de Haute-Normandie,
 Sotteville-lès-Rouen, France
Frederik Meijer Gardens & Sculpture Park,
 Grand Rapids, Michigan

Galéria mesta Bratislavy, Bratislava, Slovakia
Glasmuseet Ebeltoft, Ebeltoft, Denmark
Glasmuseum, Frauenau, Germany
Glasmuseum alter Hof Herding, Glascollection,
 Ernsting, Germany
Glasmuseum Wertheim, Wertheim, Germany

Haggerty Museum of Art, Marquette University,
 Milwaukee, Wisconsin
Hakone Glass Forest, Ukai Museum, Hakone, Japan
Hawke's Bay Exhibition Centre, Hastings, New Zealand
Henry Art Gallery, Seattle, Washington
High Museum of Art, Atlanta, Georgia
Hilo Art Museum, Hilo, Hawaii
Hiroshima City Museum of Contemporary Art,
 Hiroshima, Japan
Hokkaido Museum of Modern Art, Hokkaido, Japan
Honolulu Academy of Arts, Honolulu, Hawaii
Hunter Museum of American Art, Chattanooga, Tennessee
Huntington Museum of Art, Huntington, West Virginia

Indianapolis Museum of Art, Indianapolis, Indiana
Israel Museum, Jerusalem, Israel

Japan Institute of Arts and Crafts, Tokyo, Japan
Jesse Besser Museum, Alpena, Michigan
Jesuit Dallas Museum, Dallas, Texas
Joslyn Art Museum, Omaha, Nebraska
Jule Collins Smith Museum of Fine Art, Auburn University,
 Auburn, Alabama
Jundt Art Museum, Gonzaga University, Spokane, Washington

Kalamazoo Institute of Arts, Kalamazoo, Michigan
Kaohsiung Museum of Fine Arts, Kaohsiung, Taiwan
Kemper Museum of Contemporary Art, Kansas City, Missouri
Kestner-Gesellschaft, Hannover, Germany
Kobe City Museum, Kobe, Japan
Krannert Art Museum, University of Illinois, Champaign, Illinois
Krasl Art Center, St. Joseph, Michigan
Kunstmuseum Düsseldorf, Düsseldorf, Germany
Kunstsammlungen der Veste Coburg, Coburg, Germany
Kurita Museum, Tochigi, Japan

Leepa-Rattner Museum of Art, St. Petersburg College,
 Tarpon Springs, Florida
Leigh Yawkey Woodson Art Museum, Wausau, Wisconsin
Lobmeyr Museum, Vienna, Austria
LongHouse Reserve, East Hampton, New York
Los Angeles County Museum of Art, Los Angeles, California
Lowe Art Museum, University of Miami, Coral Gables, Florida
Lyman Allyn Art Museum, New London, Connecticut

Manawatu Museum, Palmerston North, New Zealand
Matsushita Art Museum, Kagoshima, Japan
Meguro Museum of Art, Tokyo, Japan
Memorial Art Gallery, University of Rochester,
 Rochester, New York
Metropolitan Museum of Art, New York, New York
Milwaukee Art Museum, Milwaukee, Wisconsin
Mingei International Museum, San Diego, California
Minneapolis Institute of Arts, Minneapolis, Minnesota
Mint Museum of Craft + Design, Charlotte, North Carolina
Mobile Museum of Art, Mobile, Alabama
Montreal Museum of Fine Arts, Montreal, Quebec, Canada
Morean Arts Center, St. Petersburg, Florida
Morris Museum, Morristown, New Jersey
Musée d'Art Moderne et d'Art Contemporain, Nice, France
Musée de Design et d'Arts Appliqués Contemporains,
 Lausanne, Switzerland
Musée des Arts Décoratifs, Palais du Louvre, Paris, France
Musée des Beaux-Arts et de la Céramique, Rouen, France
Museo del Vidrio, Monterrey, Mexico
Museo Vetrario, Murano, Italy
Museum Bellerive, Zurich, Switzerland
Museum Boijmans Van Beuningen, Rotterdam, Netherlands
Museum für Kunst und Gewerbe Hamburg,
 Hamburg, Germany
Museum für Kunsthandwerk, Frankfurt am Main, Germany

Museum of American Glass at Wheaton Village,
 Millville, New Jersey
Museum of Art, Washington State University,
 Pullman, Washington
Museum of Art and Archaeology, Columbia, Missouri
Museum of Art Fort Lauderdale, Fort Lauderdale, Florida
Museum of Arts & Design, New York, New York
Museum of Arts and Sciences, Daytona Beach, Florida
Museum of Contemporary Art, Chicago, Illinois
Museum of Contemporary Art San Diego, La Jolla, California
Museum of Contemporary Arts and Design,
 New York, New York
Museum of Fine Arts, Boston, Massachusetts
Museum of Fine Arts, Houston, Houston, Texas
Museum of Fine Arts, St. Petersburg, Florida
Museum of Northwest Art, La Conner, Washington
Museum of Outdoor Arts, Englewood, Colorado
Muskegon Museum of Art, Muskegon, Michigan
Muzeum města Brna, Brno, Czech Republic
Muzeum skla a bižuterie, Jablonec nad Nisou, Czech Republic
Múzeum židovskej kultúry, Bratislava, Slovakia

Naples Museum of Art, Naples, Florida
National Gallery of Australia, Canberra, Australia
National Gallery of Victoria, Melbourne, Australia
National Liberty Museum, Philadelphia, Pennsylvania
National Museum Kyoto, Kyoto, Japan
National Museum of American History, Smithsonian Institution,
 Washington, D.C.
National Museum of Modern Art Kyoto, Kyoto, Japan
National Museum of Modern Art Tokyo, Tokyo, Japan
Nationalmuseum, Stockholm, Sweden
New Britain Museum of American Art,
 New Britain, Connecticut
New Orleans Museum of Art, New Orleans, Louisiana
Newark Museum, Newark, New Jersey
Niijima Contemporary Art Museum, Niijima, Japan
North Central Washington Museum, Wenatchee, Washington
Norton Museum of Art, West Palm Beach, Florida
Notojima Glass Art Museum, Ishikawa, Japan

O Art Museum, Tokyo, Japan
Oklahoma City Museum of Art, Oklahoma City, Oklahoma
Orange County Museum of Art, Newport Beach, California
Otago Museum, Dunedin, New Zealand

Palm Beach Community College Museum of Art,
 Lake Worth, Florida
Palm Springs Art Museum, Palm Springs, California
Palmer Museum of Art, Pennsylvania State University,
 University Park, Pennsylvania
Philadelphia Museum of Art, Philadelphia, Pennsylvania
Phoenix Art Museum, Phoenix, Arizona
Plains Art Museum, Fargo, North Dakota

Polk Museum of Art, Lakeland, Florida
Portland Art Museum, Portland, Oregon
Portland Museum of Art, Portland, Maine
Powerhouse Museum, Sydney, Australia
Princeton University Art Museum, Princeton, New Jersey

Queensland Art Gallery, South Brisbane, Australia

Racine Art Museum, Racine, Wisconsin
Reading Public Museum, Reading, Pennsylvania
Rhode Island School of Design Museum,
 Providence, Rhode Island
Ringling College of Art and Design, Sarasota, Florida
Royal Ontario Museum, Toronto, Ontario, Canada

Saint Louis Art Museum, St. Louis, Missouri
Saint Louis University Museum of Art, St. Louis, Missouri
Samuel P. Harn Museum of Art, University of Florida,
 Gainesville, Florida
San Antonio Museum of Art, San Antonio, Texas
San Jose Museum of Art, San Jose, California
Scottsdale Center for the Arts, Scottsdale, Arizona
Seattle Art Museum, Seattle, Washington
Shimonoseki City Art Museum, Shimonoseki, Japan
Singapore Art Museum, Singapore
Slovenská národná galéria, Bratislava, Slovakia
Smith College Museum of Art, Northampton, Massachusetts
Smithsonian American Art Museum, Washington, D.C.
Sogetsu Art Museum, Tokyo, Japan
Speed Art Museum, Louisville, Kentucky
Spencer Museum of Art, University of Kansas,
 Lawrence, Kansas
Springfield Museum of Fine Arts, Springfield, Massachusetts
Štátna galéria Banská Bystrica, Banská Bystrica, Slovakia
Suntory Museum of Art, Tokyo, Japan
Suomen Lasimuseo, Riihimäki, Finland
Suwa Garasu no Sato Museum, Nagano, Japan

Tacoma Art Museum, Tacoma, Washington
Taipei Fine Arts Museum, Taipei, Taiwan
Tochigi Prefectural Museum of Fine Arts, Tochigi, Japan
Toledo Museum of Art, Toledo, Ohio
Tower of David Museum of the History of Jerusalem,
 Jerusalem, Israel

Uměleckoprůmyslové muzeum, Prague, Czech Republic
University Art Museum, University of California,
 Santa Barbara, California
Utah Museum of Fine Arts, University of Utah,
 Salt Lake City, Utah

Victoria and Albert Museum, London, England

Wadsworth Atheneum, Hartford, Connecticut
Waikato Museum of Art and History, Hamilton, New Zealand
Walker Hill Art Center, Seoul, South Korea
Westmoreland Museum of American Art,
 Greensburg, Pennsylvania
Whatcom Museum of History and Art,
 Bellingham, Washington
White House Collection of American Crafts, Washington, D.C.
Whitney Museum of American Art, New York, New York
Wichita Art Museum, Wichita, Kansas
World of Glass, St. Helens, England
Württembergisches Landesmuseum Stuttgart,
 Stuttgart, Germany

Yale University Art Gallery, New Haven, Connecticut
Yokohama Museum of Art, Yokohama, Japan

1941 Born September 20 in Tacoma, Washington, to George Chihuly and Viola Magnuson Chihuly.

1957 Older brother and only sibling, George, dies in Naval Air Force training accident in Pensacola, Florida.

1958 His father suffers a fatal heart attack at age 51, and his mother has to go to work.

1959 Graduates from high school in Tacoma. Enrolls at College of Puget Sound (now University of Puget Sound) in his hometown. Transfers to University of Washington in Seattle to study interior design and architecture.

1961 Joins Delta Kappa Epsilon fraternity and becomes rush chairman. Learns to melt and fuse glass.

1962 Disillusioned with his studies, he leaves school and travels to Florence to study art. Unable to speak Italian, he moves on to the Middle East.

1963 Works on a kibbutz in Negev Desert. Returns to University of Washington and studies under Hope Foote and Warren Hill. In a weaving class with Doris Brockway, he incorporates glass shards into woven tapestries.

1964 Returns to Europe, visits Leningrad, and makes the first of many trips to Ireland.

1965 Receives B.A. in Interior Design from University of Washington. In his basement studio, Chihuly blows his first glass bubble by melting stained glass and using a metal pipe.

1966 Works as a commercial fisherman in Alaska. Enters University of Wisconsin at Madison and studies glassblowing under Harvey Littleton.

1967 Receives M.S. in Sculpture from University of Wisconsin. Enrolls at Rhode Island School of Design (RISD) in Providence, where he begins exploration of environmental works using neon, argon, and blown glass. Awarded a Louis Comfort Tiffany Foundation Grant for work in glass. Italo Scanga, then teaching in Pennsylvania State University's Art Department, lectures at RISD, and the two begin a lifelong friendship.

1968 Receives M.F.A. in Ceramics from RISD. Awarded a Fulbright Fellowship, enabling him to travel and work in Europe. Becomes the first American glassblower to work in the Venini factory on the island of Murano. Back in the United States, spends four consecutive summers teaching at Haystack Mountain School of Crafts in Deer Isle, Maine.

1969 Returns to Europe and meets glass masters Erwin Eisch in Germany and Jaroslava Brychtová and Stanislav Libenský in Czechoslovakia. Establishes the glass program at RISD, where he teaches for the next eleven years.

1970 Meets James Carpenter, a student in RISD Illustration Department, and they begin a four-year collaboration.

1971 On the site of a tree farm owned by Seattle art patrons Anne Gould Hauberg and John Hauberg, the Pilchuck Glass School experiment is started. Chihuly's first environmental installation at Pilchuck is created that summer. He resumes teaching at RISD and creates *20,000 Pounds of Ice and Neon*, *Glass Forest #1*, and *Glass Forest #2* with James Carpenter, installations that prefigure later environmental works by Chihuly.

1972 Collaborates with Carpenter on more large-scale architectural projects. They create *Rondel Door* and *Cast Glass Door* at Pilchuck and *Dry Ice, Bent Glass and Neon*, a conceptual breakthrough, in Providence.

1974 Supported by a National Endowment for the Arts grant at Pilchuck, James Carpenter, a group of students, and he develop a technique to pick up glass thread drawings. In December at RISD, he completes his last collaborative project with Carpenter, *Corning Wall*.

1975 At RISD, begins *Navajo Blanket Cylinder* series. Kate Elliott and, later, Flora C. Mace fabricate the complex thread drawings. He receives the first of two National Endowment for the Arts Individual Artist grants. Artist-in-residence with Seaver Leslie at Artpark, on the Niagara Gorge, in New York State. Begins *Irish Cylinders* and *Ulysses Cylinders* with Leslie and Mace.

1976 An automobile accident in England leaves him, after weeks in the hospital and 256 stitches in his face, without sight in his left eye and with permanent damage to his right ankle and foot. After recuperating, he returns to Providence to serve as head of the Department of Sculpture and the Program in Glass at RISD. Henry Geldzahler, curator of contemporary art at the Metropolitan Museum of Art in New York, acquires three *Navajo Blanket Cylinders* for the museum's collection—a turning point in Chihuly's career. A friendship between artist and curator commences.

1977 Inspired by Northwest Coast Indian baskets he sees at Washington State Historical Society in Tacoma, begins the *Basket* series at Pilchuck, with Benjamin Moore as gaffer. Continues teaching in both Rhode Island and the Pacific Northwest.

1978 Meets Pilchuck student William Morris, and the two begin a close, eight-year working relationship. A solo show curated by Michael W. Monroe at the Renwick Gallery, Smithsonian Institution, in Washington, D.C., is another career milestone.

1979 Dislocates his shoulder in a bodysurfing accident and relinquishes the gaffer position for good. William Morris becomes his chief gaffer for several years. Chihuly begins to make drawings as a way to communicate his designs.

1980 Resigns his teaching position at RISD but returns periodically in the 1980s as artist-in-residence. Begins *Seaform* series at Pilchuck. In Providence, creates another architectural installation: windows for Shaare Emeth Synagogue in St. Louis, Missouri.

1981 Begins *Macchia* series.

1982 First major catalog is published: *Chihuly Glass*, designed by RISD colleague and friend Malcolm Grear.

1983 Returns to Pacific Northwest after sixteen years on East Coast. Further develops *Macchia* series at Pilchuck in fall and winter, with William Morris as chief gaffer.

1984 Begins work on *Soft Cylinder* series, with Flora C. Mace and Joey Kirkpatrick executing the glass drawings. Honored as RISD President's Fellow at the Whitney Museum in New York.

1985 Begins working hot glass on a larger scale and creates several site-specific installations.

1986 Begins *Persian* series with Martin Blank as gaffer, assisted by Robbie Miller. With *Dale Chihuly objets de verre* at Musée des Arts Décoratifs, Palais du Louvre, in Paris, he becomes one of only four Americans to have had a one-person exhibition at the Louvre.

1987 Establishes his first hotshop in Van de Kamp Building near Lake Union in Seattle. Donates permanent collection to Tacoma Art Museum in memory of his brother and father. Begins association with Parks Anderson. Marries playwright Sylvia Peto.

1988 Inspired by a private collection of Italian Art Deco glass, Chihuly begins *Venetian* series. Working from Chihuly's drawings, Lino Tagliapietra serves as gaffer.

1989	With Italian glass masters Lino Tagliapietra, Pino Signoretto, and a team of glassblowers at Pilchuck, begins *Putti* series. With Tagliapietra, Chihuly creates *Ikebana* series, inspired by travels to Japan and exposure to ikebana masters.
1990	Purchases historic Pocock Building on Lake Union, realizing his dream of being on the water in Seattle. Renovated and renamed The Boathouse, it serves as studio, hotshop, and archives. Returns to Japan.
1991	Begins *Niijima Float* series with Richard Royal as gaffer, creating some of the largest pieces of glass ever blown by hand. Completes architectural installations. He and Sylvia Peto divorce.
1992	Begins *Chandelier* series with a hanging sculpture at Seattle Art Museum. Designs sets for Seattle Opera production of Debussy's *Pelléas et Mélisande*.
1993	Begins *Piccolo Venetian* series with Lino Tagliapietra. Creates *100,000 Pounds of Ice and Neon*, a temporary installation in Tacoma Dome.
1994	Creates five installations for Tacoma's Union Station Federal Courthouse. Supports Hilltop Artists, a glassblowing program in Tacoma for at-risk youths, created by friend Kathy Kaperick. Within two years, the program partners with Tacoma Public School District.
1995	*Chihuly Over Venice* begins with a glassblowing session in Nuutajärvi, Finland, and subsequent blow at Waterford Crystal factory, Ireland.
1996	After a blow in Monterrey, Mexico, *Chihuly Over Venice* culminates with fourteen *Chandeliers* installed all over Venice. Creates his first permanent outdoor installation, *Icicle Creek Chandelier*.
1997	Expands series of experimental plastics he calls Polyvitro. *Chihuly* is designed by Massimo Vignelli and copublished by Harry N. Abrams, Inc., New York, and Portland Press, Seattle. An installation of Chihuly's work opens at Hakone Glass Forest, Ukai Museum, in Hakone, Japan.
1998	Participates in Sydney Arts Festival in Australia. A son, Jackson Viola Chihuly, is born February 12 to Dale Chihuly and Leslie Jackson. Creates architectural installations for Benaroya Hall, Seattle; Bellagio, Las Vegas; and Atlantis, Bahamas.
1999	Begins *Jerusalem Cylinder* series with gaffer James Mongrain in concert with Flora C. Mace and Joey Kirkpatrick. Mounts a challenging exhibition, *Chihuly in the Light of Jerusalem 2000*, at Tower of David Museum of the History of Jerusalem. Creates a sixty-foot wall outside from twenty-four massive blocks of ice shipped from Alaska.
2000	Creates *La Tour de Lumière* sculpture as part of *Contemporary American Sculpture* exhibition in Monte Carlo. More than a million visitors enter Tower of David Museum to see *Chihuly in the Light of Jerusalem 2000*, breaking world attendance record for a temporary exhibition during 1999–2000.
2001	*Chihuly at the V&A* opens at Victoria and Albert Museum, London. Groups a series of *Chandeliers* for the first time, as an installation for Mayo Clinic in Rochester, Minnesota. Presents his first major glasshouse exhibition, *Chihuly in the Park: A Garden of Glass*, at Garfield Park Conservatory, Chicago. Artist Italo Scanga dies after more than three decades as friend and mentor.
2002	Creates installations for Olympic Winter Games in Salt Lake City, Utah. Chihuly Bridge of Glass, conceived by Chihuly and designed in collaboration with Arthur Andersson of Andersson•Wise Architects, is dedicated in Tacoma.
2003	Begins *Fiori* series with gaffer Joey DeCamp for opening exhibition at Tacoma Art Museum's new building. Museum designs a permanent installation for its Chihuly collection. *Chihuly at the Conservatory* opens at Franklin Park Conservatory, Columbus, Ohio.

2004 Orlando Museum of Art and Museum of Fine Arts, St. Petersburg, Florida, become first museums to collaborate and present simultaneous major exhibitions of his work. Presents glasshouse and outdoor exhibition at Atlanta Botanical Garden.

2005 Marries Leslie Jackson. Mounts major garden exhibition at Royal Botanic Gardens, Kew, outside London. Exhibits at Fairchild Tropical Botanic Garden, Coral Gables, Florida.

2006 Mother, Viola, dies at age ninety-eight in Tacoma. Begins *Black* series with a *Cylinder* blow. Presents exhibitions at Missouri Botanical Garden, St. Louis, and New York Botanical Garden. *Chihuly in Tacoma*—hotshop sessions at Museum of Glass—reunites Chihuly and glassblowers from important periods of his career. A film, *Chihuly in the Hotshop*, documents this event.

2007 Exhibits at Phipps Conservatory and Botanical Gardens, Pittsburgh. Creates stage set for Seattle Symphony's production of Béla Bartók's opera *Bluebeard's Castle*.

2008 Presents major exhibition at de Young Museum, San Francisco. Returns to his alma mater with an exhibition at RISD Museum of Art. Exhibits at Desert Botanical Garden in Phoenix.

2009 Begins *Silvered* series. Mounts garden exhibition at Franklin Park Conservatory, Columbus, Ohio. Participates in 53rd Venice Biennale with *Mille Fiori Venezia* installation. Creates largest commission with multiple installations at island resort of Sentosa, Singapore.

2010 Exhibits outdoors at Salk Institute for Biological Studies in La Jolla, California. Presents exhibitions at Frederik Meijer Gardens & Sculpture Park in Grand Rapids, Michigan, and Cheekwood Botanical Garden, Nashville.

2011 Holds exhibitions at Museum of Fine Arts, Boston, and Tacoma Art Museum. Construction begins on buildings for *Chihuly Garden and Glass*, an exhibition within Seattle Center.

Born in 1941 in Tacoma, Washington, Dale Chihuly was introduced to glass while studying interior design at the University of Washington. After graduating in 1965, Chihuly enrolled in the first glass program in the country, at the University of Wisconsin. He continued his studies at the Rhode Island School of Design (RISD), where he later established the glass program and taught for more than a decade.

In 1968, after receiving a Fulbright Fellowship, he went to work at the Venini glass factory in Venice. There he observed the team approach to blowing glass, which is critical to the way he works today. In 1971, Chihuly cofounded Pilchuck Glass School in Washington State. With this international glass center, Chihuly has led the avant-garde in the development of glass as a fine art.

His work is included in more than 200 museum collections worldwide. He has been the recipient of many awards, including ten honorary doctorates and two fellowships from the National Endowment for the Arts.

Chihuly has created more than a dozen well-known series of works, among them, *Cylinders and Baskets* in the 1970s; *Seaforms, Macchia, Venetians,* and *Persians* in the 1980s; *Niijima Floats* and *Chandeliers* in the 1990s; and *Fiori* in the 2000s. He is also celebrated for large architectural installations. In 1986, he was honored with a solo exhibition, *Dale Chihuly objets de verre*, at the Musée des Arts Décoratifs, Palais du Louvre, in Paris. In 1995, he began *Chihuly Over Venice*, for which he created sculptures at glass factories in Finland, Ireland, and Mexico, then installed them over the canals and piazzas of Venice.

In 1999, Chihuly mounted a challenging exhibition, *Chihuly in the Light of Jerusalem*; more than 1 million visitors attended the Tower of David Museum to view his installations. In 2001, the Victoria and Albert Museum in London curated the exhibition *Chihuly at the V&A*. Chihuly's lifelong affinity for glasshouses has grown into a series of exhibitions within botanical settings. His *Garden Cycle* began in 2001 at the Garfield Park Conservatory in Chicago. Chihuly exhibited at the Royal Botanic Gardens, Kew, near London, in 2005. Other major exhibition venues include the de Young Museum in San Francisco, in 2008, and the Museum of Fine Arts, Boston, in 2011.

GARDEN AND GLASS

Special thanks
Jeffrey and Korynne Wright, Ron Sevart, Mary Bacarella, Team Chihuly

Art Direction and Design
Goretti Kao

Executive Consultants
Leslie Jackson Chihuly, Billy O'Neill

Copy Editor
Richard Slovak

Photography
Parks Anderson, Theresa Batty, Dick Busher, Judy Coleman, Jan Cook, Asahel Curtis, David Emery, Claire Garoutte,
Donna Goetsch, Itamar Grinberg, Nick Gunderson, Russell Johnson, Ansgard Kaliss, Scott M. Leen, Frank Nowell,
Dave Potts, Teresa Nouri Rishel, Terry Rishel, Buster Simpson, Nathaniel Willson

Photo credits
p. 18 Space Needle and Monorail, Seattle World's Fair, 1962; Museum of History & Industry, Seattle; All Rights Reserved
p. 20 Dale Chihuly at Bellevue Arts Festival, Bellevue, Washington, 1968; Seattle Post-Intelligencer Collection,
 Museum of History & Industry, Seattle; All Rights Reserved
p. 33 The Space Needle and fairgrounds during construction, Seattle World's Fair, circa 1961; Museum of
 History & Industry, Seattle; All Rights Reserved
p. 48 Ferry Museum, Washington State Historical Society, Tacoma, circa 1900; Washington State Historical Society,
 2009.0.465.5
p. 85 Sunset Boat, Chatsworth, England, 2006; reproduced by permission of Chatsworth House Trust
p. 113 Volunteer Park Conservatory, Seattle, 1914; Seattle Municipal Archives
p. 123 U.S. Science Pavilion arches, Seattle World's Fair, 1962; Museum of History & Industry, Seattle; All Rights Reserved
p. 131 Volunteer Park, Seattle, 1920; Seattle Municipal Archives

Cover
Blue Reeds and Marlins
Franklin Park Conservatory, Columbus, Ohio, 2009

Publisher
Portland Press
Seattle, Washington
www.portlandpress.net

ISBN: 978-1-57684-039-9

Printed and Bound in China by Global PSD